To <u>th</u>
for reading my truth,
my story, and my testimony.
Always see the Beauty
in your struggles and
pain.

Beautiful
Wounds
Lori Ann

Beautiful WOUNDS

One woman's journey from birth to rebirth

LORI ANN SMITH

BEAUTIFUL WOUNDS

This autobiography is based on true events. The author has tried to recreate events, locales, and conversations from memory. To maintain anonymity, the author has changed the names of some individuals and places. Some events have been slightly altered for entertainment, and some dialogue has been recreated.

BEAUTIFUL WOUNDS Copyright 2019 Lori Ann Smith

ISBN-13: 978-0-578-58925-1
ISBN-10: 0-578-58925-7

Published by Lori Ann Publishing
Hawthorne, NY

Printed in the United States of America
First Edition November 2019

Cover Design: Make Your Mark Publishing Solutions
Interior Layout: Make Your Mark Publishing Solutions
Editing: Make Your Mark Publishing Solutions

ACKNOWLEDGEMENTS

In loving memory of Cora Lee Mayes, Nannie Gladys (Mala) Mayes, Gladys Beatrice (Tracie) Mayes-O'Field, George Scott McCleary, Annie Smith, and James Vincent (Vinnie) Cohen. You all have impacted my life, and it's because of you that I am who I am and who God created me to be. This is my story, and it's written from my point of view. It wasn't my intent to paint any of you in a negative way but to shed light on my life and how each relationship and situation guided me and molded me into the person I am today. I love each of you with all my heart, and if I had to do it all over again, my actions would have been different. However, the people in my life would still be the same. I wouldn't erase one person from my life, for you all taught me so much, and the knowledge I obtained was priceless.

In loving memory of Jerrard L. Barrett, my little brother from my father's side, my only brother. Not having much family growing up made life difficult. Whether we'd spent time together or not, I found comfort in knowing you were there. You will be forever in my heart like all my other family members who have passed on. Sleep in peace until we meet again.

This is the beginning of my closure, my healing, my understanding of my purpose. I thank you all for teaching me how to navigate through my ever changing and evolving life. It took me a while, but I've got this now!

Cora Lee Mayes, Ma, you taught me how to stand on my own

two feet and be independent despite what was thrown my way. Forgive me for all the hurt and sorrow I've caused. You were my best friend, and life hasn't been the same without you. I carry you in my heart and soul. I will never have a friend like you. Our mother/daughter relationship was complicated, but you will always be my best friend, my teacher, and the voice of reasoning that's constantly in my head. Not a day goes by without thoughts of you.

Vinnie, no one will ever understand our bond, our connection, our love. Our relationship was toxic. Like oil and vinegar, we were incompatible but dared anyone to tell us otherwise. If ever you could love someone too much ... Well, that's what we had. I learned so much from you, and I wish things could have turned out differently. But I know God put you in my life for a reason and a season.

To my other family members, I love you, and know that we shall meet again. I am thankful for your guidance and nurturance. You all touched me in unforgettable ways.

Thank you!

My five sons, times were hard, but we managed to stay strong together. You all have turned out to be amazing sons, and there is nothing I wouldn't do for you. I was far from perfect, but I love each of you with every fiber of my being.

Ronald Leon Davis Jr., my first born, my backbone, and my biggest fan. We grew up together and had to overcome many obstacles. It wasn't easy for us, but we did it. You are so smart and talented. There isn't anything you can't do if you put your mind to it. Rise above your circumstances and step into your next chapter. It's reachable and attainable. History doesn't have to repeat itself. Let it end with you. My ol' soul, I love you always!

De'Von William Ritter, my second born, my realist, my joker, the comedian, and my shoulder to cry on, Mister Family Man, the glue that holds us all together, the one I can always depend on when we are weathering the storm. I am so proud of the man you have become. You have shown me what a real man is and how a real man takes care of his family. I love you always.

Jarrin TréQuan Mayes, son number three, my dreamer, my strength, my provider, will give you the shirt off his back, my storyteller, and my gentle teddy bear. It's not over until God says it's over. You are strong, and you are the most loyal person I have ever known. As Alexander Hamilton once said, "If you don't stand for something, you will fall for anything." You are missed every day. I love you always!

Justin Da'Quan Cohen, son number four, my fighter, my premature baby, my serious one, my level headed one, the thinker, and my visionary. You finally figured out your niche and, trust me, you got this. No holds barred. The sky is the limit. Our relationship has grown so much, and I appreciate the new and improved you. Continue to be the best you. Be the leader you are destined to be. I love you always!

Tylin Ashton Mayes, son number five. Last but not least. My twin (physically and emotionally), my debater, my baby, and my creative one. You are impressionable and can accomplish whatever you want. Yesterday is gone, but tomorrow is yours for the taking. It's never too late to make your dreams come true. You are resilient, and you can do it. Now is the time for you to soar. Fly, Ty. I love you always!

Shawn Smith Jr., my stepson, Mister Dapper, Mister Suave, and Mister I Am Going to Be Successful, follow your dreams. I appreciate all the talks. You are going to do well. Love you!

Thank you, guys, for including your writings and thoughts in this book. I am so proud of each of you.

Shawn Smith Sr., my husband and friend, we have hit some bumps in the road, but I will always love you. God sent you to me. You proved to me I am worth it. Our love story continues.

To my grandchildren, Emarie A. Davis, Zaire A. Davis, Masai A. Davis, Kylen A. Ritter, J'aliyah A. Mayes, Nasir A. Davis, James E. Mayes, and A'mayah A. Helfinstine. Your nana loves you with all her heart. You all are so special to me. I love your unique personalities and the way your smiles light up the room.

Andrea' Redd, my best friend for life. Distance could never come between our bond. I admire you, your style and grace. You were my shoulder to cry on in my darkest days. There were times when you knew me better than I knew myself. Shit, you even knew when I was up to no good (not that you could stop me from falling off the ledge). I have learned so much from you, and I love you like a sister. You inspire me to do more and not settle for less. You are a classy lady. Never bend about those things you know to be unfair and unjust. Like you always say, "This too shall pass."

Barbara Whyte, my road dog, my copilot, my confidant, my best friend, and my sistah for life, I truly appreciate the talks, the cries, the struggles, and the laughter. It was you who kept me from going insane. You have my back through thick and thin. I love you from the core of my soul.

Jemir Anderson, my girl, you say you have learned so much from me, but I have learned a lot from you. I know the road seems rough now, but, trust me, it will get better. Never change who you are!

Family and Friends: Carolyn Whitted (godmother), Sandra Washington (cousin), Megan Ritter (daughter-in-law), Sharnise Mayes (daughter-in-law), Selena Cohen, Angelique Barge, Bea Thompson-Samuels, Michael Spindler, Gerald Hudson, Beatrice Newton, Sandra Newton, Brittany Whyte, Brandon Whyte, Giselle Lopez, Terry Bynes, Shandia Fryer, April Smalls, Lisa Fields Linnen, Leif Redding-Keolamphu, Wilfredo Ayala, Jonathan McLean, Valerie Cortalano, Larn Cunnigham, Keith Eversley, Luis Moore, Anthony Evans, Denise White-Smith, Alma Sampson, Erwin Canady, Gregory Shedrick, Lakier Smith, Will Shephard, Ronald L. Davis Sr., Cheryl Middleton, Priscilla Augustin, Timothy Smith, Christina Morgan, Vernessa Bovastro, Denise Peart, Tempest Cohen, and many more. Please forgive me if I didn't mention your name. I still carry you in my heart. I thank you all for being a part of my journey. Your support gave me the strength I needed to pursue my dreams.

Writing my autobiography wasn't an easy task. I was filled with

self-doubt and was leery about the process. I am forever grateful to Monique D. Mensah of Make Your Mark Publishing Solutions for bringing my autobiography to life. Your insight, encouragement, and editorial support were phenomenal. I know, without a shadow of doubt, I couldn't have done this without you. You are talented, knowledgeable, and a force to be reckoned with. I am honored you chose to go on this journey with me.

I thank you all for your support. You have touched my heart in a special way and inspired me to do more and become greater.

DEDICATION

To my fives sons for always supporting me and showing me unconditional love. You guys never judged me and have been so understanding, even during my craziness!

&

To all the women who have a story to tell. It is my hope and prayer that you find comfort and strength from reading my story.

AUTHOR'S NOTE

As my good friend Andrea would say, I am doing the damn thing! I have finally decided to step out on faith and write my autobiography. This process was not an easy one but necessary for my healing. My faith has been tested, and I pray for inner peace and restoration. Throughout this story, I will incorporate my thoughts and current emotions as reflections or "My Truth." My truth is from my perspective only. My sons and those who know me and shared moments with me may have different accounts or perspectives about how each situation played out, and I welcome their input. Each of us view the world in our own unique way. We may have been involved in the same situation but have different opinions and tell our own versions based on how we felt.

I wasn't, by any means, an angel. At different phases of my life, I've caused my loved ones grief and pain. I let my selfish ways dictate my decisions and often used manipulation to get my needs met. But I am beyond that now. I have grown and become a better mother, woman, and friend. Standing now is a woman with dreams and higher self-esteem. I am not broken, bitter, or angry about my past. Reminiscing is for the sole purpose of my evolution. I have let go of the things I can't change but relish in the fact that I've made it through. It wasn't always pretty, and it came with countless bumps and bruises, but my wounds are finally healing. I am peeling back the onion and uncovering the scars. To my surprise, I realize the wounds have laid dormant while beauty was being birthed.

My deliverance is happening as my thoughts are transcribed on paper, each word transforming into my story, which is setting me free. The scars are visible but covered in love and hope. I am stronger, wiser, and unafraid of failure while gravitating toward victory. I am a strong black woman, fearless and determined, with a fight in me that is too powerful to be defeated. As long as I have breath in my body, I will continue to strive for greater for my family, friends, myself, and others.

My objective is to create a platform for women and empower them to share their stories and take the journey of healing. I want to assist you with your stories, and I want to know how you feel as you read my story. Did you get upset about something I shared? Have you experienced something similar? Or did I make no damn sense at all and you want me to provide clarification. Please let me know. Shoot me an email, call me, or let's set up a meet and greet.

I implore you to speak your truths and share those innermost thoughts, the good and not so good parts of you. These remnants of you are what makes you who you are. Start journal writing. It's therapeutic, and it will help you get through those dark moments.

I have had my share of ups and downs but refuse to give up. I understand and know my purpose, which is to empower other women to live their best lives. We all need to create the life we dream of. Many times, we let our pasts dictate our futures, but the past is what it is, and it will be what it's going to be. Keep moving forward!

I have always dreamed of writing. I wrote a play called *This Too Shall Pass* and a movie script titled *Triggered* about twenty-five years ago. When I was writing the play, God told me to write my story. I picked the play back up about three years ago but never got it off the ground because it wasn't the story I needed to tell. This is what He told me to do, and I hadn't listened. But now, God and I are telling my truth through my story.

God's grace and mercy kept me. If He did it for me, I know He can do it for you. He's able. But I would be a liar if I said God and I have always been on the same page. Not at all. As a matter of fact,

we aren't on the same page now. I am a believer and a witness that He is real; however, I am disappointed and angry with Him, so I wrote this book for my own personal healing. The plan is for me to heal and be healed. What that will look like, honestly, I don't know.

There will be an opportunity for you to join my book club, so we can discuss further. Please keep notes. I am an open book. No part is off limits. I am available to talk about it all!

What are your *Beautiful Wounds*?

"'Yet even now,' declares the Lord,
'Return to Me with all your heart, and with
fasting, weeping and mourning.'"

—Joel 2:12-13

PROLOGUE

In God We Trust.

I sat in the courtroom, numb, staring at those words strategically planted on the wall, anticipating the life-changing verdict the cold-hearted foreman was about to read aloud (at least he appeared cold hearted). I thought about those words—In God We Trust—as my eyes remained fixated. With tears rolling down the sides of my face, I knew no matter how often I had prayed, God wasn't going to make a miracle happen. My son's fate was in the hands of the jury. The jurors were comprised of young and old white folks, men and women, his so-called peers. Was I truly expecting this jury to be impartial?

I don't think so!

Not a black juror in sight to offer any form of support, comfort, or understanding for his family or me, better yet, him. How could this jury be impartial, fair, and just? How could they be fair when they didn't have the complete story, the entire picture with all the details? I wanted them to know more about the man who sat before them. I wish they had known what led up to this moment. How he got to this point. What our family had gone through—all the devastation, confusion, and grief. All the years of heartache, sorrow, and pain. I wanted them all to know that, although he had made many mistakes in his life, he wasn't an animal. He was remorseful about his decisions and the crimes he committed. And so was I.

I wanted to scream from the top of my lungs, "You all don't understand!" But thoughts crowded my head. Had I been the cause

1

of his path? What hadn't I done correctly? What could I have done differently? So many unanswered questions. Was I to blame? I wanted to take my baby home and hold him in my arms just like I had done when he was a little boy. I wanted to protect him from what they were about to hand down. But I felt hopeless. There was nothing I could do but watch and listen as they described a man I didn't know. I knew they had the right man but the wrong person. Who was this person they were talking about? Not the man I'd known for twenty-eight years. They must've been mistaken. Maybe they had the wrong guy. Maybe he looked like the person they were claiming him to be. A mother knows her child better than anyone else. They were wrong about him. My son wasn't who they described.

His exterior wasn't a true reflection of his interior. If they had met him prior to this incident, they would know how much of a loveable and likeable guy he was, how caring and friendly. He was a dedicated single parent who walked miles to make sure his kids' needs were met. The family man, who woke up at four a.m. to get himself and the kids ready for work and school. The man who worked ten to twelve hour shifts to put food on the table. The man who called his mother every day just to say hello. The same man who wore a tattoo of his mother's name. Who fed his friends when they didn't have a dime to their name and hadn't had a bite to eat in days. Who stopped and gave a homeless person a few dollars if he had it in his pocket. The man who showed up if someone needed help and went above and beyond the call of duty. That's who I wanted them to know. And so much more. Lord knows there was more to him than met the eye.

But clearly, the paperwork they'd received told a different story. He had committed a crime, and that was why we were sitting in a courtroom awaiting a decision we couldn't control. I wasn't delusional about the matter before the court.

The People versus ...

We all know how it goes. That was all those folks cared about. They were there to draw blood and couldn't care less about anything

else. Besides, it wasn't one of their family members sitting in that chair. They weren't emotionally connected to his story. I could read the expressions on their faces: another black man in trouble again. It was their civic duty to get a criminal off the streets. Though the room was quiet, I could hear their thoughts.

It wasn't hard for them to realize who I was and why I was there. They tried not to stare at me, but I sensed they felt sympathy for me. Still, I'm sure they questioned what type of mother I had been. They sized me up daily as I sat behind him. I was stricken by a numbing pain, rendering me unable to think clearly. My thoughts were jumbled, and nothing made sense. Periodically, I heard the court clerks moving about the room and talking, but it sounded more like noise coming from their mouths, muffled as if they were under water.

All I could think about was the amount of time he was facing, and the more I thought about it, the harder it was to keep my emotions in check. How was a mother to cope with the thought of her son spending up to thirty years behind bars?

Thirty years.

That was what his public defender told me, and he'd tried to convince my son to take a plea deal. If he'd taken the deal, he would only do ten.

What was he accused of? Murder or something extreme? It wasn't to that degree. The case is being appealed, so I can't go into the specifics, but bear with me.

There's a reason the jury isn't made aware of how much time a defendant is facing when deciding the verdict. Had they known, I am sure they would've drawn a different conclusion based on who was involved and the circumstances.

Not every black man decides to commit crimes because he has nothing better to do. There are some heartless individuals who engage in criminal activity just because they're ruthless. But not this man. With all the crimes being committed, I understand that many

people couldn't care less about what led an accused criminal to this point, but we should look at the individual and what makes sense.

I have worked in social services with youth in the foster care system for a long time. I have seen things from both ends of the spectrum. Part of my role was to look at the children's history and become knowledgeable about what led them into care. I always tried to look past the behavior and meet them where they were. The behavior is a means to an end. It's usually a way for them to express their pent-up emotions, anger, rejection, and resentment. Reading their stories, I was quickly able to get a sense of what brought them into care and understand who they were or, better yet, the circumstances that led them there. The stories were troubling. Many of them had been abused sexually, physically, and emotionally, suffering by the hands of their birth or foster parents. By the time they reached us, they were angry and had distrust and disdain for adults. Adults were supposed to protect them but hadn't kept them safe. And we became part of the problem. They acted out and became physically and verbally abusive. But we understood where the behavior came from. As much as we wanted to help them, they weren't about to reach out to us with open arms. We didn't excuse the behavior, but we understood it.

Several of the youth in the program committed crimes and landed themselves in the juvenile justice system. I spent countless hours listening to judges read aloud the crimes they had committed: petit larceny, assault, some misdemeanors, some felonies. Nobody cared about what they had been through or what created the rage inside them.

But despite the backstory, a crime is still a crime. My heart goes out to the broken souls who feel hopeless with no support systems in place. I have firsthand knowledge of how we're treated compared to White America and those who aren't financially challenged. We don't get a slap on the hand with another chance. They'd just as well lock us up and throw away the key.

It's not difficult to feel like a nigger when you're caught up in the

judicial system. I bet the majority of Black America, who don't have the money to properly defend themselves, have felt the same way. We are treated unfairly, and it's a known fact. The odds are stacked against the non-whites and poverty stricken. As much as people want to believe otherwise, money is power.

We don't stand a chance with a public defender. This isn't a knock on public defenders. Imagine where we would be if they didn't exist. I'm sure a lot of lawyers work hard to defend their clients, but we all know the investment isn't the same when the attorney is appointed by the courts. I don't know much about the law, but I have watched some public defenders perform and said to myself, "Shit, I could've done a better job."

This courtroom was just like any other, with two defendants and their two attorneys, twelve jurors and two alternates, the district and assistant attorneys, three officers who held court behind the defendants, the mother of the other defendant, a stenographer, and me. This wasn't a high-profile case, but it was big enough for the town of Poughkeepsie, New York.

Poughkeepsie has a population of about 35,000. The crime rate is forty-five percent higher than the New York average and one percent lower than the national average. The violent crime rate is ninety-eight percent higher than New York's and eighty-four percent higher than the national average. The city has a mandate to get the criminals off the streets and rightfully so.

Crime affects us all and needs to be addressed. And the criminals should be apprehended. I, by no means, imply that black men and women should not serve time for the crimes they commit, nor am I saying the jails are filled with innocent people. Each case is different and should be judged accordingly. This isn't about innocence or guilt. If you commit a crime, you should do the time. However, there needs to be uniformity. It shouldn't be based on money or social status, race or biases.

Surveying the courtroom, it was easy for me to point out the disadvantages my son faced. Most black folks have felt it before,

knowing the cards are stacked against them and there's nothing they can do about it. With no control of the situation, they can only hope and pray for the best outcome. But their gut tells them, *Nope, this won't turn out the way you want it to.* That was how I always felt whenever I stepped into a courtroom or had encounters with police, not just negative situations but all. Not all police are bad, but my interactions with them haven't been positive, and I have never been arrested or incarcerated. My sons have had dealings with them, and they've suffered mistreatment and discrimination. Truth is truth, and the law isn't always there to protect us.

This courtroom didn't seem fair at all. I knew we were in trouble from the moment I stepped inside. I could feel the coldness, the racism, the unfairness from all the others who had been in front of the judge. My discernment is always on point, and I can instantly sense when danger is near. I knew we were in for the ride of our lives.

The judge was white, the jurors were all white, the court officers were white, and the police. We were doomed before we'd even started.

How could anyone think it was fair? To make it look good, they threw in a black assistant district attorney. Was she supposed to make me feel confident because she was one of our kind? Hell nah! So fucking what! I watched that bitch parade around the room in her Target pantsuit (pretending she'd bought it from Bloomingdales) and costume jewelry like her shit didn't stink. Her gear was as fake as her ass. And just because she was dressed for the job didn't mean I couldn't read her. I knew from the moment I saw her that her mission was to win the case, even at the expense of justice. She was a cold-blooded sistah (and calling her that is giving her too much credit). She didn't give a fuck. Her black skin may have been a constant reminder of our likeness, but alike we were not. Black was something she didn't want to be. She could be classified as one of those "uppity Negroes." I don't know if it was boredom or just something women do, but I sized her up during the trial. She appeared to be in her late forties or early fifties, kind of tall with a

slender build. She was average looking with a semi-dark skin tone. I
believe I saw a dimple or two the one time she'd smiled. There were
a few times when I wanted to ask her why she hadn't done her hair.
It was a nappy mess. She'd attempted to gel it down but, clearly, it
hadn't worked out too well.

I could tell by her awkward walk she had something to prove.
This case would be the one to put her on the map. She couldn't care
less about the young man who stood before her. She was thirsty for
a win, and she was going after it by any means necessary. It would
help her fit in with her peers, whom she clearly wanted to impress.
Each time she walked past me, I saw the smirk on her face. She
was confident that she would win. And, as much as I didn't want
to believe it, I also knew that, this time, he wouldn't get away scot-
free. He'd had run-ins with the law when he was younger. But this
time felt different. This would be a major turning point in his life. I
knew it, he knew it, his public defender knew it, and it was too late
for us to turn back.

However, my God had never failed me. Throughout my life,
He had been by my side. He was my calm after the storm, and we'd
had many storms, but I trusted that when all was said and done,
He would not fail or desert me. My God always showed up right on
time. We didn't have it easy, but God always came through, making
a way out of no way. So I had to believe in His word and know in
my heart that He was with me. He had proven Himself loyal to me
in the past. I hadn't always been faithful to Him, but He had been
consistently faithful to me.

From the start of the trial, I prayed like I had never prayed
before. I called on all my prayer warriors, and they prayed with me
for us and held a vigil. I stayed prayed up so no weapon formed
against me would ever break me.

Besides, I needed my son home, and his kids needed him.
God wouldn't allow him to be away from his family, would He?
How could He, with all we had been through as a family, all the

heartache, the pain, the loss and struggle? This wasn't going to happen. The devil is a lie!

Although the courtroom isn't a comforting place for Black Americans, in an eerie way, I found solace. Sitting in silence gave me the opportunity to reflect on my life and past transgressions. My son wasn't the only one to face years of imprisonment. I had been imprisoned for most of my life by my own poor choices birthed by a lack of self-love.

Being in that courtroom conjured up multiple feelings. I questioned my role as a mother. Had I failed him? Had my mother failed me? With a heavy heart, it was time to face my past, to retrace every step of my journey and find the answers to my burning questions and take responsibility for my life—for his life. Venturing into unchartered waters is always difficult but necessary, but, by now, I knew how to embrace the pain.

So I let my journey, my truth begin ...

From
DE'VON W. RITTER

This is about a journey, a girl growing up, having kids, and overcoming adversity. It's not about where she started and ended, rather, how she got there. In the Oreo of life, the journey is the cream filling. It's how we can all relate but also what separates us. Everyone has a journey, a song to sing, things that make us unique. This is just that but also so much more. Before you go on to read, take a moment to think about life and the path that got you to where you are ...

How did that make you feel?

Did you smile? Did you laugh? Did you become angry, happy, sad, or inspired? Whatever the feeling, that energy is part of you.

Now dig deeper. Go to those tough moments that shaped you, the ones that maybe you don't like to speak about or you leave in a box only to be visited at certain times. Those are wounds, and we all have them. We all have pain that has shaped us and turned our world upside down, forcing us to adapt. This book is about those moments in a girl's life that many would not want to see or talk about. But although there's not always a happy ending, it's possible to find beauty in the wounds born from those situations.

You will get to know the story of Lori Smith. However, to me, she is better known as Mom, "Mommy," to be more precise. I am her second born of five children. She will introduce some of the details of our relationship over the past thirty-three years. But I want to share

with you who Lori Smith is to me. As you will learn, I didn't live with my mother for the entirety of my childhood. However, that, in many ways, made our relationship stronger. We have had to battle one another, time in and time out, to get to where we are, mostly because we're similar. Through those battles, we have become not only mother and son, but also best friends.

My grandmother, Lori's mother, was the backbone of our family; she was the foundation. And my mother is the hand, her five children representing the digits. Just like fingers from a hand, her sons can stretch and reach for the stars but would never do so without the hand. When the digits come back to the hand, strength comes in the form of a fist, able to battle anything that stands before it.

BEAUTIFUL WOUNDS
by De'Von W. Ritter

If I showed you a beautiful wound
how would you react?
Would you allow me to show the world
or beg me to keep it back?
Would you understand its being
and the depth of its presence
or berate its beauty
and question its essence?
Would you grow to doubt me
view me as flawed and incomplete
or view me with godly eyes
as blessed are the meek?
For if a beautiful wound can exist
in a world of perfection
then the wounds we carry
are our beautiful lessons
We are all wounded
caused by mental, physical, and emotional strife
and the wounds we carry
make this a beautiful life

CHAPTER
One

I was born on March 7, 1968 to Cora Lee Mayes, her first and only child. I grew up in Peekskill, New York, a city in Westchester County about forty miles north of New York City. Peekskill is situated on a bay along the east side of the Hudson River. It had a population of about 20,000 people when I was growing up.

Peekskill is a small town, and growing up there had its advantages and disadvantages. Everyone knew everyone, and there were a lot of big families, or kinfolks, in our town. There were some fun things to do like going to the movies, a nearby roller skating rink, or bowling alley, typical to most neighborhoods. But I felt sheltered, and it seemed like we were in our own little world, a desert island. There weren't many new faces. We hung around the same people every day.

Lee was my mother's middle name but for some strange reason, people who were raised in the South combined first and middle names, so they called her Coralee or "Redbone" because of her light complexion. She was a feisty woman who stood about 5'4" and weighed a buck ten on a good day, and she was one of the most intelligent people I'd ever met. She was well versed in a lot of things, and she didn't take shit from anyone. She never cared how big a person was; if they fucked with her, she held her own. She was spunky and had a lot of tenacity. I've witnessed her, first-hand, go toe-to-toe with women and men of all different sizes. Shit, one time,

I watched her get into an argument with a damn near 300-pound woman.

Yvonne got in my mother's face, and Coralee jumped her ass up and told her, "Bitch, I will kill you!"

By the time Coralee was finished, Yvonne had sat her big ass down and said, "Little mama, I was only messing with you. We cool."

"No the fuck we ain't cool. We can go outside and settle this. I'll beat your big, fat ass up and down Lincoln Terrace, bitch. I ain't the one to be fucked with."

Now, you can only imagine how stupid Yvonne looked, backing down from my mother's little, skinny ass, but she sure did stay down and didn't move. She laughed and said, "Girl, you know we like family."

Coralee was no joke. She never backed down from anyone. And when it came to her only child, as said in her words, she would "die and go to hell for hers." If some kids were messing with me at school, shit, she would show up and be ready to fight them herself. She let them know, "You can mess with any other child, but you better not put your hands on this one. She's mine, and no one better touch her. Go get your mama, and if she got a problem, tell her to come see me."

When a group of kids jumped me after school, she told me, "I know you don't want me to handle it, so I tell you this; pick the biggest or baddest one out the bunch and beat the mess out of her. I guarantee they won't bother you again."

I was afraid of them, and I didn't want to fight. But I was also tired of those girls beating on me day after day for no apparent reason. They said I thought I was better than them, but I didn't even know what that meant. We all lived in the same neighborhood. But apparently, I thought I was cute because I had long hair and nice clothes, so I became their target. I hated when school ended because no matter how fast I ran, one of them was bound to catch me.

I was always glad when my mother picked me up from school,

but there were days when she couldn't or just didn't feel like it. I was on my own and had to deal with the consequences. I was tired of it and tried to reason with them, but it didn't work. It was me against them—the big, fat bully, Jessica, the ugly bully, Dianne, the want-to-be-down bully whose name evades me, and the so-called friend/family bully, Michelle. I'd had enough, so I did exactly what my mother told me to do. I grabbed the fat one and knocked her against a fence and started tussling with the ugly one. I transformed into a beast, a raging bull. I don't know where all that strength came from. Shit, I wanted to draw blood. I was so crazed, I scared myself. They looked petrified and started hauling ass. When I saw them running, I started laughing. How could little ole me cause them to be afraid? From that moment, things changed.

The girls befriended me as if they had liked me all along. They told me the only reason they picked on me was because I was pretty and had long hair. That was stupid. I learned so much from that experience, and since then, I despised bullies. At school, I always took up for the underdog. If I saw someone being bullied, I did my best to help them. I didn't allow that shit to take place under my watch. I knew how it felt to be picked on and teased, and I didn't want anyone else to go through it. For what?

Coralee was my everything. She was my protector and always had my back. If I told her a teacher or adult was bothering me, shit, she was on it. She would go to the school raising hell. When she finished with them, they were nice to me. I played that to my advantage. Half the time, I made up stories about the teachers, knowing I was the one in the wrong, but it didn't matter because Coralee would come to my rescue.

Coralee was born in Spartanburg, South Carolina on October 10, 1948 to Nannie Gladys Mayes and Roscoe Mayes. My grandmother migrated to Peekskill after her husband, Roscoe, walked out on her—and I mean literally walked out the door. Said he was going to the store but never returned. He'd gotten up on one normal day, got dressed, and told her he was going to the store to get milk and

bread and he'd be right back, but she never saw him again. She didn't know if he was dead or alive. All she was left with was his memory. The man she loved had left her to care for the three children he'd left behind. No phone calls, letters, or messages from friends or family. He disappeared without a trace.

My grandmother never got over that loss. I can't count the number of times she sat and drank her Schaeffer beer and said, "You know he's coming back." She believed in her heart that her husband was coming back for her. As the years kept coming and going, Grandma was still waiting for the knock at the door. I could tell by the look in her eyes that she never gave up on love. She loved that man until her last breath. She spoke of him with respect and dignity. She'd say, "Loriann, your grandfather was something else, and, boy, was he fine." She told me about his days in the service, and I could see the glow in her eyes, how much she admired him. I let her go on and on about him, even though he didn't sound that damn great to me. How could he be that wonderful when he'd left his family behind? Nope, I wasn't buying it. But it wasn't my story to tell, so I just listened, pretending to be excited to learn more about the man I never knew.

My grandmother needed to tell the story. It was her story, and she could tell it any way she wanted. If it made her happy, I was happy for her. Whenever my mother or aunt interrupted her, she was quick to tell them off. Shit, my grandmother always had a comeback. She would tell them, "Shut up! Y'all crazy asses probably ran his ass way."

I would take up for her and add in my two cents. "That's right, Grandma. You tell them." I let my mother and aunt know, "You better leave my grandma alone!"

They would give me a look and say, "Girl, shut up. You don't know what you're talking about." We'd all laugh.

My grandmother and I had the best relationship, and she would get so tickled when people mentioned how much I looked like her. They would never match me with my mother due to our

complexions. My mother was high yellow just like her two siblings, and I'm brown-skinned like my grandmother.

I remember asking my grandmother if she really believed Roscoe was coming back, especially since it had been so long. From the look she gave me, I knew never to ask again. She was angry at me for asking what she thought was a stupid question. There was no doubt in her mind. She was convinced that, one day, her husband was going to come walking through that door despite the fact that she wasn't living in Spartanburg, South Carolina anymore. Wherever she was, he was bound to find her—so she thought.

Years later, when she filed for retirement benefits, she learned through the Social Security Administration that he was alive and well living in Bronx, New York, which was only thirty-five minutes from her home in Lincoln Terrace. That really fueled her fire. The fact that he was close had her convinced it would only be a matter of time before he knocked on her door. I think that's partially the reason my grandmother was hesitant to move into a senior citizen building. She was worried that her husband wouldn't be able to find her.

She referred to him as her husband, but Roscoe had remarried. We weren't sure how he was able to pull that off because he had never divorced my grandma, but Roscoe was her husband, and she never let anyone forget it. When she found out he'd remarried, she didn't believe it. She lived by her vow—"Til death do us part."

Not having my grandfather in our lives affected the whole family. It was the beginning of the loss of the male figures in our lives. It was difficult for my grandmother, and I'm sure that's why she never remarried. I heard stories about men who pursued her, but I never saw my grandmother with any other man. I don't recall my mother, aunt, or uncle talking much about their father, but I am convinced not having their father around was difficult for them. Why wouldn't it be?

Unless one has had an absent parent, they may not understand how it affects every relationship. Yes, single parents can do one hell

of a job raising children, but it is with a disadvantage. I am not discrediting those parents who do it alone, whether they be single mothers or fathers, but the child suffers in the long run. It creates self-doubt and leaves them feeling like they weren't good enough.

Because of my grandfather's absence, his children had to figure out relationships on their own. All they knew was they had a father who had walked out on them and never looked back. They were children when he'd walked out, not even teenagers. He didn't call or visit, and he died not even knowing if they were all right. I wish I had met him. I would've asked him what he was thinking. What made him walk out the door? Maybe I don't have the full picture, but it's something I'll never get an answer for.

His departure probably affected his children's adult relationships. Loss is loss and absence brings forth voids in life. Those children grew up not knowing why he'd left, and I am sure there were points when they blamed themselves. Parents shouldn't do that to their children. Unfortunately, there was a point in my life when I did something similar. I dare not cast the first stone.

Aunt Tracie got involved with a married man when she was a teenager. He was abusive and treated her badly when he was drunk, the same shit he did to his wife. I don't know what went down, but I know his wife left him, and he moved my aunt in. My aunt was a good woman to him. She worked every day and brought home the groceries, cooked the food, made sure he had what he needed, and blah, blah, blah ... We women put so much time and energy into no-good motherfuckers, the ones who treat us like shit. When he was home, she waited on him hand and foot, putting him before herself. But that didn't matter to him. He knew he had her right where he needed her. When he wasn't home drunk beating on her, he was busy running the streets, chasing any tail that would give him the time of day. She knew exactly what he was out there doing, but she was willing to fight for the relationship. Years later, they married, and he stopped beating her.

Aunt Tracie's husband treated her like shit; however, they were

together until her untimely death. My aunt worked for *Reader's Digest* for well over twenty years. Back in those days, a van picked the workers up and took them to Mount Kisco, New York, where the agency was located. My aunt was on her way to work in the van with coworkers when she started throwing up. The driver pulled over, and my aunt had a heart attack and died in the ambulance on the way to the hospital. She never complained about much. In all the years she had been employed, she never missed a single day on the job.

Had her father been around to show her how she should be treated—like the queen she was—maybe none of us would have fallen victim to domestic violence.

There must be a correlation. As I think about the female role models in my life, I see patterns. We all learn from our experiences. At some point in our lives, we become our mothers. The more I proclaimed I wasn't going to be like my mother, the more I became just like her. My older sons always point out when I'm being like her. They say, "Okay, Coralee."

My aunt was one of my biggest cheerleaders. When my mother gave me a hard time, she was quick to come to my defense. She never had children of her own, but in some ways, I was like the daughter she never had. She spoiled me as if I were her own. She enjoyed taking me shopping at Macy's, her favorite department store. We would spend hours upon hours shopping. I learned a lot from my aunt about life. She spoke in a rather quiet manner, but I always understood where she was coming from and what she was saying.

I think I also got all my phobias from her. She feared heights, and so do I. She was petrified of elevators; so am I. She and my mother were deathly afraid of cats, and so am I. My aunt was so down to earth. I could talk to her about anything. She wasn't one to judge. She would say, "Do you think that's a good decision?" and "What could you have done differently?" She was authentic and never compromised her uniqueness. When I called on her, she was right there. But as much as she defended me, she would put me in my

place as well. She knocked me down a notch or two when I needed it, not physically but verbally.

Tracie was a drinker but mostly on the weekend. During the work week, she was about business and business only. Her death was a major loss for me. I miss her a lot.

My uncle, my mother's brother, married twice. His first wife left him, and he was devastated. I'm told he had a nervous breakdown. I never had a connection with him, and he never cared for me. In his eyes, I didn't live up to my potential. I was the black sheep of the family, the only one to become pregnant at an early age. I guess I was an embarrassment that he never got over. Whenever he saw me, I could tell he was disgusted by my presence. In the last thirty years, we've probably had four conversations, and the most talking we've done was at my mother's funeral. I have learned to live without that side of my mother's family. They don't call me, and I don't call them.

I had it damn good throughout my childhood. My mother, grandmother, aunt, stepfather, and godmother spoiled me to no end. I never wanted for anything. They always made sure I was taken care of, and my mother never held back any punches.

At an early age, she told me there was no such thing as Santa Claus. She was Santa. And shortly after, I learned that the man I thought was my father really wasn't. She always kept it real, whether I liked it or not. I found out that my father lived in the same town and had a whole other family. He knew about me and claimed me, but we never had a relationship.

I was told my grandmother ran my father away because she wasn't going to allow him to take advantage of my mother. She wouldn't let him come by when he wanted to and not help her support me financially. Had he wanted to be a part of my life, he could have. All he had to do was make the effort. My mother would have made sure he was able to spend time with me. Besides, we lived in the same town.

He lived with his wife, her kids from another man, and my brother. His wife's daughter found out he was my father and tortured

me when I was a little girl. Whenever she saw me outside playing near where they lived, she would say, "You know William isn't your father, and he doesn't like you."

Why are kids so mean? Don't they know how much words hurt? I ran home to my mother in tears. Coralee wasn't having it. When I hurt, my mother hurt, and she wasn't going to tolerate that bullshit. We marched right over to William's house, and she told him what happened, how his stepdaughter and others were treating me, how they were telling people I was lying about who my father was. William made his stepdaughter apologize to me, and he finally announced to the world that Loriann was his daughter. I felt like I belonged to someone, happy that he had acknowledged me. From that day on, I inherited a new family that I didn't even want. Some said I was their cousin, sister, or niece.

I was hoping this would be the turning point for William and me, but it wasn't. It was good that he'd told everybody, but he and I were back to the same old way. He would see me and say, "Hey, girl!" and keep on about his business. He never asked me how I was feeling, if I needed anything, or if I wanted to hang out with him. I never got a gift, money, a card, anything. Shit, I wonder if he even knew when my birthday was.

William died a few years back. I don't even remember which year he died. I heard I have four or five sisters out there, but who knows. His mother has met me before, but I don't know his family at all. I don't know where they're from or, for that matter, where he was from.

It's selfish for a person not to give you the information to get to know the other side of you. There exists a whole other family that wasn't shared with me, a half of me I have no knowledge of, the missing pieces to the puzzle. I wish I had some clarity about things, but I guess things are the way they need to be.

My Truth

All I wanted was unconditional love and to have a supportive family. My father never gave a shit. Not once did he tell me he loved me. He acted as if I didn't exist. How could someone I didn't know leave such an emptiness inside me? After all these years, I'm still in pain. Being abandoned fucks with me mentally. Why wasn't I good enough? For many years, I pretended it wasn't a big deal. But it was. He had walked past me several times, and all he'd said was "Hey, girl." What the fuck was that? Asshole, that's all you could think to say to your daughter, your own flesh and blood? No, motherfucker, it wasn't good enough. I don't dwell on it, but thinking about him drudges up a lot of emotions. I am still angered and hurt.

He made me feel invisible, like I wasn't worthy of his love. How dare he do that to me and walk around like he was the shit? His lack of fatherhood still shows up when I'm dealing with men. My need to be needed and wanted by a man perpetuates bullshit. I have tolerated so much nonsense that I get sick to my stomach thinking about it. Most of the men I have dated were caught up in their own selfishness and didn't really give a damn about me. I was an opportunity for them to use or abuse emotionally and physically. I saw it, but I told myself differently. I looked past their flaws because I was looking for acceptance and the love my father never gave me. Shit, I gave them the love I wanted to have, my unconditional love. I put my wants aside for their wants. I

lowered my standards so much I forgot what the hell I really wanted in a man. And for the sake of not being alone, I dated men who were broke, who couldn't fuck, were ugly, street thugs, abusive, lazy, on drugs, uneducated, and those who were certifiably crazy.

Lord have mercy! See what happens when little girls don't have their daddies around? They wind up making bad decisions because they're trying to fill the void of being daddyless!

CHAPTER
Two

In hindsight, William wasn't much of a factor. At least that's what I made myself believe to mask the void his absence caused in my life. I am sure that had a lot to do with my mother making sure I had everything I needed. I never wanted for anything, and I had more than enough. I was a spoiled brat. My mother wasn't rich or well off, but she was a provider, and for most of my life, my stepfather, George Scott, was there to hold me down as well. My mother wouldn't have had it any other way. If she couldn't get it for me, George would.

But like most men, he came with a price, and I grew to resent him because he beat my mother. George was an abusive, possessive, obsessive man. But if she was so smart, why didn't she leave him? Domestic violence is tricky. Most abusers have some great qualities, and that's what draws their victims. Other factors play a part as well: how long they've been together, what needs are being met (financially, physically, etc.), and how the victims feel about themselves. And I'm sure there are many more on the list. One may never understand the dynamics unless they fall victim.

One day, when I was four, my mother and I were walking from my grandmother's headed home when George pulled up and started arguing with her, accusing her of not wanting to be with him. I could see the fear in her eyes as she said to me, "Baby, it's going to

be all right, but if something happens, run and get help. Ma's going to be all right."

Within minutes, that three-hundred-pound black bastard pounced on her little body, slamming her head against the concrete and punching her in the face. I can still hear her screaming for me to go get help.

I don't think her directive for me to get help was entirely about her need for assistance. Even in that moment, she was more concerned about what I was witnessing. She understood how traumatic it was for me. I wanted him to stop, and I screamed for him to leave my mother alone. But he was enraged, and nothing mattered to him. I knew I couldn't leave her, and before I knew it, I had run to him and started kicking him with all my might.

He wasn't fazed. "Loriann, move," he said.

But I wasn't about to give up. I looked for something to hit him with but couldn't find anything. I bent down and sunk my teeth into his fat-ass arm. He screamed in agony. He tried to push me off him, but his first attempt was unsuccessful. I thought he was going to hurt me, but I was determined to get him away from my mother. With more effort, he was able to push me to the ground. But I had stunned the hell out of him, and my bite left a lifelong scar, a reminder of his actions and how I was able to stop him from killing my mother.

That wasn't the first or last time I'd witnessed his violation. I hated him for what he put her through. He was the reason I suffered from anxiety, because of the many nights I was awakened by him breaking into our house to cause my mother pain. Because of him, I was a nervous wreck. I'd stay awake, fearful I would fall asleep and be unable to help my mother. And when I did manage to close my eyes, I had nightmares of him breaking into our home and torturing her. It went on for years. She did leave him, though. She left New York to get away from him, and we moved to Inman, South Carolina.

My mother had had enough. When I was about four years old, she packed up our belongings, and we moved. My great-aunt

JessieMae and great-uncle Bud had a house in Inman. They owned a farm and a lot of land. It was different from New York, but I was young and didn't care where we went. I loved going with Uncle Bud to feed the hogs. Their house wasn't located on the farm, so Uncle Bud and I would get into his old pickup truck and head to the farm. He had hogs, chickens, and other animals, but my favorites were the hogs. I can still smell the slop. Once we were finished at the farm, we headed back to the house and tended to the garden. They had everything in that garden, all sorts of vegetables and fruits.

I made friends fast. My mom hooked up with some friends she'd grown up with, and we were doing just fine. We joined a church, and life was good. I didn't have to worry about someone breaking into our home and hurting my mother.

However, as soon as we were settled and things were going well, here came George. He had followed us and convinced my uncle and aunt that he was a changed man and wanted to prove to his wife that he could be the husband she needed. My great-aunt JessieMae fell for his bullshit, and before we knew it, George was there with us. As one could predict, he was back to his old ways in no time, and we fled again, New York bound.

And of course, he followed us.

I respected my mother. She tried to live a normal life despite what George put her through. She even tried to date; however, that made things worse. George felt that if she wasn't going to be with him, she wasn't going to be with anyone else. When my mother was between relationships, I slept in bed with her, my way of making sure she was safe and protecting her. I slept with my mother until I was a teenager.

Some of the guys she dated were okay. But I made it difficult for her to date after Bill, the first man she dated when I was nine years old. He was a sort of nice-looking man, about six feet tall, thin, light-skinned, well-groomed, and he always smelled good. He adored my mother and catered to her like a man is supposed to. I don't recall how long they lasted, but it seemed like a long time to me, too long.

Bill was a smooth talker. He was cunning and knew how to appeal to women, a real ladies' man. He didn't mind spending money. He took care of home, making sure the bills were paid, and he seemed to be a straight shooter, making sure he did everything right. He was a provider, and I'm sure my mother appreciated that, but Coralee wasn't a gold digger. She didn't mind working, and any job she went after, she got on the spot.

Bill had impressed my mom and my family, and they thought the world of him. Before long, he was living with us. At first, I was glad he was there. Maybe he could protect us from George. A man in the house made me feel at ease. I was safe, and I could sleep comfortably at night. The sounds at night frightened me so much, I would jump. I was a nervous wreck. But Bill was there now, so I could sleep in my bed knowing he would help my mom if she needed him. I'm sure my mom felt some comfort with him being in the house. She was a tough cookie, but she was no match for George, and most times when he came, he caught us off guard to give himself an advantage and we wouldn't be able to immediately call the police. George would lurk around at night. Often, when we looked out the window, we saw his car sitting outside as he watched the house to see who was coming and going. Bill was there now, and George knew he was there. He saw everything.

At first, Bill was great. He was always willing to watch me afterschool until my mother came home from work. He was protective of me, telling my mother how he didn't feel comfortable with me going to another person's house. He kept me close to him, never letting me out of his sight. I was closer to him than his own daughter.

I met his daughter soon after he moved in. One day, he brought her over, and she spent the night with us, but it was awkward. He was ranting and raving about me so much that it made her feel uncomfortable. And for that, I could tell she hated me. In her mind, I had replaced her. She picked a fight with me over something stupid, and, without hesitation, Bill told her to get her stuff because he was

taking her home to her mother. He was more upset than I was. She and I had argued, but it wouldn't have lasted long because I hadn't done anything to her.

Bill was like that with all my friends. If I had a problem with a friend, he was there to solve it, even if it meant I couldn't play with the kid anymore. He would tell my mother he didn't want me going to such-and-such's house because they were a bad influence on me, and he thought they were jealous of me. I was his little angel who could do no wrong.

The way I saw it, I had a father figure in my life. I guessed this was how daddies treated their little girls. George had been a consistent figure, but I was angry with him for what he'd put my mother through. Yes, he made sure I always had everything, but there was no excuse for him abusing my mother.

For a while, things were fine. Bill would take me to the park, movies, afterschool activities, and shopping. I thought highly of him and was thankful that he never raised his hand to my mother or even raised his voice. This, to me, was what family should look like. Peace and quiet. I felt relaxed. It had been a while since I had been awakened by shattering glass, doors being kicked in, and screams.

But the real Bill eventually showed up. It was a typical Sunday, our lazy day. My mother had finally finished cooking the Sunday meal, which meant she had to run over to my grandmother's house to take her a plate.

"Hey, you going with me to Mala's house?" she asked me.

Before I could answer, Bill already informed her that she could leave me. He planned for us to watch a show.

I don't think she was out the door all the way before Bill was standing next to my bed. I looked up at him, and he seemed excited.

He asked, "What you are watching?"

Before I could answer, he had already asked if he could watch it with me.

"Sure, you can," I said.

"Well, move over."

I slid over to make room for him. I don't quite remember what the show was about, but he seemed to be very interested and, oddly, he was laughing hysterically. The show wasn't making me laugh.

Bill turned to me. "Do you like me?" he asked.

"Of course, I like you."

"So give me a kiss."

I leaned over to give him a kiss on the cheek, and he "accidentally" moved his face to meet my lips with his. I knew it wasn't an accident, but I was only nine years old, so I convinced myself that he'd made a mistake. He started to laugh again, and I was puzzled about what was so funny.

Bill looked at me again and asked, "Can you see the television?"

He didn't even give me a chance to answer before he motioned for me to lie on top of him.

I did as I was told, climbing on top of his long, thin body. I wasn't scared. I was confused. As we lay there with my head on his chest, I could hear his heartbeat. The longer I lay there, the faster it beat. Bill told me to scoot up as if I were hurting him. He unbuckled his belt and reached into his pants to adjust his manhood. Once he was done, he put his hand on my back and guided my hand first to his chest then to his upper thigh.

As he continued to laugh, he rubbed my lower back. Between laughs, he let me know how much he loved me, how special and beautiful I was, and how much he wanted to make my mother and me happy. He made sure he let me know that George would never hurt my mother or me again. He said when he was around, we were safe. We were his responsibility now, and nobody was going to interfere with that.

The more he talked, the more I hated him. The more he laughed, the angrier I became. I wanted to tell him to stop. I wanted to scream, but I was numb, frozen, and remained silent. And that still haunts me today. I don't know if I was just afraid, but I couldn't move. I wanted to move. I wanted to stop him from lifting my nightgown and tugging at my panties. His laugh was excruciating to my ears. I

prayed for the sound of his heartbeat to stop. It was loud. I wanted it to end. I wished for his death. I just wanted the day to be over, and I hoped I could block it out. His wet, sloppy kisses were disgusting. His clammy hands felt like Brillo Pads scraping against my body.

I was uncomfortable, but he didn't care. This moment was all about him, his pleasure and succumbing to his desire to be with me, an innocent little girl. He didn't care if I would be traumatized for the rest of my life.

I thought about my mother and how this would affect her. Her knight and shining armor was a fake, a phony. He wasn't who he'd portrayed himself to be, so I vowed never to tell her about him. I didn't want her to feel responsible for bringing a pedophile into our home and subjecting her daughter to his crazy ass. She'd had enough pain. Had I told on Bill, he wouldn't have lived to see another day. My mother or stepfather would have killed him, and I didn't want to be the cause of that. I didn't want to bring her unnecessary stress.

Bill left shortly after that. I've tried to remember why, but I guess I've blocked it out. I had probably created some type of spectacle or plan to get him to leave. Bill knew I could expose him for who he truly was.

He had been grooming me all along, waiting to strike, and I was a sitting duck. My mother didn't see it coming. Maybe he did care about my mother, but he was a sick man. Any man who would think about a young girl that way and act on his disgusting desires is a sick pedophile. He made me view the world differently. It didn't keep me from living my life, but it blurred my vision. It made me question every man I saw with a young girl.

For many years, I did my best to hold on to the secret, but during a heated argument with my mother ten years later, it all came out. By that time, I had children of my own, and I needed to release the information because I knew it played a part in the way I dealt with men.

Because I'd held it in for so long, my mother didn't believe me. She thought I was trying to hurt her. I would never lie on a man

like that, and I despise any girl or woman who would. I think she wanted to believe me, but because we had been so close and she thought I told her everything, she figured I would have mentioned it way before then. There weren't many secrets I kept from my mother, but after holding it in for so long, it had become irrelevant, or so I thought. I figured why was it worth saying if he didn't penetrate me. So, in my mind, it became insignificant. Had I said anything, he would've denied it anyhow. But even though he'd left shortly after it happened, the harm was already done. He took trust from me. After him, I had a hard time trusting any man's objective.

I am sure, after some time, Bill forgot all about me. He probably moved on to the next innocent little girl. But I never forgot about him. I can remember every detail about that day, what I was wearing, how he smelled, the weather, the noises, and all the events leading up to that moment. I don't dwell on it, but I remember as if it were yesterday.

My Truth

Bill represented good and evil. I was happy my mother was away from George, which, at the time, represented good. However, he was a fake. His motives weren't pure, and now I see him as a caricature of what a real man should be.

Bill violated me, leaving me with a long-lasting image in my mind, a vivid picture of mistrust and deception. His actions prevented me from liking or getting involved with anyone older than me.

There was a point when I despised older men. Growing up, I looked older than my age, and a lot of older men would try to get with me. I hated it and often cursed them out while letting them know I was young enough to be their daughters. Some didn't care. They would still smile and try to hit on me. But others had made an honest mistake, and I wouldn't give them a hard time.

I am good at reading people. I have discernment. I can pull the pedophiles out of the crowd. Bill taught me to keep my senses up and never let my guard down.

Women, I beg you to pay attention to your children. Look at the signs. They're always there. If it doesn't feel right, it probably isn't. People are deceptive, with hidden agendas. I pray Bill didn't go on to violate other little girls, but I'm sure he did.

*Lori Ann Smith*

I don't fully understand why I didn't tell my mother what happened. But I didn't. I knew she had already endured enough pain and sorrow. And knowing Coralee, had she found out, there would've been a different outcome to this story.

34

THIS WOMAN
HAS FOUGHT A THOUSAND BATTLES
AND IS STILL STANDING
HAS CRIED A THOUSAND TEARS
AND IS STILL SMILING
HAS BEEN BROKEN
BETRAYED
ABANDONED
REJECTED
BUT SHE STILL WALKS PROUD
LAUGHS LOUD
LIVES WITHOUT FEAR
LOVES WITHOUT DOUBT
THIS WOMAN IS BEAUTIFUL
THIS WOMAN IS HUMBLE
THIS WOMAN IS ME!

Unknown Author

CHAPTER
Three

I 'd always felt alone. Not having siblings can have that effect. Growing up, all my friends had siblings. My mother must have known I was lonely because she always allowed me to have a friend or two stay over. She either felt bad for me or got sick and tired of trying to entertain me herself.

The only time I didn't feel alone was when I was with my cousin Sandra. My grandmother and her grandmother were sisters on our mothers' side. I don't recall how many siblings they had, but the number was close to nine. We had other cousins close by, but she and I spent the most time together.

Sandra was a cute dark-skinned girl, and she was always well put together. She was on the tall side, small on the top but big where it mattered. She had a big behind, which drove the guys wild, and a full head of hair. It wasn't long, but it was thick. We were inseparable, more like sisters than anything else. Being only children bonded us. Sandra was older than me, and I looked up to her. She was the perfect big sister.

We always had fun together. I loved being at her house. We enjoyed playing for hours. She had two or three big black garbage bags full of Barbie furniture, cars, clothes, and dolls. When we were younger, we played with her Barbies for hours upon hours. She had two rooms upstairs in the attic set up like a bedroom and a sitting

room. She would go on one side of the room and I'd take the other side to set up our pretend homes. Each time, we set it up differently, and we did it every weekend. When we weren't playing with Barbies, we were playing with paper dolls. Kids today will never understand that concept. In those times, play was left to the imagination.

We also fought like cats and dogs, and she made sure she let me know I didn't stand a chance going up against her. Mainly, the fights were about me not listening to her when she told me to do something or when she didn't want to be bothered with me. Sometimes, I was forced on her, and as she got older, she started to resent me being around. She wanted to be with kids her age. It got to the point where she had to take me everywhere she went.

One night, when she didn't want me to go with her to Depew Park to see the Supremes and the Spinners in concert, she gave me hell. However, her mother told her either she took me or stayed home. Of course, with those options, we went—lucky me. She yelled at me, letting me know how much she couldn't stand me. It wasn't my fault, but to her, it was my fault for being born. When we got to the park, she said, "I'm going with my friends, and you go with yours. Make sure when it's over, you come find me."

I didn't know which friends of mine she had in mind, but I don't think she cared much. After being there for a while, I finally ran into a kid I knew who was with her family. I pretended like I was glad to see her and hung out with her until we met up with some of the other kids from our school. The concert ended two hours later, around ten. The crowd began to disperse, but I couldn't find Sandra. My friend's parents asked me if I needed a ride home. Although I wanted to take the ride, I knew I couldn't go home without Sandra. Her mother would kill her if she knew she'd left me.

I searched for her. The park was big, but it wasn't that damn big. She wasn't there. I stood at that damn gazebo for hours, and I didn't see her. I was scared because it was dark, and there were only a few people left in the park. I decided I'd better walk with the crowd of people heading toward home.

I started walking home, trying to come up with the story I would tell as to why I wasn't with my cousin. I was going to blame myself. I planned to say I was the one to leave Sandra. Had I not said that, Sandra would have beat my ass. Her mother would only yell at me. I could handle that much better than Sandra's ass whooping.

About halfway home, I heard Sandra yell, "Loriann, get your behind over here!" She was mad at me like I had done something wrong, but she was the one who had left me at the park. But of course, she blamed me. She blamed me for my existence. She was still angry for having to escort me around. I had interfered with her plans. She didn't want or need a shadow.

She grabbed me by my blouse. "Why did you leave the park? I've been looking all over for you!"

She was just trying to impress her friends. She knew good and damn well she wasn't looking for me. I didn't know where she was or who she was with. All I knew was she wasn't where she was supposed to be. But like always, we both knew she had the upper hand. I would get her back, though. I was a bonafide tattle tale, and her day was coming, as it always did.

I told my mother everything and swore her to secrecy. My mother would keep the secret until she and Sandra's mom got drunk and started arguing. Then the cat would be out of the bag. Sandra would find out I'd told on her, and I knew what would happen next.

Sandra taught me a lot. She introduced me to a Pentecostal church, Christ Community Church. It wasn't the first church we'd attended, but it would be the one we ended up joining. When it came to church, Sandra didn't play. She had given her life to Christ. Back then, the church was strict. Damn near everything was restricted. They didn't allow women to wear flashy earrings or makeup, and dresses had to be below the knees. We had to wear prayer caps while at church, and we couldn't wear pants. And that was only the beginning. We were in church seven days a week. Sunday was Sunday School, church service, and evening service. Monday was

bible study, Tuesday and Saturday were choir rehearsal, Wednesday was church meetings, Thursday was a meeting for ushers (I was a junior usher and Sandra was on the young adult usher board), Friday was prayer night, and usually on Saturdays, we were at a revival or some church program.

When I didn't feel like going, Sandra would let me know that not going to church wasn't an option. Shit, she was worse than my mother. I had to get my mother to convince her not to make me go. What kind of bullshit was that? When Sandra got me alone, she told me how disappointed she was and made me feel like I had committed the worst sin ever under God. And when we were at church, she watched me like a hawk. I couldn't make a move without her knowing. When I misbehaved, she gave me a look that said, "Little girl, you better act like you got some sense and home training."

I will always be indebted to her because, through her, I met Jesus.

When I was twelve years old, Sandra got married and moved away, which was her dream. She had told me that as soon as she could, she was going to leave. Like my mother, her mother, who was my godmother, drank all the time. She went to work every day at the telephone company until she retired, and she made sure she provided for my cousin. Like me, Sandra didn't want for anything materially. But the difference between her mother and my mother was that my godmother believed in a good old-fashioned ass beating. She didn't mind getting a belt and whooping some ass. After seeing how she used to hit Sandra, I felt lucky that she had never done that to me. I would cry when Sandra got a beating. My mother fussed but never hit me. Her mother's discipline was a lot more physical and verbal. At least her father was a buffer, and he would intervene. Today, it would be considered abuse, but back in those days, that was the way a lot of black mothers disciplined their children and kept them in order. My mother should've whooped my ass a whole hell of a lot.

When Sandra moved away, I was left to figure out life on my own. My support system was gone. I stopped going to church and started doing me.

My Truth

Being an only child sucked for me. Sandra and I were like sisters, and when she left, our relationship dwindled, leaving me to search damn near my whole life for someone to share my innermost thoughts and hang out with, someone to be like a sister to me, a real ride or die.

I struggled with this for many years. It became almost impossible to build relationships with girls my age. There was always a constant battle, some twisted competition, or a stupid popularity contest when trying to befriend them. They always turned against me and ended up doing something crazy to eventually destroy our friendship. They'd sleep with my so-called man, create drama, or do some real foul, fucked up shit. In hindsight, they weren't friends, but wolves in sheep's clothing. They weren't genuine, but I was. They used my friendship to get what they wanted—money, jobs, a place to stay, and rides here and there.

It makes me chuckle to myself. It's funny how I want to work with women and help them when I have been hurt and beat down by the women in my life. But I know now what it was. Hurt people hurt people. Those who have hurt me were hurting inside, and they took their pain out on me. I was there for them when their own families had turned their backs. These people know who they are, no need for me to point fingers. What good would it serve now? I was their true ride or die. Too bad it wasn't reciprocated.

But I have forgiven … Ooh chile! I am a different person today.

It has been a long time coming. I am acknowledging the hurt and analyzing things for what they are. Part of my past pain stems from feelings of being alone, no one to turn to when I needed people the most. I wanted to be liked and fit in. Some pretended to be friends but they weren't. But all wasn't lost. I am stronger and more independent because of it. Not having a lot of people around made me learn to depend on myself because, sometimes, that's all I have—me.

Now, I am surrounded by people who keep it real with me and have hearts of gold.

Family is more than the blood you share; it's the bond that can't be broken!

From

SHAWN CURTIS SMITH JR.

Trust your process. Timing is everything.

Appreciate and understand that every step serves a purpose in your journey. Even if you don't know what the purpose is, just trust and believe it will work out for the best in the end. You're not always going to know your very next step, and your current circumstances do not determine your future. Keep the faith. Envision what you desire, and actively do something toward that goal.

Never stop striving. Eliminate toxic and negative energy by any means necessary. Pay it forward, and never forget where you came from or who helped you get to where you are. You're appreciated and have a gift for the world.

My mother eventually had two other significant relationships after Bill left, one that George destroyed and one that I destroyed.

Relationship number two: David the Jamaican. David was handsome. He was nice to her, and she had met him through a friend. He stood about six feet tall, and he was dark-skinned with deep dimples. He was nice, but, most of the time, I couldn't understand a word he said. His accent was too thick. So unless I had to, I avoided talking to him because it gave me a fucking headache. All I knew was he made Coralee happy, and that was enough for me.

I was twelve years old and had enough friends to keep me busy, so my mother had enough time to talk to him without me around. I remember hearing her on the phone with my godmother as she sipped gin, laughing about how she didn't know what the fuck he was talking about most of the time. But she enjoyed being around him. From the sound of it, when they got together, they had a good time.

Coralee was a drinker. Today, she'd be known as an alcoholic. But in those days, she was just known to like to sip from time to time. My mother drank until the sun went down and came back up—every day. She kept a quart or half-gallon bottle of Gordon's or Seagram's Gin in the house, and her chaser was a Schaeffer Beer.

My mother's favorite past times were drinking, playing cards, and taking care of me. She was a neat freak, known today as having obsessive compulsive disorder or OCD. Her drinking conflicted with her OCD and messed with her psyche. The only time our house was ever messy was when Coralee was on a drinking binge; otherwise, it was spotless. Watching how crazy she would get after one of her binges was hilarious. As soon as she sobered up, she'd commence to cleaning. She'd be upset with me for the mess, but she had been the one to tear the house apart. She'd leave dishes on the table and clothes strewn around. In the beginning, I would clean up once she went to bed, but I soon got sick of it and let it go so she could see it the next morning. She'd curse me out while getting things back in order. It was her therapy. Once the house was back to normal, so were we.

I don't know how long my mother's relationship with David the Jamaican lasted, but I know how it ended. My mother and David were in the living room sipping and listening to music. Cora loved to sing and dance, especially when she had a few drinks in her. I could hear their laughter and the music from my bedroom. They were listening to the Stylistics and enjoying each other's company. My mother came out of the room to check on me and grab a cigarette from her bedroom. Marlboro was her brand of choice, which was odd because most black women smoked Kools or Newports. As she turned to go back to the living room, we heard what sounded like an explosion.

George had struck again.

He'd come crashing through our front door like he was the Incredible Hulk. I knew this wasn't going to end well. My mother started screaming, and David ran to her to see what the fuck was going on. They were all in the kitchen. David glared at George to let him know it was on! For the first time, I could see fear in George's eyes. He knew David was a live one, but it was way too late to turn back.

Within seconds, David picked up a knife from the kitchen drawer and said to George, "Yeah, big man, I'm ready for you."

George *was* a big man, but even he knew the Jamaican was going to give him a run for his money. I could see the wheels turning in his head. He said, "Cora, you going to let this man stab me?"

My mom, though terrified, responded with a smirk. "I don't know what to tell your dumb ass."

George looked at her in disbelief before gasping for air and charging at David.

And just as expected, David stabbed his ass in the chest. George had been tormenting my mother for years, and it was about time he'd gotten a taste of his own medicine.

David started panicking, realizing what he had done. I'm sure he didn't regret stabbing George, but the possible outcome.

George's blood dripped all over the place. There was blood on the stove and the refrigerator, the cabinets, floors, and counters. George was known to be dramatic, and this time was no different. He slid his big ass to the ground and yelled, "Cora, help me! I'm dying. Call an ambulance and get the police!"

David paced the kitchen. My mother told him to calm down, that she needed some time to think.

"Cora, you know my situation. I can't be here when the police come." I later learned that David was in the country on a Visa, so they would ship his ass back to Jamaica with the first sign of trouble.

Coralee told him to leave, that she would take care of everything. Her solemn expression told the story; her relationship with David the Jamaican was over. She had gone from being happy and on cloud nine to one of the worst moments in her life. George had done it again. He'd caused her pain, not physically this time but emotionally.

David gathered his things and ran out the door. Coralee walked over to George. "Get the fuck up," she commanded.

Shocked, he stood. She looked at him with disgust. She wasn't afraid, and she wasn't sorry for what had happened to him. She sure

as hell wasn't going to coddle him, either. "I'm going to call the police and let them know you just broke into my house," she said.

George didn't want her to do that. The police had warned him that the next time he harmed or attempted to harm my mother, he would go to jail for a long time. He begged her not to call and promised to repair the damages. They came up with some cockamamie story, and she took him to the hospital.

He survived. Like my mother would say, "His ass was too mean to die."

If there was any good to come of this, it was that the tables turned on George. It was the last violent outburst he ever had. I guess he realized he could have lost his life that night, and it hit home. My mother would never again be his victim. She was empowered and became the one in control. I was just glad the abuse was over. We had suffered for way too long, and we needed a break from the nonsense.

Coralee dated again, but my selfish and spoiled ass wouldn't let her date in peace. I'm not sure why, but after David, I blocked every man that came into her life. With one of her boyfriends, I had created so much drama until, finally, he walked away and started dating a lady who lived downstairs from us.

I was the cause of her unhappiness during the onset of my teenage years. I was acting out. My relationship with my mother became volatile. I didn't like her, and she damn sure didn't like me. She had every right not to like me because I was behaving like a "stupid bitch," as she referred to me whenever she was drunk. She'd called me a bitch so much that I got used to it, and it fit me because I was acting like one.

I gave Coralee hell every day, acting out at school and home. The teachers called her constantly. I talked back to her and hung out with the wrong crowd, and I'd come home at all times of the night. Instead of getting her rest for work the next day, she'd be out walking the streets looking for my selfish ass, calling my friends to see if I was at their houses. I was never at the places she called because

those friends had curfews, and their parents wouldn't allow me to be there that late.

I had found a new set of friends. It's not hard to find peers to hang out with when you don't want to do the right thing. I didn't have to look far. Their parents either couldn't control them, had issues themselves, or had thrown up their hands. But my mother wouldn't give up on me. She figured I was going through something, but I would get back on track. She was a fighter, and she would fight till the end.

She contemplated sending me away, but my grandmother said, "I've never put your ass away, and you won't do that to her, either."

I don't think my grandmother realized how bad things had gotten. I could've used a wakeup call to set my ass straight. My mother was tired and needed a break from the things I put her through. She told me, "The things you're doing now, oh, sister ... Wait until you have kids. It will be a hundred times worse."

Growing up in a toxic environment or dysfunctional family will likely cause rebellion at some point. I was at an age where nothing mattered to me. It wasn't just one thing that made me act out; it was a combination of everything.

What was my breaking point? Was it because I had witnessed so much violence and it was finally my way of releasing the pent-up emotions? Whatever it was, I needed some type of therapy. My mother tried that, too, because the school had recommended it. I met with the woman once and because I didn't like her, I didn't speak to her.

She told my mother, "Listen, I can't help her if she won't talk."

I never saw her again.

My Truth

My teenage years were difficult for me. I became rebellious, sexually active, and I dabbled with alcohol and substance abuse. I was in search of something and looking for love in all the wrong places. I don't know why I was acting out. I've tried to figure it out, but I can't. I want to say it had something to do with me coming of age, but that's not quite it. I wish I could get inside my head as a young girl. I have so many unanswered questions about my behavior. I did what I wanted when I wanted, and it led to years of self-destruction. I was hurting and hurting the people around me who were watching my actions.

My mother tried everything in her power to guide me, but I was too far gone. I was hard headed, and the only changes bound to happen were going to be life lessons. Life has a way of making you realize how fucked up you truly are. You will either learn on the front end or the back end, but you will learn. Trust me, I have. I have learned the hard way.

Many nights, I have cried myself to sleep, trying to figure out how I got to that place. But I know it was partially because of my actions and partially the bullshit I'd been subjected to. Fortunately, I was able to put the pieces of my life together. My lessons became my blessings. I started working with teens to assist them with making changes and trying to steer them down the right path. While others crucify teens, I try to get a better understanding of who they are and what has led them to this point because I have been there.

CHAPTER
Five

By the time I was thirteen, all hell broke loose. I started hanging out late, drinking and drugging, and having sex. By the age of fifteen, I had my first child. I was young and dumb. My fast little ass thought I was grown. I found out about the baby seven months in, but the good thing was I was in love ... well, what I perceived to be love.

Ronnie Davis was light-skinned, handsome, and solid. He was so fine. We met at school, and I had an instant super crush on him. I was one year older than him but, to me, that didn't matter.

The thing about Ronnie was that he knew he was fine. All the girls his age, my age, and older wanted him, and he knew he could have any of them. He played into it, too. He was a real ladies' man. Girls would fight over him all the time. But I knew I was different. I wasn't the most beautiful girl in the bunch, but I held my own. I was cute, too. At least that's what everyone told me.

I was brown-skinned with long hair, and I was shapely. I had a walk that made guys' heads turn. You wouldn't believe how many older men tried to talk to me. But I wouldn't give them the time of day. They made me feel dirty, and I hated when they watched me walk. Over the years, my preference was always younger guys and, at the time, I didn't understand why. Later in life, I pieced together that I didn't like older men because I had been molested by an older man.

I was dating a guy named Kelly when I met Ronnie. He was nice, and my mother adored him. But that didn't matter because I liked Ronnie, and I liked everything about him. He was different to me. Underneath his toughness was a likeable guy. He showed me the other side of him, his compassion, his caring heart, and all the good qualities he possessed. I'd always had a thing for bad boys, and he damn sure had that going for him as well.

Ronnie's nickname was Bull. I suppose he was given the name because he fought like a bull and his birthday was May 3, which made him a Taurus. It seemed like every day, he knocked some guy out, so many that I couldn't begin to count. I guess he had an anger problem. Shit, most black kids who have family issues wind up having anger problems. He eventually spent time in a boy's detention center for—what else—fighting. He had hit a guy so hard that he knocked him unconscious. The police got involved, and his grandmother agreed to have him sent away.

Ronnie's mother had him at the age of thirteen. By the time I started to talk to him, he was being raised by his grandmother. It was a difficult situation because his mother lived in the same projects as he did. He lived on the fourth floor with his grandmother, and his mother lived on the eighth floor.

Ronnie's mother, Denise, was beautiful. She was tall with a caramel complexion, a shape to die for, and an irresistible walk. She could have had any man she wanted. Not only was she nice looking, but she was smart as hell. When I met her, she was enrolled in school, taking psychology classes. I'm not sure if she finished or not, but in terms of brains, style, and looks, she had it all.

Ronnie wound up with his grandmother due to his mother's alcohol and substance abuse. She just wasn't ready for a baby at her age. Ronnie resented his mother because his younger brother, Kareem, lived with her. There were three of them: Ronnie, Kareem, and Chris, who lived with his father. They all had different fathers.

Our relationship started off well. We laughed a lot and spent a lot of time together. And we played house, thinking we were grown.

Ronnie could be controlling at times. He never wanted me to go to parties. I figured he didn't want me there because I would see him with other girls. Let him tell it, he never wanted me to be like other girls in the streets. He wanted me to be different. It was okay for him to run around with those other types of girls in the streets, but he wanted to put me on the shelf until he got ready to take me off. Hell no, I wasn't going to stay inside! So my ass made it to every party. He knew he had his hands full with me. I wasn't that type of girl. I had my own mind and moved to the beat of my own drum.

I told his ass, "If you want me in the house, you better be in the house with me."

He'd say, "I promise I'll come after the party is over. I have something to do."

"Okay," I'd say, and as soon as the party started, I was right there.

When he spotted me in the crowd, he'd grab a girl's hand and start dancing with her. I'd look at him and smile, grab the hand of some guy that was eager to dance with me and lead him to the floor. Before I knew it, Ronnie would knock the guy out. Eventually, guys stopped dancing with me unless they were from out of town and didn't know any better.

Neither of us had a father figure in the home, and both of us had mothers struggling with addiction. By playing house, we were attempting to create the family composition we desired, one that gave and received love. I'd always felt love from my mother but craved love from a man. Ronnie and I had a special bond. I am reminded of that bond every time I hear our song, the one Ronnie dedicated to me back in the eighties: "Lady in My Life" by Michael Jackson. As the king of pop crooned about listening to his heart with promises of loving more each day, we adopted those feelings as our own. I was the lady of Ronnie's life, and I believed him when he sang about keeping me warm and always making me feel all right. The song became our anthem. Even now, hearing the words to the

song takes me to a special place at a special time. We were young and carefree, loving life and enjoying each other's company.

I was in love, and so was he. But at our age, it didn't mean much. How could it? Girls still liked him, and guys were still chasing me. We tried, but kids will still be kids. We were on again and off again. We skipped school and met up at my house to have sex while my mother was at work. It seemed right because we didn't know any better, but we should've had our butts in school.

Day after day, we cut school or left early to be with each other, laughing and playing around. Everyone knew we were a couple. We spent so much time together that we'd sometimes grow sick of each other, so we took breaks from time to time. Breaks gave Ronnie an opportunity to date other girls, which infuriated me. But he'd come back around with some story about how it was all rumors and lies. In the next breath, he'd say he heard things about me as well. But he knew better. Ronnie knew he had my heart, and I didn't dare talk to another guy. If I had, he would've beat him up anyway, so it wasn't worth the headache. I only wanted to be *his* girlfriend. None of the other guys held my attention. Something about him piqued my interest, a combination of things like his sweet, delicate side and his masculinity that drew me in, or the way he looked into my eyes with warmth and sincerity.

We played house for a long time but, eventually, it caught up to us. When you think you're grown, living like you're grown, grown things will happen. I remember the day I found out I was pregnant. My mother had taken me to the doctor because I kept complaining about a pain in my side I'd had for a couple of weeks. My mother figured something was wrong with my appendix, so she took me to get it checked out.

The doctor said, "Ma'am, did you know your daughter is pregnant?"

My mother looked confused. She didn't even know I was sexually active. She knew I had lost my virginity but didn't know I had continued. I had told her about my first time with all the details. I'd

met a guy from Brooklyn one night at a party in Peekskill. I went to my friend's house afterward, and my naïve ass let him convince me that I was going to be his girlfriend. It was one of the most painful things I had ever endured. I told my mother how much it hurt and that I refused to let anyone do that to me again. I had convinced myself that I didn't want to have sex again.

Well, that lasted until I got a boyfriend, Kelly. He and I were together for about a year, and he was super-duper fine. I liked him at first, but he became boring. My mother loved him and thought he was the nicest young man ever. He would be at my house all the time, even when I wasn't home. He and my mother would sit and talk for hours. I'd tell him not to come over, but she told him he could come anytime he felt like it. She didn't know we were sexually active. She thought we were just hanging out. Had she known, she probably would've stopped him from coming over so much.

But here I was now, pregnant, and she realized her daughter was still having sex.

My mother asked me, "Are you going to have this baby?"

"She doesn't have a choice. She's approximately seven months pregnant," the doctor said.

Coralee sighed. "Well, we're going to be all right." I could see the hurt in her eyes, but she wasn't going to tell me how she really felt. She didn't want to make me feel any worse than I was already feeling.

As soon as we walked out of the doctor's office, she headed to Panios Liquor Store to get her medicine. I was surely in for a rough night.

On the way home, she said, "You know this could be worse."

"How is that?" I asked.

"Kelly is a decent young man, and I know he'll step up to the plate."

Cora, you are about to have the shock of your life, I said to myself. She was going to need another bottle of liquor once she found out the truth.

I hadn't seen Ronnie in a few weeks, but that was normal. I was

sitting on the porch with my girlfriend Tricia, trying to figure out what the hell I was going to do. A teen mother. Shit was about to get real.

I watched Ronnie walk up the ten steps to my house. "What's wrong with you?" he said with a smirk.

What's wrong with me? I thought. *There's a whole lot wrong with me, idiot. I'm sitting her scared and pregnant, not knowing what I'm going to do, while you'll be out there still running the streets with your friends and talking to this girl and that girl!*

I needed so much from him. I wanted him to hold me and tell me everything was going to be all right, even if it wasn't. I needed for him to come into my house and tell my mother he was going to step up and do his part to be a good father for his son. But in my heart, I knew he wasn't ready for this. He was immature and had a lot of growing up to do. I knew damn well I wasn't ready, but all the tears in the world weren't going to change our circumstances. Our decisions had led to this point, and there was no button we could push to change the outcome. It was happening whether we wanted it to or not.

I just looked at him.

"You have a glow. You're pregnant," he said.

For the life of me, I don't know how he knew. I hadn't shared the news with anyone, and I was still trying to figure out how to tell him. I was going to wait until we had some alone time. But God has a way of working everything out. So instead of me going to Ronnie, God had brought Ronnie to me. The timing wasn't right for me, but it didn't matter. The time was right now.

Ronnie started backing down the stairs. "Who is the father?"

That made me angry. "You are, asshole!"

He took off running just like a kid.

My Truth

Ronnie was my first love. Looking back, I still smile at the thought of us. When I talk to him about the good old days, we can't stop laughing. Boy, you couldn't have told us anything back then. We just knew we were going to be together, thinking we were so in love.

It's clear to both of us that we truly had love for each other, and we agree that we made many mistakes. We'd spent so much time trying to get even that we'd lost our way. I often feel like he was the one who got away. He has moved on, and so have I, but it was a love worth having.

Today, we laugh about the way he responded to the pregnancy news. He tells me all the time, "You just don't know how scared I was."

I asked him how he knew I was pregnant.

"Because you had a glow about you, and when I saw you, I knew right away."

He also explained that he knew it was his baby, but he was nervous. If he was scared, imagine how the hell I felt! I hadn't done this before and didn't know one thing about having a baby.

We weren't together forever, but I know we were imprints for each other. If we had to do it all over again, I am sure the outcome would've been the same. Your first love is just that, someone who has touched your life and has significant placement in your heart.

Every man I've encountered has taught me a lot about me. Ronnie taught me to forgive and move on without being vindictive. I had often

set out to hurt him just as he had hurt me, but in the process, I hurt myself. It took me a long time to realize that, but I eventually got it.

I am thankful for the relationship and glad we were able to remain friends.

January 26, 1984, my mother and I went to the health center for my routine prenatal checkup. Fifteen minutes into the appointment, my doctor instructed my mother to take me to the hospital and he would meet us there. I was a little nervous but not too alarmed. I was aware that I was due to deliver on January 27. I had waited for this day, and it was about to happen.

On January 27, 1984, my son Ronald Davis Jr. (Ronnie Jr.) was born after twenty-three hours of hard labor. My blood pressure had shot up so high, they didn't think I was going to survive giving birth. I found out later that the doctor had asked my mother if she wanted him to save me or the baby if it came to that. Of course, my mother had to say something smart. "Save my daughter. I don't know him."

Ronnie Jr. came out kicking and screaming, the spitting image of his father. So all the naysayers were stopped dead in their tracks. Numerous friends and enemies had rushed to the hospital to get a glance of my little bundle of joy. They were all suspicious about Ronnie Sr. not being the father because of rumors that had surfaced around school. I was accused of sleeping with guys I didn't even know. It was hurtful. They didn't realize I wasn't the one sleeping around; Ronnie Sr. was. But it didn't matter. I was the talk of the town. My name was dragged through the mud.

I wanted to tell them how embarrassed I was by becoming a

teen mother. How it felt knowing I had disappointed my mother and shamed my family. Their ridicule added to the pain I already felt. I wished they understood how their comments inflicted more suffering. I knew they didn't care; I didn't matter to them. I had become the joke of the town. I had made my bed, and I was lying in it. When a girl was young, pregnant, and not married, it became par for the course.

I tried to hold my head high and deal with the bullshit coming my way. I had no time to sulk and be depressed because my son needed my attention. My intentions were good. I had set out to be a good mother... well, the best I could be. But I was naïve and didn't have a clue as to what was about to happen.

I realized early on that being a mother is one hard job, especially at fifteen. I had a little person depending on me to take care of him, nurture and love him. I loved him from the moment I felt him kicking in my stomach. But to show real love, I had to love myself first. I didn't love myself. As a matter of fact, I didn't even like myself.

I don't know what happened, but Ronnie Jr. cried from the moment we left the hospital until he was four years old. I wasn't ready for the responsibility. Playing house had gotten too serious. I was still a kid myself, and there weren't any programs to help me figure this shit out. The weight of it all was way too heavy to carry on my shoulders.

Ronnie Jr. was a busy body. He was into everything, a real handful. He was advanced, too. He was walking by the time he reached nine months old, talking shortly after, and potty-trained right after that. The only time he was quiet was when *Sesame Street* was on. He loved that show. PBS became our best friend. By two years old, he knew several words in Spanish and could hold a conversation.

I started feeling trapped. I wanted to spend time with my friends and go to parties. I was mad at Ronnie Sr. because he was still able to enjoy his life while I was at home pulling my hair out. I wanted out; I was tired of being an adult. The responsibility of motherhood

was driving me crazy. My friends had already stopped calling and coming to my house because they were busy having fun and doing things. I missed my alone time and independence.

I threw in the towel and told my mother I was done. The look on her face said it all. She realized her daughter was out of her fucking mind. She thought I was having a mental breakdown, and maybe I was. It was more than I had bargained for, but she was convinced that I was going to be a mother no matter what, and she laughed it off in disbelief.

Fortunately, my mother had my back. She was the one to raise Ronnie Jr. for the first part of his life. I was too irresponsible. History was repeating itself. Ronnie Sr.'s mother had him at thirteen, and here we were, fourteen and fifteen years old with our first child. I wish I had taken the time to ask his mother some questions and share stories, but we never got around to it. She did let me know that she understood what I was going through and she would always be there for me. True to her word, when I needed her, she was always right there. We had a connection, both having been teenage mothers with all the odds stacked against us.

Ronnie Sr. and I went through a lot of heartache. His relationship with my mother struggled, probably because she knew how much he was hurting me. And like her mother had done during her relationship with my father, she pushed him away. She wouldn't allow him to see his son, and I was stuck in the middle of all their bullshit. I defended him to her and her to him.

Ronnie Sr. asked his mother to intervene, but it made matters worse. One night, while both our mothers were in drunk stupors, they got into a heated argument over the phone. Before I knew it, Denise was at the door. She was just as head strong as my mother. It took George, Ronnie Sr., and me to keep them separated, but it wasn't an easy task. Neither of them was backing down. Eventually, they calmed down and were able to work through the nonsense. They realized they were about to come to blows when the baby wasn't even their child. How stupid was that?

Once Ronnie Sr. and I were out of the picture, they became the best of friends. Shit, they had something in common: Both their children were teen parents and fuck ups.

When Ronnie Sr. was sentenced to juvenile detention, he left me to figure this shit out by myself. I was devastated when he left. I felt like he had abandoned me when I needed him most. I was on a ship in the middle of the ocean by myself. It didn't seem fair. I was left with no friends, no boyfriend, no one.

My mother was always on me about how to raise my son. School was difficult because people gossiped about me, making me feel low. I had nowhere to turn, but I was a fighter, so I did what was necessary to get through my day.

Then came the shock of my life. Rumor had it that Ronnie Sr. had another baby on the way. I was devastated. I called him, and he said, "Mother's baby, father's maybe," a term he had learned from my mother when all the rumors about us were floating in the air. In other words, until we knew, we wouldn't know. My world was crumbling around me.

When Ronnie Sr. was released from juvie, he was damn near living with his new baby mama. I couldn't handle it. I started drinking and acting out. I felt lost and alone. I began hanging out with a male friend who lived downstairs from me. He became my refuge because I didn't have anywhere else to turn.

One night, he'd had a few of his friends over, and I hooked up with one of them who had a crush on me. It turned into a semi-relationship. Tyrone was also messing with Stacy, one of the girls who lived upstairs from me. It was messy. I didn't find out until months later, and she was the one to tell me.

Stacy had moved upstairs about a year prior. She had befriended me, and we became close. I didn't think she would do something like that to me. I also didn't know she had been sleeping with him before I started seeing him. I was clueless because she had been seeing his friend. She was ratchet. Had she told me, I wouldn't have had any dealings with Tyrone. I felt betrayed, but I wasn't mad because I

didn't have strong feelings for him. Tyrone and I both knew we weren't in a relationship. He was being a young man, and I was being an idiot with no self-control. I wasn't looking to have sex; I just wanted to be wanted by someone, and anybody was better than nobody. I was just searching for *something* and feeling inadequate after Ronnie Sr. had let me down and disappointed me.

Tyrone was tall, light-skinned, and lanky. I didn't know much about him, but I knew he wanted something out of life. He played by the rules. He didn't get into any trouble. He wasn't a fighter, and I never heard his name mixed up with any street drama. He went to school, hung out with his friends, and took his ass home before it got too late. He was an average guy doing average things. He didn't muddy the waters.

We fooled around for a while, but we knew it wasn't going anywhere. Had he put forth more effort, it may have worked out. But he made things clear when he took one of his friends' ex-girlfriend to the prom, which let me know he wasn't at all interested in being involved with me. I was disappointed but not overly so. I was just a lost girl.

My rationale for all my decisions were flawed. I can't describe what I was thinking because I wasn't thinking. I still hadn't learned any lessons. I continued to do what I wanted how I wanted. My mother would look at me and shake her head. She had no idea of what to do with me, either. She probably thought I'd had a setback, but I would get it together. After all, I had enough smarts to excel in school and even go to college. But little did she know, I had no plans of pursuing any of that. My main goal was self-gratification. If I thought it would make me feel better, I did it, whether that meant drinking, drugging, or sexual stimulation. I was spiraling downward and on the verge of hitting rock bottom.

I was depressed and didn't think much of myself. I tried not to let it show, but I was miserable. I cried all the time, and I hated my life. It became harder and harder to pretend like life had purpose. How could I raise a child when I barely had enough strength to get

him a bottle or nurture him? I loved the little guy, but I was in a dark place. I couldn't give him what he needed, so I gave my responsibility to my mother.

It felt like I was babysitting for her while she worked, and as soon as she got home, I was off duty. Ronnie Jr. knew it, too, because he would light up when she was around and cry all day long with me. At night, she kept him in her room, so she could watch over him. She didn't trust me at all, which was probably the reason she called me fifty times a day from work, checking to see how her grandson was doing or if I had killed him. As soon as she walked in the door and got herself together, she took over. I was fine with it because I would go downstairs and hang out all night with my friends. That was my routine.

I would've gone further, but Coralee would've had a conniption and cursed me out. The few times I tried to exit, she came and got me with baby and all. One time, I called myself leaving to go to a party, and she marched into that party and told me to bring my ass home, and I did. I guess she figured if she was raising my son, the least I could do was have my ass around. Her way of forcing me to be a mother. But it probably would have been better to let me hang out with friends. Keeping me close made it worse. Instead of going to the party, I brought the party to me. Had I not been in solitary confinement, I wouldn't have been sleeping with Tyrone.

Tyrone kept me from being lonely. He filled a void, although it was temporary. Just as I wasn't in love with him, he wasn't in love with me. I don't even think we liked each other very much. After a short period, we stopped seeing each other, but I found out I was pregnant. Yup, pregnant again, this time by a guy I didn't have feelings for. What the hell was I thinking?

On December 29, 1985, when I was seventeen years old, De'Von W. Ritter was born. Baby boy number two. He was the cutest little thing, and he came out looking like my mother. Coralee was in awe of him and thought he was adorable. As he got older, he started to resemble his father, but I could still see my mother in him.

My hospital stay, this time, was different. I didn't have difficulty with my blood pressure, things weren't as chaotic, and there weren't a lot of nosy visitors trying to figure out who the baby's daddy was. This time, people believed Tyrone was his father. But nobody cared. It wasn't like I had any friends. I wasn't a factor anymore. I was a once sort-of-popular girl, now just a girl with babies. Most of my time was spent at home, so I wasn't on anyone's radar.

Tyrone and his family came to the hospital, and they let me know I had their support. I was to call them if I needed anything, and they were willing to keep De'Von whenever I needed. I could feel the love pouring out of them instantly. They were going to make sure they played a role in De'Von's life.

Tyrone was a provider, and when I needed him, he was there for his son. His family loved De'Von. I don't think they cared much for me, though. De'Von was a good baby, a sweet little pudgy thing. He was calm and friendly, a real joy to have around. If Tyrone's family had their way, they would've taken custody of him and raised him themselves. But hell no! Coralee Mayes would never have allowed that to happen, not if she had breath in her body. As she always said, she would die and go to hell for hers. She was still a feisty little thing who held her ground. She had cussed out Ronnie Sr. and his mother over Ronnie Jr., and she cussed out Tyrone and his sister over De'Von. Shit, she had even cussed me out over her grandkids. And boy could she cuss! That's where I got my mouth from.

De'Von was much easier to handle. As a baby he had a good temperament. He didn't create a lot of fuss over anything. He seemed happy to be in the world. But I still wasn't ready to be responsible. I dropped my new baby into Coralee's arms, and she had to raise another child. With the added stress, her drinking got worse. Shit, anyone left to involuntarily raise someone else's kids would get drunk, too. But she was good to those boys, better than I could have imagined.

I had made a mockery out of my life. I had hooked up with Tyrone because Ronnie Sr. hurt me. And after all that, we came

to find out that the baby Ronnie Sr. thought was his belonged to another guy. He came across a letter his girl had written to the real daddy. They both were light-skinned and had similar features. Shit, she could've gone to her grave with the lie. But Ronnie Sr.'s mother knew from day one that the baby wasn't her grandchild, and she was very vocal about it.

Unlike with my son, the first time she saw the baby in the hospital, she laughed and said, "I don't know who that baby belongs to, but she isn't any kin to me." When I had Ronnie Jr., she had come marching into the hospital, and as soon as she saw him, she said, "Yup, he's ours. That's my grandbaby right there, without any doubt."

In those days, being a teen mom wasn't common. There were no television shows that let others know how difficult it was, and I was shunned. Besides me, only one other girl my age had become pregnant during high school and kept the baby. Shawnda was a pretty girl. She was mixed, with long hair and a cute shape. She had been dating her boyfriend, Gary, for years. They were inseparable, and they ended up having several children together. But with most teen relationships, it ended abruptly. Things got so bad between them that they wound up not even speaking to each other.

It was way too late for Ronnie Sr. and I to turn back. Too much had taken place, too much pain. We tried to reconnect, but it didn't work. He couldn't get over the fact that I had been with another guy and had a baby by him. He tried to act like it didn't bother him, but we both knew it did.

His family was great because they didn't separate my boys. They would never take one without the other. Ronnie Sr.'s grandmother and mother treated De'Von like their own grandchild. For Christmas and birthdays, they made sure De'Von was included. I am not sure how Ronnie Sr. felt about it, but he never said a word, and he grew to like De'Von.

My mother and I had a big argument, and she kicked me out, so I moved in with Ronnie Sr.'s mother and brother with my two boys.

The plan was for me to keep her ten-year-old son, Kareem, during the day, and she would provide me with a place to stay.

Ronnie Sr. would come upstairs and spend the night, but one night, we had a few friends over. We were all partying, drinking, and listening to music. Ronnie Sr. started acting funny toward me, and I couldn't figure out why. It may have been the alcohol talking, but I was getting upset. He and I got into a heated argument because I hadn't put the kids to bed. Kareem kept coming out of his room, and Ronnie Sr. yelled at him. It pissed me off because I was the one who dealt with the kids all day while he was out doing whatever the hell he wanted. Who the hell was he to say a damn thing about anything? When was the last time he took his son to the park? I was the one doing the most, and Kareem regularly helped me with the boys. He was my support system, and I wasn't about to let anybody fuck with him.

We kept arguing. I knew he didn't want a scene in front of his friends, but I didn't give a fuck. I said what I wanted when I wanted. I didn't play when it came to defending my own. That's when the Coralee inside me showed up.

The argument got more intense. As he turned to walk away, I threw a cast iron skillet at him, and it hit him on the head, catching him by surprise. He rubbed the top of his head as blood gushed everywhere. When he looked at me, I knew things weren't going to go in my favor. I saw rage in his eyes, and there was nowhere for me to run or hide. Within seconds, he was punching me. I tried to get away but to no avail. Somehow, we ended up down the hall in the bathroom. I couldn't scream, but it wouldn't have mattered. He grabbed my throat as if punching me hadn't been enough for him. I had drawn blood, and he wanted to draw blood or worse; he wanted me to die. And I wasn't too far from death.

Kareem ran into the bathroom. "Ronnie, stop! You're going to kill her!" he screamed.

Ronnie Sr. snapped back to himself. Kareem had saved my life. We all knew he was the reason I survived that beating.

I could see the remorse and fear in Ronnie Sr.'s eyes. Just as he had done when I confirmed my pregnancy, he ran away and didn't even look back.

He left me with a broken jaw, and he had to get staples in his head. But our fight was about more than a young couple having an argument. It was about hurt feelings, the pressure of being teen parents, and the end of a friendship and relationship. Ronnie Sr. and I never tried again, but, fortunately, we learned to become friends again. He remained an active father in his son's life. There was even a period when Ronnie Jr. went to live with him.

My fight with Ronnie Sr. wouldn't be the last time a man hit me. I still wanted to be loved and give love, but sometimes, attention is mistaken for love. Sometimes, what you think you want is not what you need. Let my mother tell it, what I really needed all my life was one good ass whooping. She was probably right. My mother never laid a hand on me, but she would cuss me out to death. She would fuss and cuss so much until I wished she slapped the shit out of me. That would have been better than hearing her goddamn complaints all the time. And when she was drunk, the demon really came out. That was when she expressed how much she couldn't stand my ass.

I was a spitfire and, like her, I didn't take shit from anyone. I'm not proud of it, but as I got older, I cursed right back at her. I became so disrespectful that she couldn't tolerate me anymore. She started kicking me out regularly. I'd go a few blocks away to stay with my grandmother until she got tired of looking at my dumb ass and sent me back home.

My grandmother would call her and say, "You created this monster, and she ain't treating you no different than you used to treat me."

Coralee let me know, "Don't nobody want to be bothered with your dumb ass. Even your grandmother put you out." She found amusement in it.

The shit wasn't funny to me, but I didn't say a word because I knew how to get along with her when she was sober, and I was ready

to be back home in my own bed (well, the bed she allowed me to sleep in).

When she was drunk, Coralee didn't have a problem letting me know that she had paid the cost to be the boss, and everything in that house belonged to her. I was a visitor, and she couldn't stand me anyhow. Her disdain for me got worse when the babies came. She'd always gone off on me when she drank, but as I got older and more rebellious, her words became more vicious and hurtful. Instead of being a bitch, I was a whorish bitch, a dumb bitch, and whatever else came to mind. I attribute all of it to her unhappiness with me and her own life. I'm sure she had been looking forward to me going away to college. I had been an A+ student before the babies and could've had my choice of colleges.

I was an excellent writer and excelled in everything I did. My teachers all loved me and said the same thing: "She can do anything she sets her mind to. The only problem is whether she wants to do it." I don't know why I didn't want more for myself. After I had my first son, I could've graduated high school and furthered my education. But I dropped out in the eleventh grade. I had been in the eleventh grade but taking twelfth grade classes. I had always been ahead of my class. Maybe it was the pressure of being a half-ass mother; maybe I just didn't like myself, or maybe I needed to find myself. Whatever the cause, I threw in the towel, and things were catapulted from bad to worse.

My Truth

❧

I am healing as I go through this process.

My teenage years were complicated. I was in search of something but not sure of what. I rebelled and gave my mother hell.

I want to have a conversation with the little girl who was confused with no sense of purpose. I want to ask her what her motivation was. Was it really based on the emptiness of not having her father around? Was it about all the abuse she had witnessed? Was it about watching her mother drink to oblivion? Was it about the rejection of her first love? Was it about the man who attempted to violate her? Was it about sex or acceptance? Was it about love? Was it about wants or needs?

Or did it have nothing to do with any of those things? What was she searching for?

I have tried to put myself in the place of the little girl inside me. Is she proud of who we have become? Has she let go of the past? If she had to do it all over again, what would she change?

I smile at the thought of her innocence, her desire to cope with the roughest times, but, most of all, I am proud of her. She never gave up despite the cards she was dealt.

Thank you, little Lori, for being strong. Your strength paved the way for the adult Lori!

MY S.C.A.R.S.

(Strength, Courage, Awareness, Revelation, Story)
By Ronald Davis Jr.

A strength that comes from deep within
From the depth of my soul
To the edge of my skin
A pain outside I can't ignore
Forced to endure
This blemish that I'll always see
A lesson
A blessing
Beautiful imperfection
Our wounds are where strength and pain collide

CHAPTER
Seven

The year was 1988. My mother was raising my boys, and I was lost. I felt all alone. Running the streets was more appealing than anything else. Going to church was in my rearview mirror. I was a part-time mother, and that never equated to much. My mother got tired of the back and forth. It was time I got out of the way and let her give the boys some stability. Her drunkenness was better than my immaturity and inconsistency. Coralee was a good woman. She made sure those kids had everything they needed just like she had raised me.

She and George had formed a solid friendship. They didn't live together, but he was at her house regularly. He tried so hard to win her back. No matter what, he always loved her. She'd curse him out and even stop talking to him for days, but whatever Coralee wanted, she got. And what she wanted was help with her grandchildren.

When I had found out I was pregnant with Ronnie Jr., George made a nursery for him. He spent well over three thousand dollars on furniture, carpeting, and supplies. He told me he'd planned to buy me a car for my sixteenth birthday. When he showed me the room instead, he said, "Say hello to your brand new car." It wasn't funny at all. I already knew I had fucked up majorly and didn't need any reminders, especially from him, the devil in plain view.

George flooded the living room with gifts under the Christmas

tree, made sure there was plenty to eat, and kept up with the bills. He did it all financially. Shit, he would even babysit to give my mother a break so she could go to Atlantic City. He'd give her about five hundred dollars and tell her to go relax and enjoy herself. My mother loved to gamble, and I inherited that trait from her. From what I've been told, my father was a gambler as well.

While they took care of my children, I walked around like somebody owed me something. I had mixed emotions. I wanted to be a mother to my boys, but I wasn't emotionally ready. I couldn't stand to be home because it was a constant reminder of my failure as a mother and a young woman. Instead of trying to figure it out, I stayed away. I wound up with the first guy who showed me interest, continuing a pattern of self-destruction.

This would've been a good time to get myself together while my poor mother raised my children. But, of course, I didn't. I fell in love again. But this love would be different. This was the kind of love that almost ended my life.

James Vincent, better known as Vinnie, was eighteen years old, two years younger than me, and he'd had a crush on me for a long time. He didn't care that I had two kids. He liked me enough, so it didn't matter. I was never interested in him, and in the beginning, I didn't even think he was that cute. But as time went on, he became more attractive and sexier. Vinnie was about 5'11" with a slender build. He was chocolate with deep dimples and bow legs. He had a cut upper body, and he was street. That's what I liked about him.

Our relationship happened fast. Why wouldn't it? I didn't have anything or anybody else. He became all I had. All he wanted was to be around me, and I didn't have anything else going on, so I obliged. I needed someone, and he was a willing participant.

We were always together. He was as smart as they came, but he wasn't in school because he had gotten kicked out of every school he attended because of his behavior. I spent the day at his house when his mother was at work, and we would leave before she got home. We

hung out at friends' homes because we needed a place to go. When he thought his mother had fallen asleep, he snuck me into the house.

My mother had kicked me out of the house again, and I had nowhere else to go. His mother was religious and wouldn't have allowed me to stay at her home, so we snuck in and out. When she caught us, we vowed it wouldn't happen again, but it did.

Vinnie lived with his mother and sister, Selena. Selena was dark-skinned with long hair. She had a small frame, and she was a cute girl. She was a year older than her brother and excelled in school. She did everything she was supposed to do and went to college. I envied her because she was doing what I should have been doing.

Vinnie's mother was soft spoken and one of the nicest women you could ever meet. And she could sing. It was clear that she loved God and her children. Like me, Vinnie was a spoiled brat. He was the baby. Whatever he wanted, he got. Selena was a go-getter, driven and ambitious. Vinnie, on the other hand, wanted things out of life, but his temper always held him back. An intelligent black man with anger issues is an oxymoron. The black man has already been given the short end of the stick, and Vinnie was his own worst enemy.

I understand our connection. I, too, was my own worst enemy. Our commonality was our intelligence. We were alike but different. He was disappointed with his life, and so was I. He had made mistakes, and so had I. Our future was grim and dim. We had nothing to look forward to. We became each other's refuge, comfort, support, teacher, lover, and best friend. We became codependent. We held on to our relationship for dear life, refusing to allow anyone to separate us or come between us.

He told me, "If I can't have you, no one else will," and, secretly, I felt the same way. Till death do us part.

With most relationships that have gone awry, people tend so say, "But it was good in the beginning." You won't hear me say that. It wasn't all that good in the beginning, middle, or the end. Yes, we had many good days, but each good day was coupled with several more bad days. But when you don't have much, something is better

than nothing. When living a life of hopelessness, that's all that matters—having something. I was broken.

Our relationship was chaotic, and the good didn't outweigh the bad. When we were good, it was great, and when we were bad, it was worse. We fought constantly. I would cuss him out, and he would beat my ass. We argued about everything. It could be something as simple as the weather, or me taking too long at the store, or him hanging out all night. He and I got into our first fight about a month after being together. I was mad at him because he'd agreed to babysit for a friend of ours, and it turned into a major event.

I knew we weren't right for each other. How could we be? We didn't have anything. Neither of us had a job, we weren't in school, and we didn't have a place to stay. Misery loves company. Because I was unhappy, I tolerated whatever came my way. I don't know if I attempted to stop it before I got caught up, but I did look for an outlet. I knew, once again, I wasn't making the best choice.

Knowing this and still longing for my children, I swallowed my pride and called my first love. I cried out to him and told him I needed him. My mother didn't want anything to do with me, and I didn't have any place to go. I was tired of fighting with Vinnie and needed to be away from everybody and everything. I was desperate, hoping he could rescue me from making more bad decisions. Ronnie Sr. could hear the pain in my voice; he was concerned. He still loved me, and I knew that. I don't know if he knew what I was looking for, but he wanted to console me. He could relate to my pain, and he wanted to help me.

I arrived at his house looking pitiful. He grabbed my hand and led me to his room. If he only knew how much I needed him. I was sorry for the hurt I had caused him, and the look in his eyes let me know he felt the same way. I told him my mother had kicked me out, and I didn't have a place to go. He said we would figure something out. Ronnie Sr. was comforting. He made me feel as if everything was going to be all right. I knew that he wanted to erase the pain and be there for me. We talked and laughed all night long. He made

love to me and held me in his arms. I woke up to breakfast in bed (he always cooked for me). After breakfast, I got up, took a shower, and got dressed. The plan was for us to talk to his grandmother about me staying there until we figured out our next move.

As he and I discussed what we were going to say to his grandmother, the phone rang. It was his best friend, Benny, telling him about a party at the Kiley Center (AKA the Canteen). He was making sure Ronnie Sr. was going to come and asking what they should wear.

In those days, gangs were called crews, and everybody was in one. But most crews weren't about violence and selling drugs. They were about brotherhood and sisterhood. Ronnie's crew was PHK, Party Hearty Killers, and they didn't always start problems, but they damn sure solved them. They were always in the spotlight. At every party, someone from PHK crew got into a fight with either someone from out of town or another crew. Before it was all said and done, Ronnie Bull had knocked someone out.

I was part of a crew called Together Girls (because we did everything together). Our crew had about twenty members, and we had what we called get togethers. Our get togethers would be at one of the older members' homes, providing us a place to drink brews and smoke joints.

There were other crews, like ICE Crew, Candy Girls (they always wore pink and white) and Jr. Candy Girls, Play Girls (they were nasty), and Vice Crew.

I watched Ronnie's excitement as they spoke about the party. From the sound of it, they had been looking forward to it for a while. Since having my kids, I couldn't attend the parties like I had done in the past. My life had changed. I missed my life and having fun, but things were different. I was a mother who had given up her children. I wasn't in school, and my life was in a tailspin. I was jealous. Here he was talking about a party and having fun, and I missed it all. I wanted to go back in time when I didn't have children. I wished I could start over. I loved my children, but I would've waited to have

them. The more Ronnie talked, the more excited he became. I even heard him talking about all the girls who were going to be there. He had forgotten I was sitting there.

He turned and looked at me, and a tear rolled down the side of my face. He immediately hung up the phone. "Lori, I'm sorry," he whispered.

"It's okay."

He probably thought I was hurt because of the phone call and the comment about the girls. I wanted to tell him that I wasn't upset about any of that. My pain was way deeper. I knew my life was spinning out of control. I had lost my savior.

I put on my shoes, grabbed my coat, and headed for the door. Ronnie maneuvered around me and blocked the door. "Don't leave," he said. "Where are you going?"

I looked him in his eyes. "I'll be fine. Thank you for last night. You take care of yourself, and, by the way, enjoy yourself tonight at the party."

Both of us knew that when the door closed, it would be closed forever. As much as I wanted to turn around, I couldn't. It was clear he wasn't ready or mature enough to handle the responsibility of me and all I came with. He still needed time to grow up and learn about being a man.

My Truth

James Vincent Cohen was one of the guys I'd met while hanging out with the Together Girls. He lived on the same street as one of the girls whose house we would frequent when her mother wasn't home. Every time I saw him, he tried so hard to get my attention. I would brush him off because he was younger than me. I could tell he had a crush on me, but I laughed it off and went on about my business. I told him repeatedly that I wasn't interested in him, but he wouldn't stop trying. He became a thorn in my side, a real pain in my ass. He knew he was getting on my last nerve, but he didn't care. We had begun a silly game of cat and mouse.

We ended up together unexpectedly. I had just finished arguing with my mother and was walking to my grandmother's house with Ronnie Jr. and De'Von. Ronnie Jr. was acting out because he was tired of walking, and he was trying to get into the stroller with De'Von. It was hot, and I was aggravated and mad at the world. I was crying and didn't want to be bothered.

Vinnie approached me with a dumb-ass look and said, "Do you need some help?"

Frustrated, I replied, "Do I look like I need some fucking help?"

Vinnie looked puzzled and burst out laughing. "Actually, it does look like it."

All I could do was laugh, too. I probably looked like a lunatic. I was

a mess and my hair was disheveled. Before I knew it, Vinnie had leaned down and picked Ronnie Jr. up, putting him on his shoulders the way fathers often carry their sons.

The walk to my grandmother's house was about fifteen minutes, but we must have taken the long route because we laughed and talked for over an hour. At that moment, I saw him in a different light. His conversation was mature, and he was smooth with a cool way about himself, things I hadn't previously experienced when being around him. When we got to my grandmother's home, I didn't want him to leave. He had intrigued me, and I wanted to know more. He made me laugh, and he seemed endearing. He wasn't the goofy boy who had been getting on my nerves and following me around. I wanted to hang out with him longer, but my grandmother wouldn't have allowed him to come inside. I gave him her number because I knew I wouldn't be going back to Coralee's house any time soon.

Later that night, Vinnie called me, and we talked for hours. He was a sweet guy. As we got to know each other, I became more caught up with his personality. He kept me laughing, and he took an interest in my kids. He enjoyed taking them to the park with me, and sometimes, he took them and told me to stay home and rest. He would bring me food, flowers, and anything I wanted. He was what the doctor ordered, my escape from reality.

I fell victim to his need to be with me. I see it now, but I hadn't back then. I had a distorted view of our relationship. I mistook dependency and possessiveness for love. We were in this thing together. We were so encapsulated with each other that we lost ourselves. It went from being a relationship of trust, loyalty, and respect to envy, jealousy, and rage.

Vinnie was my longest relationship and the most toxic. But I will forever be grateful for his love.

CHAPTER
Eight

I walked down the stairs from Ronnie Sr.'s building in slow
motion. I had no sense of urgency. Where was I going? Maybe
to a friend's house, but why? My friends were all going to the
party. The tears came faster and turned into uncontrollable sobs. I
wanted to go to my mother, but for what, so she could look at me
with disgust? I could go to my grandmother, but I didn't want to
worry her and bring her more heartache. My grandmother would've
opened the door, but my uncle would've gotten upset with her if he
knew I was staying there. He'd hated me from the time I'd gotten
pregnant and became the black sheep of the family.

My uncle's second marriage was to a woman outside of his race,
and I always felt he looked down on the other side of his family,
although his children were biracial. It's not as if he liked me much
prior to my pregnancy, but that was all it took for him to be done
with me forever.

The other problem with me being at my grandmother's was
that my mother and my sons had an apartment upstairs from her.
My grandmother was a peacekeeper, and I knew she didn't want to
defend me all the time. It would have put a strain on her relationships
with my mother and uncle. I needed to stay away. The few times I
had stayed were too painful.

I knew my boys were in pain. They wanted their mother, and I

couldn't bear to see that pain, so I stayed away as much as possible. I couldn't be the mother they needed me to be.

With no other options, I stopped at a phone booth and dialed Vinnie's number. He answered on the first ring as if he knew it was me or had been waiting for my call. I could tell by his deep, sexy voice that he was excited about my call.

He said, "Where are you? I called your grandmother's house a few times last night and today."

I told him I had stayed with a friend, and I was down the street from his house.

"Come over to my house."

I pretended that I didn't want to, but there was nowhere else for me to be. I let him think he had to persuade me, but I was only waiting for the quarter I had used on the payphone to run out, and I was going straight to his house. Before I knew it, he had made his way to me, which made me feel wanted. We had been seeing each other for a while, but this would be the beginning of our relationship.

Vinnie and I got tired of sneaking in and out of the house, and I was tired of not doing anything with my life. He made extra money babysitting, doing odd jobs, and selling drugs. Crack was big then, and there was good money in slinging drugs. Vinnie was a hustler. Although I was older, he taught me so much about everything. I learned how to maneuver on the streets and deal with drug customers. He taught me the ins and outs of the hustling game. Vinnie was an avid reader and knew a lot about different things. He was one of the most intelligent people I have ever known. He was the one who showed me Times Square. We would dress up and head off to the city. We dined at expensive restaurants, watched Broadway plays, shopped at elegant stores, visited arcades, and traveled. He was an attentive young man. He ran my bath, cooked and cleaned, and gave me gifts. At times, he even waited on me hand and foot.

I was tired of sleeping all day and being up all night, hanging out with friends until the wee hours of the morning, the same routine day in and day out. When we weren't having sex, we were fighting

over nothing. Not an hour of the day or night went by when we weren't together. We were together so much people said we started to look alike. I believed them because I'd noticed we started to act the same, too.

I became frustrated, and so did he. We needed space, and I needed my children. I cried all the time because the void was still there. My mother had decided it wasn't healthy for me to see the boys. She claimed they had a difficult time after my visits. They would cry and get angry. I decided it was time to get myself together and started looking for a job. I told Vinnie but, somehow, he misconstrued what I was saying. He thought I was saying I didn't want to be with him. I hadn't thought of it that way. I just knew I needed more.

But it wasn't in the plan.

Shortly after our conversation, I found out I was six months pregnant. I was devastated. I hadn't taken care of the first two, and now baby number three was on the way. But what did I expect? I was having unprotected sex every day, all day. Vinnie was excited. He wanted me to have the baby. It didn't matter that we didn't have legitimate income or our own place to live and I had two other kids I wasn't providing for. Nope, he didn't care about that. He was happy to be having a baby. He figured his mother would now allow me to live with them. He had everything planned. He was going to get a job and take care of the baby and me. I believed him because he always made sure I ate.

First thing's first; we told his mother I was pregnant. Of course, she didn't jump for joy, but she was willing to support us. She gave us permission to live with her until we could get a place of our own. A few months later, we moved to an apartment on the other side of town, not too far from where my grandmother and my mother and sons were living, literally right down the street.

Vinnie found a job and started saving money. I was happy for him. He couldn't wait to share the pregnancy news with the world, but I didn't want to tell a soul, partially because I felt like an idiot.

I didn't have my other two children, and I hadn't changed anything about my life for the better. Now, I was pregnant with baby number three. I could hear my mother going off about how she knew I wouldn't amount to anything and how she was raising my boys while I lay around getting pregnant again. As deep as her words cut, she would be 100 percent accurate.

I tried to pretend like I was happy, but I wasn't. It wasn't about the baby; it was about me and not being able to support this child. My relationship with Vinnie wasn't so great, either. Our relationship consisted of drinking, drugging, and fighting. If we weren't consistent with anything else, we were damn sure consistent with that. He was obsessive and possessive. I couldn't look at another man or have too much conversation, or he would beat my ass. It didn't matter where, when, or who was around. It was never a secret. He did it in the open.

People used to say, "Lori's a good girl, but Vinnie beats her all the time." Why didn't I leave? Leave to go where, to do what? Part of me believed I deserved it. My self-esteem was gone, and in some crazy way, I felt like he had rescued me, and I was indebted to him. I knew he loved me, and I still carry that sentiment in my heart. His insecurities and rage got the best of him. Besides, he was just repeating what his father had done to his mother.

History repeats itself, and until the cycle is broken, it will continue to repeat. I, too, had grown up in a household of violence, so we had a commonality. We weren't good together, but we always felt like we would be worse apart. I'd left him many times, but before I knew it, I was right back with him again. Our relationship became a revolving door. One day, we were on and the next day, we were off. My mouth and his aggression were a bad combination. I didn't mind arguing to get my point across and neither did he. But of course, he had the upper hand.

The first time I left him, I was six months pregnant. We had been out most of the day, and when we came back in, I wanted him to do something for me, but he didn't feel up to it. I got upset and

started cursing him out—mistake number one. He jumped up and slapped the shit out of me. I screamed, and he told me to shut the fuck up. Hell no, not Loriann! He may beat me, but I was going to say whatever the fuck I wanted to. I continued mouthing off, and he started beating me. One of the neighbors called the police, and he was arrested for assault.

I fled to my grandmother's house, and she told me I could stay with her. The look on her face made me feel worse. My mother came downstairs, and, instead of her usual criticism, she was compassionate. "I was wondering how long you were going to take the abuse," she said.

They both had received numerous calls from my friends about how bad Vinnie was treating me. My mother knew about the time when we were walking to his house and he'd thrown me to the ground, punching me. She knew about several other times, too.

"If that man is beating you outside, I can only imagine how he is treating you inside," she said.

All I could do was break down and cry. My mother grabbed me and held me for dear life.

"Leave him," she said

"I can't. I'm pregnant."

She was in disbelief. "Not again. Why would you put yourself in that situation again?" She was concerned, but she made herself clear. "I cannot and *will* not raise any more of your children. "You will figure this one out, but I am here for support."

Vinnie was incarcerated for several months, giving me an opportunity to clear my head and get a fresh start. It was time to dust myself off, stop feeling sorry for myself, and put the pieces of the puzzle together.

Vinnie was out before I knew it. I had a protective order, and he was told to stay away from me, but that didn't last long. Every day for weeks, he called, sent messages through friends, and walked back and forth in front of my grandmother's house. He knew he would get to me eventually. Besides, I wanted to see him. I was over the situation

and blamed myself because I had started the argument. When we finally talked, he convinced me that he wouldn't put his hands on me again. His tears and performance seemed so real. I believed him and wanted to be with him. Against my better judgement, I went back to him. My mother and grandmother were upset. And it was difficult for Ronnie Jr., who was four years old, and De'Von, who was two, because things had gotten better, but once again, their mother abandoned them.

My Truth

This chapter was difficult for me to write because I had to admit my wrongs. The hardest truth for me to tell the world is that I left my two sons. A parent's abandonment, regardless if the parent is good, bad, on drugs, or strict, is traumatic for the child. Children always long for their parents, and so did mine.

They couldn't have cared less about how fucked up I was; they wanted their mommy. I made a conscious decision to leave them with the person who could give them what I couldn't financially and emotionally. I cried out for them every night, but I was trapped in my own self-pity. I made decisions based on that self-pity and the disdain I felt for myself. I didn't love myself, and my actions proved it. I continued to bump my head against the same wall repeatedly.

I have forgiven myself and so have Ronnie Jr. and De'Von. They forgave, but none of us have forgotten. We're able to discuss the good, bad, and the ugly. Believe me, it didn't happen overnight. There were many arguments and disagreements. Shit, many times, we were out to draw blood with vicious words. But it needed to happen because it was our process and our way of handling what I had put them through.

Before releasing this book, I let my sons read it. They were moved by my courage and strength. It has aided them in getting a better understanding of what I have gone through. I am being transparent,

letting them in on my innermost thoughts and the deeply rooted secrets I have been holding inside.

This is my therapy. I have exposed myself so I can grow. This is my way of forgiving myself. The pieces of the puzzle are starting to come together.

We have wounds, but we are healing!

Nine

On July 3, 1989, Jarrin Tre'Quan was born. He was the apple of his father's eye. Vinnie loved his son more than anything else. I could see and feel the love. He didn't mind daddy duty; he enjoyed it. We would take turns. Vinnie would be up with him at night, and I took the day shift, which I preferred. We moseyed along, being the best parents we thought we could be.

Vinnie had lost his job when he went to jail, and it was time for him to get back on his grind, which meant he was back to hustling until something better came through. Several months later, he found employment. Things were looking up. My mother was allowing me to see the boys, mainly so she could keep an eye on me. She was concerned about her child. She wanted better for me and questioned why I didn't want better for myself.

Things were going as well as could be expected, but as life would have it, it was short-lived. Whenever there were moments of good, the craziness was soon to follow. I found out I was pregnant again, and I was already six months along. From the time I'd started my menstrual cycle, I was never regular. And most women gain weight during pregnancy, but I always lost weight, so I always found out about my pregnancies late.

Again, Vinnie was ecstatic about the arrival of baby number two for us. I wasn't as happy, but it had become a way of life for me. If he

was happy, I was happy for him. So far, he had proven to be a decent father. Why not bless him with another child?

Why not? Because we didn't have a pot to piss in or a window to throw it out of. Things went from bad to worse again. Vinnie and I got into a big argument over the care of our son. Something about him not sleeping all day with me and staying up all night. Vinnie was working and needed his sleep. Just like before, the argument turned into him punching, slapping, and kicking me and tossing me to the ground—while I was pregnant.

I went to the hospital in an ambulance, leaving my son behind with Vinnie's mother. I had no choice; my water had broken, and I needed medical assistance.

They released me from the hospital, but, somehow, I hadn't delivered the baby despite my water being broken. Determined not to go back to Vinnie, I headed back to my grandmother, bloodied, abused, and pitiful. I was ashamed and embarrassed, but my options were limited. My mother told me that enough was enough this time, and I needed to get myself together. She begged me not to go back. I stood steadfast and strong. I wasn't going back. I'd had enough.

But I wasn't going to leave my baby, not another child. I had to go back to get him. Vinnie refused to give our son to my mom. He told her if I wanted him, I had to come get him. I wasn't stupid. Either one of two things were bound to happen: He would beat me again, or he would try to sweet talk me into staying. My best defense was to ignore him and stay away. He had become my addiction, and as with any addiction, to kick it, I had to stay away from the people, places, or things that triggered the craving.

I knew what to do. Every Sunday, his mother took the baby to church, so I came up with a plan. I had my stepfather drive me to church, and his mother had no choice but to give him to me.

On May 30, 1990, Justin Daquan was born. Baby number four. This pregnancy had been different. He was birthed when I was just six months pregnant. As soon as I'd found out I was pregnant, he was ready to be born. I'm not sure what caused his premature delivery.

I suspect it was because of the lack of prenatal care and because I was drinking, not knowing I was pregnant. I was also under a lot of stress. It all took place in a matter of weeks. He weighed three pounds, twelve ounces. I was happier than I thought I would be.

Justin was my little fighter. He was strong and determined. The doctors said he would be in the hospital for three months, but he came home in two weeks. Vinnie was there to see his son born, but shortly after his delivery, we got into a heated argument in the hospital, and I had to have him escorted out. Due to his threats, I requested a protective order. I arranged with the hospital that once I was discharged, he and his family could see the baby when I wasn't around. That enraged Vinnie even more because I had placed provisions on him to see his son. It was my way of keeping the peace. I wasn't trying to keep him from his child, but I was making sure I was safe.

Things were beginning to work in my favor. Before Justin was released from the hospital, I'd found an apartment and moved in. I saw my other boys regularly, and at twenty-two years old, I reenrolled into a school to get my general equivalency diploma. I was ready to jumpstart the next phase of my life.

I had wasted far too much time on stupidity. It was time to start getting my life in order. Like my mother would say, it was time to straighten up and fly right. I was tired of the back and forth. I was sick to death of myself. This was long overdue, and the time was now—right now.

However, speaking it and doing would take time. I daydreamed about a better, more productive life, but I was clueless about the steps it would take to get it. I knew I needed more. I was tired of being a baby-making machine without a damn dime in my pocket.

I began transitioning from an asshole to a half-ass adult, and it was a process for me. I took a long look at my living situation, the man I was lying next to, and the many children I had birthed and said, "Oh, hell nah!" Not only was this not going to be easy, but it

was going to take a miracle. But it needed to be done. Those sons of mine required more from me.

I asked God for favor, grace, and mercy. It was time for me to embark on new beginnings and elevate beyond the troubles of my past failures. I was ready, willing, and able.

My Truth

What's interesting to me now, as I continue to look backward, is how easy it was for me to get caught up in the same routine. I was stuck and wallowing in my own self-pity. It's almost inconceivable to picture myself in that time and at that place. If it wasn't so sad, it would be funny to me.

I didn't know my worth and didn't understand who I could become. I keep asking myself, "Who was that girl?" I am the opposite of her. I have purpose now and plans for the future. I don't take shit from anyone, especially a man! I am responsible and independent. I set goals and accomplish them. I am positive and surround myself with positive people.

Those who know me will find it difficult to believe this story because of who I am today. I am a leader, a role model, and an educated woman. But I will tell them that everyone has a story. Yours may not be the same as mine, but we all have one. It may have taken me a little longer to get where I needed to be, but I am here now.

A Prayer for My Sons

By Unknown

Lord, your gifts are many
I am thankful for every one
One of the greatest gifts you've given is the gift of my dear sons
Thank you for their life,
Dear Lord
Watch over them each day
May they be safe and free from harm as they go about each day
Bless them through life's trials
Help them choose right from wrong
An example be for all to see,
Standing, tall, proud, and strong

F inally, I had my own apartment, and I was reenrolled into school. But I was struggling. Section 8 was taking care of the rent, and I received $400 a month in food stamps and $150 every two weeks from social services. I appreciated the system helping me, but it's not designed to help people get on their feet. Maybe it shouldn't be. Maybe it's designed to push you to do more and do better. I refused to settle for the pennies they told me I needed to take care of my family. It made me realize I wanted more for myself and my children. It took a while, but it sunk in.

We didn't have much, but I was maintaining. My boys were thriving, and I had some peace of mind. I wasn't running from home to home. I was finally starting to get stability. But I was still young, in my early twenties, and didn't know how to act when I first got into my place. I had friends over regularly, and I partied more than I should have.

One night, I had Ronnie Sr.'s little brother, Kareem, spend the night. I'd told him to come into the house by eleven o'clock, but he hadn't come in. I needed to go across the street to see if he was at the park. A friend was at the house, and she told me to go check; she would watch my boys. But Jarrin, whom we affectionately called Tre', was up, and he refused to let me leave. I picked him up, put him on my hip, and we headed outside across the street.

Vinnie happened to be outside with a couple of his friends. He approached me and started yelling. "Why the hell do you have my son outside at this time of night? What the fuck are you doing?" He was bugging out for no reason.

He wouldn't let me get a word in, not that I had to explain, but I wanted to. He was filled with a myriad of emotions because he hadn't seen me or his sons in months. I had stopped seeing him for a while because I needed to focus on myself. I was tired of all the physical and verbal disputes. For a moment, I had missed him, but that changed within seconds. Before I could get a word in, Vinnie balled his fist and went to punch me in the face. But he accidentally punched his son.

We both froze.

Tre' screamed in agony.

Startled, Vinnie ran. The police arrived, and days later, Vinnie was arrested and sent back to jail.

Child Protective Services was notified, so I had to clean up my act. No more parties or having friends over. The social worker was trying to get me for being an unfit mother, and she wasn't too far off. I wasn't mother of the year—not even close—but I was trying. They settled on preventive services, which meant a worker visited regularly to make sure the children and I were in a safe environment. My preventive service worker, whom my mother knew, found a school for the boys. My boys both started school at eighteen months. Tre' and Justin are the same age for a few months of the year because Justin was born prematurely.

I was doing well. I received my GED and started working as an AmeriCorps Vista to empower teen mothers and fathers and provide services that deter other teens from becoming pregnant. I wasn't salaried, but I received a stipend every two weeks. I had other jobs, but this job gave me a sense of purpose. I worked to develop programs like Project LIFE (Learning Information Fosters Empowerment) and Project FACT (Finding Answers Concerning

Teens). I held workshops, organized toy drives, and hosted baby showers for the pregnant mothers.

Unfortunately, Ronnie Jr. was having behavioral problems. He had every right to be angry. His mother had left him to be raised by his grandmother, but I was raising his siblings. Anger was an understatement. He was enraged. I guess the circumstances didn't have the same effect on De'Von. He may have been angry, but his temperament was different. De'Von held his feelings inside while Ronnie Jr. displayed his frustration and anger like his father. My mother couldn't manage him, and he refused to go to school. He was sent to a group home in Hyde Park, which wasn't a smart decision. Now, he really felt abandoned. But Coralee's hands were tied. Ronnie Sr. stepped up and took his son home with him. That was what he needed, a male role model.

With Ronnie Jr. settled with his father, I felt good about the path I was on. The boys were doing well in school. But, as had become the pattern for me, things got worse before they got better.

Vinnie's sister, Selena, came to see me, and she informed me that their mother had passed away. My heart dropped. I knew she had struggled with sickle cell anemia for many years, but I didn't know it was serious enough to take her life. I didn't know how to react or what to say. My thoughts and body shut down. I quickly turned my attention to Vinnie's well-being. Selena informed me that her father had bailed him out of jail, and he wasn't doing well. I wanted to be there for him, but I couldn't. Too much time had passed.

I decided not to attend the funeral because I was unsure of the reaction I would receive from Vinnie. Besides, I had been told he was dating someone else, and I didn't want to interfere.

A month later, I was walking with the boys, and Vinnie appeared. I could see the hurt in his eyes from his loss. I froze. His mother was his heart, and he missed her. I also missed her. She'd always made it a point to check on me and get the kids. She had been there for me, and she had visited me shortly before passing.

Vinnie grabbed the boys and held on to them for dear life. I

knew he needed to be with them. He asked if he could take them for a few hours, and I was fine with that. As much as I pretended not to want him, I still loved him and wanted to be there for him. When Vinnie came to drop them off, I knew where things were going. I missed him and was glad he was there.

We made love like there was no tomorrow. My dumb ass had done it again. I fell for the okie doke because I wasn't over him yet. Everything was good for a while, but he was staying with me and still seeing the other girl, and she wasn't making anything easier. She lied and said she was pregnant, attempted suicide, and threatened to kill my kids. I'd had enough and put Vinnie out. He stayed with her for a short time, telling me he wanted to be with me the whole time.

I let him come back.

Shortly after, I found out I was pregnant again. Baby number five. Things weren't good between Vinnie and me. We had another big fight, and I put him out again. As we continued the cycle of fighting and making up to break up, we moved several times. There was no damn stability for my children, just a life of chaos and uncertainty.

About every two years, it was time to pack and move again. I wouldn't allow myself to get too comfortable with my situation. We'd started on Main Street in a two-bedroom apartment then moved to North Division Street in another two-bedroom apartment, Highland Avenue in a three-bedroom, North James Street in a four-bedroom, South Street in a four-bedroom, Howard Street in a three-bedroom, Young Street in a three-bedroom, and, finally, Regina Avenue in a five-bedroom house.

On February 21, 1992, Tylin Ashton was born. The biggest baby boy of the bunch, he weighed seven pounds, fourteen ounces. By the time he was born, we had moved. He would be my last baby. My body and mind were tired of the birthing process. I opted for a tubal ligation. Had I not, I'd probably still be having babies.

The decision was an eye opener for me. I was lying in the hospital, reflecting on my life, and I asked myself when I was going

to change. I was sick and tired of being sick and tired. I was tired of the physical abuse, tired of drinking and drugging, and tired of settling for less. I vowed to make changes—again.

Once again, I dusted myself off and picked myself up. I got a job at a group home, and I even started working on my self-esteem. I began using my inner voice to give myself daily positive self-talk, telling myself, "Girl, life isn't over; you're still young and have time to get your shit right." Every day, I gave myself pep talks and repeated affirmations like, "You are worthy and deserving of more." I mustered enough strength to get up every day with a bright outlook on life. I wasn't going to be defeated, nope, and I knew I couldn't depend on anybody but Lori. I had gotten myself into this mess, and I was going to pull myself out. I even changed the clothes I wore. Instead of wearing regular street clothes, I wore casual outfits and business clothes. I made sure my hair was tight and my skin glowed from good moisturizing techniques. I walked with a purpose, held my head high, and put a little extra strut in my steps. I went from being insecure to secure about my power as a young woman. As I continued, I felt stronger and confident. The weight of disappointment and self-doubt was lifted from my shoulders. I was gaining hope and no longer feeling hopeless.

Vinnie had told me no other man would want me because I was all used up and had five boys. He was wrong; men approached me all the time. I turned them down because I couldn't expect someone else to love me when I was still working on loving myself. I had allowed my life to be in shambles, and it was my job alone to remedy that.

Life wasn't great, but it damn sure got better. Vinnie and I started seeing each other again after a short separation, but things were different because I was different. I hadn't regained all my power, but I was headed in the right direction. Vinnie watched my every move and made comments along the way. "Who the hell you dressing up for?" he'd ask. He was talking crazy, too, accusing me of dating or fucking another man.

But my changes weren't about a man. Shit, men were why I

had been in the situations I was in. It was about me and wanting to become successful, having a better life for my sons and me. Men were the furthest thing from my mind.

Vinnie was having a hard time adjusting to the improved, confident Lori who put her children and herself before anything and anyone else. I was starting to live up to my potential, but he was losing his hold on me and losing it fast. He started hanging out with his friends and staying out all night.

One night, he and I had an argument about the new me. He was upset because I hadn't been spending enough time with him, and we weren't hanging out like we used to. His way of handling the transition was to call me all types of bitches. Had I still possessed my old frame of mind, we would have been in a long, drawn-out fist fight. But this time, the words just rolled off my shoulders. I couldn't care less, and I wasn't about to let his negative energy take me out of my element.

I looked at him and shook my head, giving him a smirk. It wasn't worth it. So I was, in his words, a "stupid bitch," and he was going to get with the next bitch. I thought, *Good riddance!* I was tired of the headache and needed some peace of mind.

Vinnie stormed out of the house.

At four a.m., I received a phone call from Westchester Medical Center, and a nurse informed me that he had been in a car accident. I contacted his sister and headed to the hospital.

I arrived within fifteen minutes. Vinnie was on a stretcher, and both his lungs had collapsed. Bumps and bruises covered his body. He was banged up badly. He told me how much he loved me and how sorry he was for everything. He said he had been with two of his friends, and they were on their way to New York City to hang out. It was icy outside, and someone hit him from behind, causing the car to hydroplane. One of his friends was flung through the windshield, and the other panicked and tried to get out of the car. Vinnie had heard the police talking, and one of them said that his friend Rick was dead on arrival.

Vinnie was distraught. I figured he had heard wrong. He begged me to find out what was going on. But as soon as I went back to the waiting room, I knew it was true. The family was gathered, and I heard screams of disbelief. I didn't know what to do. I wanted to tell them I was sorry for their loss. But I didn't. I couldn't. I walked back to Vinnie's room.

I told Vinnie that Rick had passed away. Tears rolled down the side of his face. "I told you," he said. He asked about Lawrence. "How is he?"

Lawrence had broken ribs and a collapsed lung.

His girlfriend, Rhonda, a close friend of mine, was at the hospital and came into the room to check on Vinnie. Rhonda told me she wanted to speak to me alone. We walked into the hallway, and she shared with me that they had been at her house prior to the accident. They were drinking and decided to head out to the city.

She began to weep. "I tried to stop them from going, but they wouldn't listen."

Lawrence and Rick were cousins, and I knew when their uncle arrived, all hell was going to break loose. He immediately came to Rhonda and me and asked if Vinnie had been drinking.

"They had all been drinking," Rhonda said.

"Oh, I thought so. This mothafucka killed my nephew." He turned and walked away, headed to where the police were standing. He told them to make sure Vinnie received a blood test for alcohol. He also explained that he would probably have drugs in his system. If he was over the drinking limit or the test came back positive for drugs, the family wanted him arrested immediately for causing the death of his nephew.

I wasn't upset with his uncle, but Vinnie also had family members in the waiting area, and I thought the way he was speaking was insensitive. However, I would've felt the same way if my child or family member had died at the hands of someone who was intoxicated.

I walked back into Vinnie's room. He had fallen asleep, but

my presence caused him to jump. "Lori, am I dreaming, or did something happen to Rick?" he asked.

"You're not dreaming," I said. "Had you been drinking or using drugs?"

"Yeah, but earlier."

I explained to him what Rick's uncle had said. Vinnie was adamant that the accident was caused by some young girls. He claimed they'd hit him from behind.

The nurse came in to draw blood, and Vinnie looked concerned. He whispered to me, "It is what it is."

Rick's uncle came over to Vinnie and asked how he was doing, trying to act concerned. I glared at his phony ass. *You hypocrite. How dare you?* I thought. But I had to put myself in his shoes, and I understood.

When Vinnie's aunts, sisters, and other family walked into his room, I stepped out. I needed a break to regroup. As I walked toward the waiting area, one of Rick's sisters gave me a dirty look. She was clearly upset with me, but I had no idea why. Rhonda asked her, but she never gave a good explanation. It wasn't my car, and I had nothing to do with the accident. I wasn't with them. Maybe I was guilty by association. I understood the need to be angry at someone, and I guess I was the target. She still carries resentment for me today, but I'm not fazed by it.

Vinnie was released from the hospital a few days later and cleared of any wrongdoing. Lawrence's family was upset and held a grudge. Several months later, Lawrence reached out to Vinnie, and they had a conversation about the accident. A few weeks later, Vinnie received notification of a lawsuit Lawrence and Rick's family had filed against him for Rick's wrongful death.

The lawsuit was thrown out, but insurance paid for Lawrence's doctor bills. Vinnie and Lawrence remained friends, but the relationship was strained.

Vinnie was under a lot of pressure. He couldn't sleep and turned to alcohol to solve his problems. He felt responsible and was having

difficulty dealing with his guilt. Although it wasn't his fault, he was the driver of the vehicle, and a friend had passed away.

He was frustrated with his life and decided to move south with family to get himself together. He probably couldn't handle looking at Rick's family. He needed to get away and clear his head. I wasn't upset about him leaving because I wanted a change. The plan was for him to get things together and he would send for me and the kids. We talked every day and became the best of friends.

The boys and I were doing well. De'Von was still living with my mother, but he was at my house regularly. Ronnie Jr. had left his father and moved in with me. I think that's what he'd always wanted. He claimed his father was too hard on him, but he just wanted to be with his mother. Ronnie Sr. resented me for years because I never sent our son back. But I couldn't abandon him again, and he told me he wouldn't go back. When I tried to make him go, he ran away. We found him hiding in the attic.

I felt guilty suggesting he go back; besides, he was about to turn thirteen and should have a voice as to where he lived. His being home was our way of making amends. He was helpful with his brothers. He made sure they had dinner, and he helped prepare them for school and made sure they completed their homework.

But as always, when things were going well, life threw a monkey wrench in the middle. I received a call from my mother. She had been sick, and she told me I had to take De'Von for a little while. I wasn't happy that she was sick, but I was excited for all the boys to be together. I was doing better, and I didn't want him to feel left out.

Shortly after her call, my mother found out she had stage IV cervical cancer with only six months to live. I didn't believe it. I thought the doctors had made a mistake. This hadn't been the first diagnosis. The night she'd gone to the hospital in pain, they'd told her she had a urinary tract infection. They'd prescribed antibiotics and told her to drink cranberry juice, so I figured they'd gotten it wrong again.

My mother had been my rock and losing her wasn't an option.

I began to think about everything I had put her through. She'd put her life on hold for me—her selfish-ass daughter—while she took care of my first two kids, I was out there being foolish. I was sorry for everything, for leaving her to do my job as a mother.

Her battle with cancer was difficult. The first time she received chemotherapy and radiation treatment, her kidneys shut down because she had a bad reaction to the medicine. This meant she would need dialysis to keep her alive. She was scheduled to go twice a week but only made one visit. We were told if she didn't get dialysis, she would succumb to the disease.

One day, I was helping her get ready, and she looked at me and said, "Loriann, I am tired, and I'm in pain. I'm not going."

"But Ma ..."

Tears gathered in her eyes. "I know what happens. It's my decision, and you will be fine. I love you, and I'm proud of the woman you've become. Do not let those kids drive you crazy. If it gets to be too much, send them to their fathers. Find your happiness; you deserve it."

My mother tried to fight but just didn't have the strength.

On Mother's Day, May 10, 1997, Coralee lost her battle with cancer. That night, her body shut down for the last time. Ronnie Jr. and I watched her until she took her last breath. I regret having Ronnie Jr. there with me, but I couldn't do it alone. I needed his support because there was no one else for me to call on. My son was an old soul, so mature. He handled it better than I did. I couldn't go back into the room once she passed, but Ronnie Jr. marched back into the room and said his goodbyes.

The matriarch of our family had left us. Now what were we going to do? My grandmother had passed a few years prior and my aunt a few years before her. I was all alone with nowhere to turn.

I was devastated and so were my sons. But my mother didn't leave this world before telling me how proud she was of me. She told me to forgive myself for the things I had done wrong and to not allow anyone to make me feel guilty for anything. She said she never

stopped loving me, even when I wasn't living up to her expectations. "Loriann, you are going to be fine," she'd said.

At the funeral, my boys and I wept uncontrollably for our loss. It was the worst day of our lives. She was all we had, but, now, *we* were all we had. Vinnie didn't make it to the funeral but came days later. I needed him in the worst way. We cried and laughed at the good times, and he told me he would never leave my side, which was just what I needed to hear when I needed to hear it. I believed, in my soul, he had my back. Despite what we had been through, I knew he wanted to take care of his family. He wanted us to be a flourishing family unit, but we had so much work to do. We both knew it wasn't going to be easy, but we wanted to give it our best shot.

My stepfather, who had been sick for a few years, passed the same year around Father's Day. I never got a chance to let him know I had forgiven him and thank him for filling in as my dad. I wished I could thank him for supporting my children. He treated them as if they were his grandchildren when he didn't have to. I have a forgiving spirit, and we all make mistakes. I don't know how he'd grown up, but I am sure his upbringing played a role in how he handled his relationship with my mother. I know, deep in his heart, he didn't want to cause her physical pain. He couldn't control his emotions. He loved her too much and probably felt no sense of control. I'm not making excuses but trying to make sense of it all. He had faults, but he was the only father I knew and, now, he was gone, too.

Like I had always done, I picked up the pieces. I didn't have much, but I had my family, my boys, and Vinnie. Maybe they were all I needed. But things were chaotic in our house. Ronnie Jr. and De'Von argued all the time. They all argued and fought constantly. One Christmas, I had decided we would have a real tree. We had been using fake trees every year. Christmas was a big deal for us, and I always tried to make it special for the boys. We didn't always have much, but I made sure they enjoyed it. We put a lot of love into the tree. It was decorated nicely with ornaments, candy canes, tinsel,

and lights. It was beautiful. It took us all night to get it right, but it was the best one we'd had.

I had just come home from work and was tired. I figured I would lie down and get up later to fix dinner. As I walked up the stairs, I heard a big commotion. I thought, *Here we go*. I figured the boys were playing and running around acting crazy. With a house full of boys, it was normal. I opened the door, and to my surprise, De'Von and Tre' had knocked down the tree, and they were fighting underneath it. I was so damn mad! I grabbed the tree and threw it down the stairs. That was the last Christmas tree we had. Not another tree went up while they were living with me.

Another time, I came home to complete turmoil. Ronnie Jr. had gotten angry with the other boys because he had a girl over and they kept bothering him and picking at him because they had a crush on the girl he was seeing. Ronnie Jr. got so angry that he started fighting them and smashed all my televisions and put holes in my walls.

If the boys weren't fighting, it was Vinnie and me, and if not us, it was Vinnie and one of his friends. He and his friend Lawrence were hanging out at the house one day, and the next thing I knew, they were fighting. It became a biting match as if they were dogs. Another time, Vinnie put his friend through my wall. Those boys kept me on my toes.

I never tried to negate the fact that my boys learned their behavior, just like I had learned from watching the years of abuse my mother endured. Violence begets violence. Like my parents had fucked me up, so had Vinnie and I with our children.

Vinnie was strict and hard on all the boys. In hindsight, he was downright abusive. But I was too busy getting my needs met to give a damn. There was always tension in the house between the boys and Vinnie. Vinnie was constantly yelling at them about something, contributing heavily to our toxic and chaotic household. One night, they had a big confrontation over pepperoni pizza. Vinnie had suddenly decided that his family shouldn't eat pork. However, I allowed the boys to eat it, so I ordered some pizzas for dinner. When

Vinnie realized the pizzas had pork, he threw them on the floor and yelled at me because he had told me not to give his boys pork, and I had disobeyed his wishes.

My boys loved to eat, so they got angry. Ronnie Jr. and De'Von picked those pizzas up and ate them liked nothing had happened, and they argued with Vinnie about it. He told his sons they better not eat them, but they waited until he left the room and ate like it was The Last Supper.

De'Von eventually wanted to move with his aunt, uncle, and cousins in Albany. He was used to a more peaceful household. I didn't want De'Von to leave, but I knew it was a better opportunity for him. I wish all the boys had an opportunity like that. Maybe things would've turned out differently for them. De'Von left and later graduated high school with top honors. He went on to attend Iona College.

On March 7, 1998, Vinnie asked me to marry him. We had gotten to a good place in our relationship. The abuse had paused, and he was ashamed and disappointed in himself, showing remorse for how he'd treated me in the past. "How could I have hurt you? I love you," he said.

Shit had been going well, and I forgave him for past mistakes. I was happy. The ring was beautiful, and it was huge. He had been right by my side day and night like he'd promised. We went on trips, had date nights, and we seemed to be as close as ever. I was ready to be his wife.

But not so fast …

Days after De'Von left, Vinnie came to me in tears. Confused, I asked him what was wrong.

"I have something to tell you, and it isn't going to be good," he said.

I felt a lump in my throat. I braced myself. Angry, I asked, "What is it?"

"I'm sorry, Lori. I've been living a lie. But I couldn't marry you

before telling you the truth." He told me he had twins, a boy and a girl, and they were two years old.

His kids were Down South, and that was a good thing for me. I wouldn't have been able to handle seeing them. First, my mother had passed then my stepfather, De'Von had left and, now, I was losing Vinnie. How much pain did God have in store for me? At first, I thought it was a bad joke. I begged him to tell me it was a lie. I had him call the mother, and she confirmed everything.

I needed for him to leave so I could clear my head. But I couldn't think and, once again, I didn't have anyone to turn to. I was mad at him, but I couldn't fathom another loss. I had way too much going on. But I knew that, under no circumstances, would we be married. He knew it, too.

I was hurting and needed someone. Vinnie stayed, but our relationship was different. I pulled away, and he began drinking and drugging more frequently. He started smoking angel dust, probably to cover up the pain he had caused himself and others around him. I didn't care why. I was uninterested in him, and he wasn't interested in me. We shared the same bed, but that was it. Here and there, I'd let him touch me when I wasn't disgusted by him. That didn't last long because I went into his phone one day and heard a message from another girl. Had the situation been different, I probably would have flipped the fuck out. But I didn't care. He was only at my house because I didn't want to be alone. Besides, I had my eye on someone else.

I confronted him about the girl only because I wanted him to know I knew. He gave me a strange look when I laughed about it. I told him I was okay with us seeing other people, and he smiled in disbelief.

I was dead-ass serious, and a guy at work became my lover. Gregory was fun. He was my escape from my pathetic life. He was tall, brown-skinned, and sexy. And he always smelled good. When Vinnie was out with his other girls, thinking I was at home twiddling my thumbs, I was out with Gregory. He kept my mind

occupied, and he looked forward to my company. The more time we spent together, the closer we became. I was ready to leave Vinnie for good. I was finding my happiness. But there's always some shit added to the game.

It was Vinnie's birthday, October 27, and he wanted to attend a party at the Palladium because someone was performing. He begged me to go with him, but I had no plans to go with him anywhere. I didn't care about him or his damn birthday. I told him to go and enjoy himself. He asked me to please stay home. He said he had a feeling I was seeing someone, and he wanted to work on us. I promised I would stay home and be there when he came back.

My plan was to stay home. I didn't want any problems. However, Gregory called and told me he wanted to see me. Against my better judgement, I went to his house and told him I could only stay for a few hours, and I needed to get back home with the boys.

We had fun. We danced, drank, played chess, and had a good time. The sex was so good that I fell asleep. When I woke up, my phone had thirty missed calls. I knew this wasn't going to end well.

I arrived home in time to take Tylin to school. When I pulled up, Tylin was waiting outside for me. But, to my dismay, Vinnie was also waiting in his car.

He got out of the car. "Bitch, I'm going to kill you!" he yelled. I believed him. He was foaming at the mouth and his veins were protruding from his neck and forehead. His eyes were dilated, and I was terrified.

When he got back into his car, I told Tylin to get into my car. Vinnie rammed his car into mine. I put the car in reverse and attempted to get away, but I never could drive in reverse. Vinnie caught up to me and continued to slam his car into mine. The air bags deployed.

We lived on a steep hill. Peekskill is hilly and mountainous. Walls were placed in certain areas to keep water from running into the streets from dangerous downpours of rain. On the passenger side of my car was a stone wall and on the driver's side was a cliff. It was

a wooded area, and the developers hadn't quite finished what they'd started when they built the homes on our road. Vinnie would either cause me to drive off the cliff or into the wall. To get away, I had to make a split-second decision. "Tylin, get out of the car!" I yelled.

Tylin jumped out of the car, and my life flashed before my eyes.

The wall was so close that I knew it was only a matter of seconds before the car would collide with the wall as Vinnie continued on his rampage. Tylin would be pinned upon impact.

Vinnie slammed into my car, and I screamed for my son.

I didn't see Tylin.

Vinnie jumped out of his car and ran toward Tylin and me. My heart felt like it was about to come out of my chest, and sweat soaked my body. I thought I was about to pass out. My knees were wobbly, and I gasped for air. I wasn't worried about my fate. I didn't care if Vinnie was coming after me. My concern was for my son.

I glanced at Vinnie, and I could see that he no longer cared about me or his anger. Our objectives had changed. We needed to see and hear Tylin. I screamed when I noticed Vinnie's stiff body as he stood frozen in shock. I was convinced that my son was dead. The proximity of the wall to where Tylin had exited would've made it impossible for him to squeeze his little body between the space. I had been so shaken by the air bags' deployment that I hadn't realized he barely had room to open the car door and jump out.

Tylin finally screamed, "Mommy!"

"Tylin!" I screeched.

He came running into my arms. I grabbed him and lifted him off the ground. God had heard my prayer. I had asked God to protect him, and He did. It was a miracle. Tylin had escaped injury and possibly death.

Vinnie jumped back into his car and pulled off so fast, I could hear his tires squealing against the pavement. A crowd had gathered. He knew it would be a short time before the police arrived.

The police came, but they were unable to find Vinnie. I told them what happened, and they just shrugged me off. They said since

both cars were in our names and nobody was hurt, there wasn't much they could do. The police were tired of dealing with our back and forth bullshit, and they no longer gave a damn. "He's gonna wind up killing you, and there won't be anything we can do. By the time we get to you, it'll be too late," one of the officers warned. They were fed up with the Lori and Vinnie saga.

Days went by, and I hadn't heard from or seen Vinnie. I was afraid to leave the house and afraid to stay at home. But sure enough, he eventually appeared.

On October 31, the boys were putting their costumes on and getting ready to head out for trick or treating. There was also a Halloween party at the youth bureau. Vinnie had called earlier, saying he wanted nothing to do with me but needed to come by and pick up his belongings. I told him he couldn't, but he wouldn't take no for an answer.

While the boys were still getting themselves ready, Vinnie arrived. I told him he needed to leave before the boys left. He just looked at me and started packing his things. I tried my best to avoid him. I left my bedroom.

He was just about finished, and the boys were about to leave. His things were in the car, and he came back to give me the keys.

He said, "I want to talk to you. I promise all I want to do is talk. We can talk outside in the car if that will make you feel more comfortable."

"Not in the car, but give me the key to the house, and I'll go outside with you."

He handed over the key. I put it away and we walked outside. Some of the neighbors were out, and kids were going from house to house.

"Lori," he said, "We don't need everybody in our business. Sit in the car."

He sat in the passenger seat and I went to the driver's side. That way, he wouldn't be able to take me anywhere. The conversation started off calm, but before I knew it, he was choking me. I couldn't

breathe. I attempted to kick the gear shift but to no avail. I couldn't scream because I needed to save all my breath. He was enraged and told me if I didn't do as he said, he was going to kill me. I believed him. I believed every word.

He forced me out of the car and back into the house. He couldn't control his rage. He grabbed a razor and sliced my leg. "Do you know I will kill you if you try to leave me?"

I did know. I had always known.

"I want you to take me to the nigga's house that you been sleeping with."

I told him I had to go to the bathroom before we left.

"Well, I'm going with you."

I went and sat on the toilet, and the phone rang. "I need to get that. It may be the boys," I said.

"No, I got it."

As soon as he left the bathroom, I found a pen and a gum wrapper. I wrote on the wrapper for someone to help me and call the police. I shoved it into my pocket and left the bathroom.

Vinnie told me to get the phone. It was Ronnie Jr. "You better not let him know anything," he whispered.

Ronnie Jr. had only called to check on me, and I told him I was fine. I didn't want him to come home because I was afraid of what could happen. He wasn't Vinnie's biggest fan, and he always felt he needed to protect me.

Before Vinnie and I could get back to the car, De'Von came up the stairs, home to visit his family. I was able to whisper to De'Von to give the gum wrapper to Melissa, our neighbor, and made him promise not to look at it.

Vinnie shoved me into the car, and he forced me to drive. I asked where we were going, and he instructed me to go to Bohlman Towers, the projects. I wasn't sure why, but I did what I was told. We pulled up across the street from the projects, opposite the park. Vinnie called someone and told them he was there. I canvased the area, looking up and down the street. I spotted a police officer parked

on the corner. I thought about driving the car into the officer's car. I attempted to flash the lights to get his attention, but Vinnie knew what I was thinking and told me I'd better not.

A guy hopped out of his car, and Vinnie grabbed the keys to his car and jumped out. I was scared, playing out multiple scenarios in my head. Each one ended with my demise. I wanted to run, but the officer had already pulled off. I couldn't rely on anyone to come to my rescue. I knew things were about to get worse. I figured I was about to die, and I hadn't told my boys how much I loved them.

I thought about how my boys would handle my untimely death. I had been beaten to a pulp before, and I had been afraid, but this was different. Vinnie had never choked me before nor had he cut me. He had raised the bar, and he didn't care about the consequences. He was prepared to go to jail and make good on his promise.

"If I can't have you, no one else will." I could hear those words vividly as though he were saying them to me.

Damn, why hadn't I left him a long time ago? I'd had many opportunities, but I kept letting him come back. I knew he was dangerous, and I knew he wouldn't change his ways. My back was against the wall. There was nowhere for me to run and nowhere to hide. I had brought this all on myself. It was all my fault, and I knew it. People had warned me and told me not to have anything to do with him, to get out while I still had a chance. My mother had said I wasn't going to be satisfied until he put me into the ground.

I suddenly decided that I wouldn't allow him to take me from my children. I was all they had. I reflected on my life. I was strong and determined. I had worked too hard to change the trajectory of my life. No, I wasn't doing anything amazing, but I was trying. Had it been a few years prior, I wouldn't have had the strength to fight, but I had it now. Besides, who the fuck was he to decide when my time on earth would end.

I became empowered, and I prayed like never before. "God, if you bring me out of this, I will never turn back." I let God know that I'd heard Him loud and clear, but I needed Him to intervene,

and I would do the rest. I had no idea what that meant, but I told God that I wasn't ready to die, to let me live.

Vinnie got back into the car and told me to drive to Depew Park. *Hell, no,* I thought. The park was dark, and it would be easy for him to kill me and leave my body there. Nope, that wasn't an option. I asked him why.

He said, "I want to talk."

"I'm not driving to the park. It's late, and I'm tired. We can talk here."

"Okay."

I couldn't believe he agreed. *Yes, God!*

"Since you don't want to go to the park, take me to that nigga's house you sleeping with," he said.

"What are you talking about?" I wasn't ready to spill my guts. I didn't want to make him angry.

"This isn't a game. It's either you or him."

Damn, those were my options. I didn't want to put Gregory at risk because this wasn't his fault.

Gregory wasn't from New York. He had relocated from Washington D.C., and when we'd gotten together, I promised him I would never put him into a bad situation with my baby daddy. He didn't have any family here, and he was a hard-working man who didn't bother a soul.

I knew, however, that Vinnie wasn't going to give in. "Oh, you must give a shit about this dude. Is he worth your life?"

He wanted to see the man I was involved with, the man with whom I'd stayed on his birthday. Nothing else mattered to him.

I drove slowly, trying to gather my thoughts and think of a plan. I had no plan. Vinnie motioned for me to pull over. He said, "I know you're stalling, but this is going down." I pulled the car over, and Vinnie rolled a blunt of angel dust. "Let's talk," he said.

He lit the blunt and asked if I wanted to get high. "After tonight, you're going to need it."

I didn't want to smoke. I wanted to go home. I wanted to see my sons and hug them.

He reached behind him a grabbed a beer. That wasn't a good sign. I knew people used drugs and alcohol to alter their state of mind, which he needed to do to complete his mission.

"Why, Diamond?" he asked, calling me a nickname he'd given me years ago.

What could I say that would have made a difference? So I started thinking that maybe his high would help diffuse the situation. It had subdued him in the past. I prayed it would have the same effect tonight. He was calm, and I figured I had a chance of getting away.

"Don't you know how much I love you?" he said.

"I love you, too." I said, trying to appeal to his softer side. That must have been the wrong answer.

His anger resurfaced. "Bitch, you don't love me! How could you lay with another man if you love me?"

I was not going to allow him to set me up again by answering his question and causing him to react negatively. I let him talk and didn't say another word.

He finished the blunt and beer and said, "Let's go."

"Where are we going?"

"I told you to take me to his house."

I knew somewhere better to take him and we had to get there fast. I started driving again and passed Gregory's house. He lived on Main Street. I drove further down Main Street to some newly built condominiums and townhomes. I didn't have a clue as to who lived there. I remembered dropping off one of the girls in my program there several weeks prior. Plus, Ronnie Jr. had been dating a girl who lived nearby. I was familiar with the area but didn't know my way around that well.

Vinnie was excited about meeting Gregory. He wanted to see him, to get a picture of the guy who was taking me from him. He needed to know what he looked like and why I was so interested in him.

"Now, tell me which house it is," he said.

I looked around at all the homes and saw one that was completely dark. It seemed like no one was home.

"Which one," he asked again.

I pointed to it, and he looked at me to see if I was telling the truth. I didn't bat an eye.

"Well," he said, "Let's sit here and wait for him to get home."

That wasn't part of my plan. I was hoping he'd say we would come back another time.

We waited for almost an hour. I was thankful that no one showed up. Finally, he said, "Let's go."

"Go where?"

"Where the fuck you think?"

The whole day was a nightmare. Now, he expected me to know what he was thinking. If I had that power, I wouldn't have been in this situation. I started the car and drove away, easing to the bottom of the hill, heading back down Main Street. I'm glad I hadn't gone to Gregory 's house. I'm convinced it would have been a disaster.

Vinnie instructed me to go home. I couldn't decipher whether this was a good thing or bad, but it was much better than being at the park or the unknown home we'd been staking out.

We arrived back at home. My neighbor, Melissa, and her children were outside. Vinnie ordered me not to look at them or speak.

Mellissa said, "Brandon was looking for you and wanted to come upstairs to see you." Brandon was her son. I didn't respond, pretending not to hear her.

When we got upstairs, Vinnie told me to go into the bedroom, and I followed his command. He started kissing on me and apologizing for his behavior. I cringed each time he touched me.

He grabbed me by the throat. "You'd rather some other guy touch you than me?" His grip grew stronger.

I begged him to stop, but he had other intentions. He insisted that we have sex. I didn't want sex. I wanted him to get the fuck away from me and leave me alone, but I knew that wasn't going to happen.

116

Vinnie, by far, was the best sexual partner I had ever encountered, but I didn't want it like this. The more I protested, the more enraged he became, seemingly turned on by my unwillingness to perform.

I heard footsteps coming up the stairs and a radio. We both knew it was the police.

He grabbed me tighter. "You called the police on me?"

"I've been with you. How could I?"

"Get rid of them."

I got up and walked toward the door.

I flung the door open and fell to the floor. It was over. The nightmare had come to an end. *Jesus, I thank You for Your grace and Your mercy.* I was free and wasn't going to turn back. Well, at least that's what I believed. Vinnie was hauled off to jail for the hundredth time.

My Truth

Losing my mother has been the hardest thing I have ever gone through in my life. I wish I could see her face and talk to her about the nuances of my life. I know she is still watching over me and the boys. So many times, I have called on her, and she worked it all out. She continues to be right by my side.

I am sorry for not allowing her an opportunity to live her own life. I gave her a responsibility she hadn't asked for. I pray she knew how much I admired her and wanted to make up for all my wrong doing. She taught me how to be independent and stand on my own two feet. I love her and miss her so much. She was my best friend, my rock, and since she's passed, life hasn't been the same, nor will it ever be.

Tylin and I have had many discussions about his traumatic experience. He tells me all the time, "Ma, I almost died!" We both know God was watching over him. It is almost inconceivable how he survived. I say that God spared his life to be the blessing he is to others. Tylin has a heart of gold. He loves children, and they love him. He brings light to them whenever he's around. He is and will always be the favorite uncle to his nieces and nephews. Thanks, Tylin, for being the light we all need after the darkness we encounter.

Vinnie had beat me so many times I've lost count, but this time was different. He was different. I was different. Before, when we fought, it was usually about him getting his way or shutting me up. This was about

more than that. We had raised the bar and evolved to another level of madness, a matter of life or death, with my life dangling in the wind.

Writing about the night Vinnie took me against my will makes me anxious. I am trying to hold back the tears. I had come close to death, and I don't take that lightly. I didn't think I would survive. I blame myself because I should have walked away sooner. Why did I put myself and my children in danger? Because I loved others more than I loved myself.

I encourage anyone who's in an abusive relationship to get out of it now. Walk away. As a matter of fact, run. I know what it's like, and I've been in those shoes. I can now be the shoulder to cry on and an echo to the little voice in your head you've been ignoring.

Love yourself enough to leave. You are worth it!

Darkness & Light

By Jarrin T. Mayes

Eyes don't lie
Dark pupils dilated
with a glazed craze
Staring into the abyss
His soul dark from
the scars of life
Anger rips through his body
A heart tormented
by loss and grief
A mind too strong to break
Filled with beautiful memories
of children, wife, and family
These are the scars
that make me stronger
Look into my eyes
What do you see?
Only the strong survive

Nannie Gladys Mayes

Roscoe Mayes

Cora Lee Mays

Lori Ann Mayes (Smith)

Lori Ann Mayes (Smith)

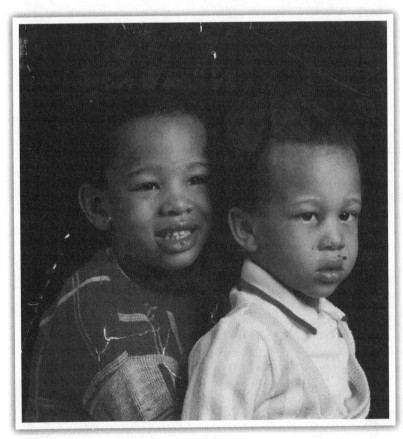

(L to R) Ronnie Jr. and De'Von

Tre'

Vinnie and Baby Tre'

(Clockwise) Vinnie, Tre', Justin, Ty

Justin

(Clockwise) Lori, Vinnie, Tre', Ty, Justin

Ronnie Jr.

Lori Ann Mayes (Smith)

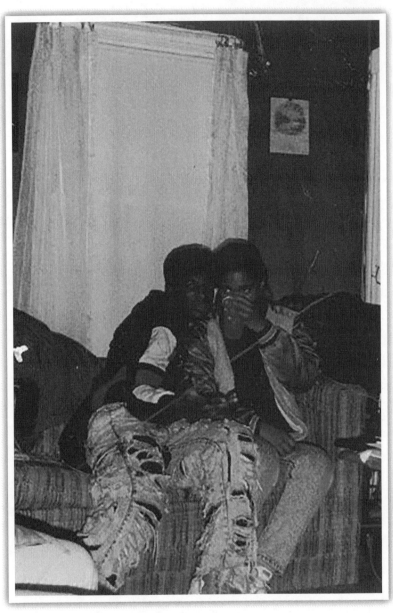

(L to R) Vinnie and Lori

Tre'

Ty

(Clockwise) Tre' and twin cousins

De'Von

De'Von (middle)

Ty

Vinnie

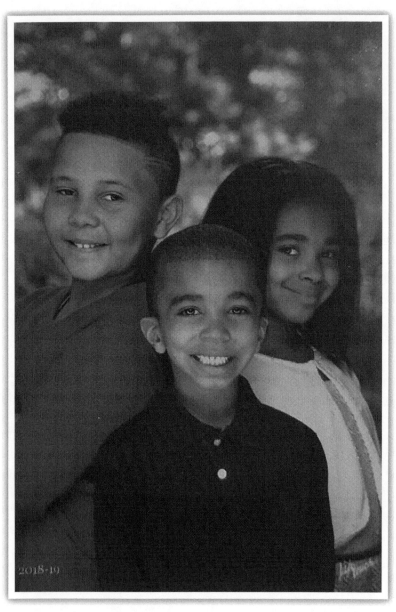

(L to R) Kylen (De'Von's son), James & J'Aliyah (Tre's children)

De'Von (Left)

Tre' Da Bus (fourth from left)

Stout Put Valley is ripe for play-off berth on '04

QB says no more excuses for third-year varsity program

PACK UP THE BUS, GUS – Put Valley is hoping that 230-pound Peekskill transfer FB Jarrin Mayes is a big hit on the grid this fall in front of RB Anthony Cortina.

News article featuring Tre'

DAD- A Sons first hero,
A Daughters first love!

Ronnie Jr. (top center) and children

(top to bottom) Masai and Nasir (Ronnie Jr.'s sons)

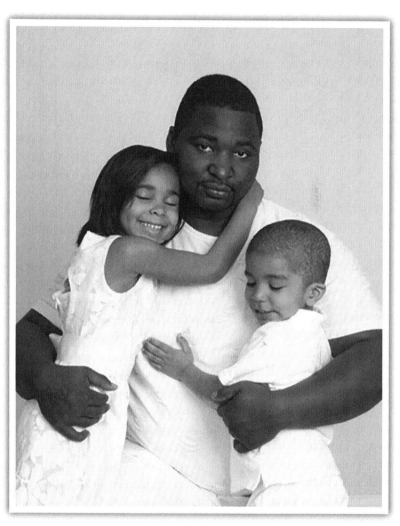

(L to R) J'Aliyah (Tre's daughter), Tre', James (Tre's son)

(clockwise) Marisa Mays, Tre', James, J'Aliyah

Lori and Shawn

Lori Ann Smith

Lori and De'Von

Lori and family

Shawn and Lori

Ronnie Jr. and Lori

(L to R) Emarie and Zaire (Ronnie Jr.'s son & daughter)

A'Maya (Tylin's daughter)

Megan and De'Von

Justin and Tre'

Jerry (Lori's brother)

SCARS

By Jarrin T. Mayes

Strength, survivor, struggles
Callous, confined, cold
Advantageous, alive, anger
Resentment, reconciliation, reality
Still, Standing, Strong!

CHAPTER
Eleven

I t was time to move again! Vinnie was released from jail and dating some girl from Yonkers, New York. I wasn't going back to him. I had moved on, too. During our last episode, I thought my life was going to end and I would never see my sons again. Dying wasn't the issue. I was more concerned about those five boys. Who was going to be there for them and nurture them if I wasn't around?

I was dating Gregory and feeling damn good about myself and life in general. Gregory was good for my soul. He made me laugh, and I enjoyed his company. We had fun together.

Things had settled down. Life consisted of work, home, and spending time with Gregory. The boys were doing well. But I always knew something was going to happen. There were patterns, cycles that had yet to be broken. But how could I break the cycle when I had no control of what would take place? Maybe I was always living in fear. What I put out into the universe, I would also receive. If I was living in fear, I was also manifesting it for myself. I tried not to worry about tomorrow, but there was always something going on in my life to worry about. Every time I thought I could take a deep breath, another traumatic event occurred. I had learned to expect the unexpected. What didn't kill me only made me stronger. It had been proven time and time again.

Ronnie Jr. and his best friend, Marc, had been having issues with

some of the guys in the neighborhood, stemming from a dispute Marc previously had. Ronnie Jr., like his father, was a fighter. The difference was that he never looked for trouble. He didn't get caught up at the parties or hanging out in the streets, and he refused to join any of the gangs. He was his own person. At an early age, he was the one who helped with his younger brothers. He didn't have time for all the nonsense. He was different, more of a leader than a follower.

One night, when Marc and Ronnie Jr. were on their way to the store, one of the guys from TLN (Thug Life Niggas), a local gang, shot at them. The bullet ricocheted and hit Marc on his right arm. Fortunately, he was fine and didn't need much medical attention.

Ronnie Jr. wasn't hurt physically but emotionally, it destroyed him. I tried to convince him to press charges. However, the code of the streets was "snitches end up in ditches," so nothing I said was going to make a difference. He was conflicted between what I was asking him to do and his honor. Whoever had come up with that saying about snitches didn't understand a mother's pain and her goal to protect her children at all costs.

I dragged Ronnie Jr.'s ass to the police station, but he refused to talk. He told them he didn't know who had shot at him. We all knew that was a lie. The officer brought out the passenger seat headrest and showed Ronnie Jr. the bullet hole. If Ronnie had not been leaning toward the window, he would've been shot in the head. Reality set in. He realized that, in a blink of an eye, his life could have been taken. This wasn't even his fight; he was only protecting his best friend. He sank into a deep depression for a year. He was lost and became introverted.

Ronnie Jr. had always been outgoing and the center of attention. In high school, he'd won the Mr. Peekskill High School Award. He was the captain of the football team, leader of Phenomenal Men, a program he'd organized at the youth bureau, and he was popular. But this event changed him for the worse. I couldn't get him off the couch. Every day, he would be in the same spot playing video games and drinking. It was like he was afraid to go outside or go to sleep.

He was worried about his family and afraid that those thugs were going to shoot up the house.

Vinnie had heard about what happened and came to the house to check on us. The night he showed up, Gregory was there. Although I wasn't seeing Vinnie anymore, I wasn't ready for them to meet. Vinnie was seeing someone, but his heart was still with me. I hadn't invited him to the house, and I wasn't going to let him in.

Gregory was in the living room playing a video game with the boys. He hung out with them regularly. He heard Vinnie at the door and told me to let him in.

"You don't know him, and I don't want any nonsense."

Gregory could see that I was terrified of the idea of Vinnie coming inside, but he was also growing angry. He figured I wasn't letting him in because I was still seeing him and didn't want the truth to come out. Men have a way of twisting things, and once they get those thoughts into their heads, it's hard to break away from them.

A few months later, we split up.

At first, it hurt, especially when I found out he was seeing someone else. It hurt more so because of the way he'd gone about it. He had me thinking he needed some time to himself, and I had fallen for it. Little did I know, he had moved the next chick in.

He was working at the hospital as a security guard. I called him at work and they paged him, but he wasn't picking up, so I decided to leave him a message on his home phone, which I had done many times in the past. When I called, a woman answered the phone.

I said, "Oh, I'm sorry. I must have dialed the wrong number."

"No problem," she said.

My dumb ass hung up and dialed the number again, making sure I had the correct number.

"Hello?" It was the same voice.

Oh, hell nah! "Hello? Is Gregory home?" I asked in a sweet tone.

"No, he's at work."

"Who am I speaking with?"

She said a name that I don't remember. I hung up and called Gregory, but homegirl had already called him before me. "Gregory, who is at your house?" I asked.

He told me she was his cousin. But he didn't know my girl was on the phone with his new girl while I was talking to him. He had told her not to talk to me because I was his deranged ex-girlfriend. He said that I had mental issues and had been stalking him.

He was trying to play me, but I wasn't going to go out like that. I didn't realize Ronnie Jr. had been listening to my conversation. People could probably hear me on the next block, cursing, screaming, and carrying on. I didn't give a shit. I threw on some clothes because I wanted to draw blood. I was going to let him know how crazy I was. My plan was to break every window in the house, pull that bitch outside (as if she had done something to me), and spit in his face. I was angry, and I was going to show him how an angry black woman reacts when she is disrespected.

When I was dressed and ready to head out the door, Ronnie Jr. looked at me and asked, "Where are you going?"

"I'm going to get that muthafucka!"

Ronnie calmly said, "No, you're not." He blocked the door.

"Move out of my way. I'm going."

"He isn't worth it. You going there for what? He still gonna be with her, and they'll probably lock your behind up."

My voice of reasoning wasn't with me. I had something to prove, but Ronnie Jr. refused to let me leave. He restrained me until I gave up. By the next morning, I was over it.

It took several months but, of course, Gregory called, begging and pleading for another chance just like I knew he would. When they've had a good woman and they mess up, they always come crawling back, partially because they can't move on to the next without making amends. It will never work out for the good.

The same thing happened with Vinnie. He called the boys all the time, conjuring up excuses to get me on the phone. I held a special place in my heart for him. Eventually, we became close again, not

close enough to live with me, but I let him come over to spend time with the boys, and sometimes, we'd have sex—damn good sex. He was the best lover I'd ever had. That was part of our problem.

Ronnie Jr. had looked out for me, but I was still concerned about him. He was still drinking and often told his brothers he was ready to end his life. His matted dreds were beginning to make him look like an unkempt Rastafarian, and he reeked of alcohol. I'd had enough. We were all concerned, and I knew he needed an intervention. I wondered why I had allowed it to go on for so long.

Ronnie Jr. was lying down when I went into the living room and, in my angry voice, told him to get his ass up. He looked up, confused, trying to gather his thoughts. I didn't care about what he was thinking.

"Ma," he said, "What did I do?"

"Nothing; that's what you did. You haven't been doing a damn thing but laying on this couch, feeling sorry for yourself. Enough is enough. Get your ass up and do something with your life. You're telling your brothers you're going to kill yourself. Well, I tell you this, you won't kill yourself here! You want to die? Well, do that shit somewhere else. I don't have time for this bullshit. You need to leave because I ain't having it anymore!"

I started walking away but quickly turned around. I wasn't finished with him. "By the way, if you plan to stay here, you better get a job and cut those nasty-looking dreadlocks out of your hair. You look like a damn smelly-ass fool."

He was in shock. He couldn't believe the way I was talking to him, but he knew I was serious. By the time I came home from work, he had cut his hair bald. I knew a change was about to come. A few days later, he found out he was having a baby.

Ronnie Jr. now had purpose. His daughter saved his life. He picked himself up and got a job and an apartment for his family.

On March 2, 2004, Emarie Ammon Davis was born, the apple of Ronnie Jr.'s eye. His daughter was his heart, and he would do everything in his power to make sure she was taken care of.

My Truth

Life has a way of turning things around. Gregory came into my life at a time when I needed him most. And Ronnie Jr. found out he was having a daughter, which gave him purpose and a reason to live and smile again. God may not give you what you want, but He is always there to give you what you need. He gives you things you don't even realize you need.

Gregory and I weren't designed to live happily ever after. He was the calm after the storm. Amen! He was for a season, and when the season was over, it was time for him to move forward. I am thankful for our time. But don't get me wrong, I was a season for him, too. If you were to ask him, he would tell you I saved his life—literally.

Gregory had taken ill and refused to seek medical attention for about a week. One night, instead of attending a class, something told me to go check on him. I got into my car and went straight to his house. He opened the door barely able to walk and quickly fell onto a chair, which wasn't too far from the door.

He said, "I don't feel well!"

I walked over to him and touched his forehead. It felt like I was touching fire.

I said, "Gregory, let's go!"

Angrily, he said, "I'm not going to the hospital!"

"Well, no problem, I'll call an ambulance."

Gregory got his ass up, and we went to the hospital. Within minutes, they were preparing him for surgery. His appendix had ruptured. His surgery lasted for hours, and the doctors were amazed at how he was still alive when he had so much poison throughout his body. I was told had I not brought him, he wouldn't have lived to see another day.

Gregory had been a blessing to me, and I had been a blessing to him. We remain friends and have a special bond. You may not know why God put certain people in your life, but know there is always a reason, and it's okay to let go at the end of the season.

CHAPTER

Twelve

onnie Jr. moved out at age twenty, and he was working and doing well. Things weren't crazy, but I can't say they were good, either. I was starting to have some difficulty with Tre'. He had taken a liking to the streets.

I thought he was running with the wrong crowd and being influenced. But Tre' wasn't a follower. He was born to be a leader. Whatever he put his mind to was going to happen. I don't like labels, but he was a street kid. He liked all the attributes of the nightlife. His father and I did him a disservice by allowing him to watch movies like *Menace to Society*, *Boyz N the Hood* and *South Central*, the shit we were watching at the time. The other boys watched, but he took a special interest, watching them repeatedly on VHS. He had a fascination, not understanding the messages in the stories but seeing the brotherhood, the love, and power.

I got a call from the assistant principal at his middle school requesting my appearance. He brought me into his office to let me know my son was hustling at school. I was embarrassed, concerned, and angry all at once. The assistant principal wanted a reaction from me. He was trying to read me, to see what type of parent I was. I started going off immediately in my head. I wanted to kill that little muthafucka.

"Where is he?" I asked. "You need to bring him into the office."

The assistant principal said, "Before we do that, Ms. Mayes, I have to let you know that he is selling jewelry."

Are you kidding me? I thought. Not that selling jewelry was a good thing, but I'd thought he was dealing drugs. "What jewelry?"

"We think it's a front for drugs. We haven't caught him, but we believe it to be the case."

"So you're accusing him, but you don't have the proof? Bring him to the office, and we'll get to the bottom of this."

I loved my kids dearly, but I didn't tolerate nonsense. I'd always told them, "If you tell me the truth, I've got your back, and there isn't anything we can't handle. Don't lie to me and make me look like a fool." I hated being embarrassed and didn't take it very well.

Tre' was the most kindhearted person you'd ever want to meet. He was handsome, dark-skinned like his father and had a smile that made my heart melt. But some people had a distorted view of him due to his size and skin color. His brothers' complexions ranged from very light to light brown. I was always curious about whether he was affected by it.

He was a big kid, built like a football player. As a matter of fact, he was featured in many newspaper articles for his gifted performances as a football star. They nicknamed him "The Bus." We thought he would eventually become a professional player. He had the talent. His father and I lived to see him play and watch the fans go crazy.

His look was deceptive. People assumed this big, dark-skinned guy was hardcore and mean. When he wanted to portray that persona, he could be, but underneath the street façade was a loving, caring young man. If anyone was around him and needed something, he made sure they had it.

Tre' could tell a story. He enjoyed seeing how far he could go before someone realized he was lying. Knowing this, I had to pick my words carefully when he came to the office.

I stared at him as he entered. That would let me know if he was going to be on the honor system or throw out some bullshit. I knew

he would never throw himself under the bus. I always told the boys, "If you're going to do something, do it by your damn self because people don't tell on themselves."

I could immediately tell he was nervous by his laugh and facial expression. The assistant principal began speaking, but I interrupted. "What the hell is going on with you?" I commanded.

This wasn't a time to play nice. This was an opportunity to find out what the hell was going on with him. I didn't have time to beat around the bush. I wanted to know if he was selling jewelry or drugs. I didn't expect to hear all the details because he damn sure wasn't going to make me look or feel bad. He knew he better not say too much if he was slinging drugs, not in front of this man, who could have his ass hauled off to jail. Both of us knew better than that.

He admitted to selling jewelry and came up with some bogus shit like he didn't know he couldn't sell jewelry at school. He thought it was harmless. I don't think the principal bought it, but he pretended like he did. I knew damn well Tre' knew better than that, but I was going to ride this one out with him.

He wouldn't have admitted to selling drugs, anyhow. He wasn't that big of a fool. I knew that and so did the principal. This meeting was designed to let him know we were on to him and watching him. By the time we were done, he said it wouldn't happen again and he was sorry.

When we got home, I chewed his ass out. "Got me down at some fucking school, looking like a damn naïve parent!" He knew it was coming. The last thing I wanted was to sit in some office to hear what my children were doing wrong. They needed to go to school and act like they had some home training and common sense.

All my boys were smart. When they wanted to do the work, they were honor roll students. None of them struggled like many kids do. They made good grades, but sometimes, they made poor decisions like talking back to the teacher or being disruptive in class.

Usually, when I was summoned to the school, it was because one of them had a fight. I'd taught them not to start fights, but

they had better defend themselves. The good and bad thing was that there were five of them, and they defended each other. They'd had several fights with other kids in the neighborhood because they wouldn't take any shit from anybody. They'd had enough practice from fighting each other all the time.

Ronnie Jr. started hustling to help his family. As the oldest, he hated seeing me unable to make ends meet. Hustling kept him from being home and gave him a sense of purpose.

Tre's escape was the streets. He wanted what both De'Von and Ronnie Jr. had: freedom from the house and to make money and be in control (because, obviously, there was no control at home). Justin always maintained and adapted to life. He was the observer, and he didn't express his feelings about the daily activities in the house. I knew he had thoughts, but he never tilted the scale. He got up every morning, went to school, and got through his day. His defense was toughness. He never let anyone see him sweat. I always felt he was angry with me for the life I'd given them. Why had I allowed everything to take place? I was the parent; why hadn't I fixed it? He was too young to understand that this life was way more than I had bargained for. We didn't speak much until he was older, but I could always read his eyes. I knew when he was sad and when he was disappointed in me. I'd seen that look repeatedly. I'd search his eyes whenever we were facing difficulties, and they told the story.

Ty, the baby of the bunch, just followed along. He watched how everybody else handled things. The years of discourse made him angry, and the anger eventually turned to rage, which turned to violence. He was such an emotional rollercoaster. Many nights, he cried about everything in his life. He never felt the love from his dad, so I tried to shower him with love. Of course, I couldn't fill the void of having a dad. It wasn't the love he needed or desired. I only made my relationship with my son more problematic. I spoiled him rotten, and my other sons gave him hell for it. He disliked being the baby because his brothers picked on him and teased him about it.

He spent much of his time proving to them he wasn't a baby. But once he started fighting, he wouldn't stop. He didn't care how big his opponent was. He was strong willed and opinionated, never letting anyone disrespect him or make him out to be stupid.

My Truth

I was fucked up, so I fucked up other people while trying to stop them from fucking up more undeserving people. I blame myself for not being a better parent and putting my kids through the bullshit. I wish I would've had the know-how to break the cycle of chaos. But I didn't know better, so I couldn't do better. I thought love was enough. I thought if I let my children know how much I loved them, the rest would fall into place. But it doesn't work like that. I am a prime example of what not to do. There was a point in my life when I didn't care if the sun never came up. What for, another day of stress, frustration, and aggravation? I wish I had read a book to let me know what not to do. The title would've been, Sit Your Fast Ass Down and You Just Might Learn Something.

This is as real and raw as it gets. I will never try to claim that my shit was together. Hell nah! My whole damn family needed therapy. I can't speak for the rest of them, but I probably still need it today.

Let the church say Amen!

Thirteen

t was time to move again! Tre' was running the streets, and I
was ready to make some changes. It was finally time for me to
leave Peekskill to get the boys away from the negativity.

De'Von had moved back with us for a while but was now on his
way off to college, so the three boys and I moved to a town not too
far from Peekskill, about fifteen minutes away, for a fresh start. They
enrolled into Putnam Valley School District and were doing well.
Tre' was a star on the football team, and Justin and Tylin excelled on
the basketball team. Vinnie visited regularly, but he lived in Yonkers.

Tre' remained friends with some of the guys in Peekskill, and
they visited often. I was used to having my boys' friends over. I
preferred them to stay at my house so I could keep an eye on them.
I sensed there was something going on. I wasn't too sure but had
my suspicions. Tre' would have large amounts of money and would
sometimes come home driving a car. I questioned his behavior, and
he always had a story. Most of the time, the stories made sense. I
suspected he was selling drugs and searched his room for clues but
came up with nothing. It was easier getting the truth when he was
younger, but as a teenager, he kept me one step behind him.

Tre' looked out for his brothers. He made sure there was food
in the house, and we always had gifts for our birthdays and special
occasions. As much as I didn't want to believe it, I knew he was

hustling. He wasn't working, so there weren't any other options. Where else could the money be coming from?

He kept a few of his friends from Peekskill with him, but he had a whole new group of friends. I didn't like what was going on. I spent countless nights talking to him, trying to figure out what he was up to. But as the saying goes, what you do in the dark eventually comes to light. I was about to get the shock of my life.

I woke up Saturday morning and did a walk-through of the house, something I did regularly, checking to see if the boys were home and who else was in the house. Tre' had two of his friends in the room; they had spent the night, which wasn't out of the ordinary. Justin and Ty were in their rooms knocked out. They had probably stayed up all night playing video games. I had heard them a few times arguing throughout the night.

I decided to make breakfast. No matter how tired they were, when I cooked, they woke up to eat and sometimes fell back asleep. After breakfast, Tre' and his friends got dressed. He said they had plans for the day, and he would see me later. Tre' knew I didn't mind him having company, but they couldn't linger all day. When I was off from work, I wanted my house clear of people who didn't belong.

Justin, Ty, and I were watching television when, suddenly, Tre's friend Jeremy came running through the door dripping with sweat. He said, "Ma, please pretend like I've been here." He ran into Tre's room, changed his clothes, and jumped into the bed.

An officer soon followed, walking through the door looking for Jeremy. I was scared and confused. His gun was drawn. "Who is in the house?" he asked.

"Just me and my sons," I replied

He walked through the house and said he was looking for a black boy wearing a gray hoodie, white sneakers, and blue jeans. He grabbed all the boys and brought them into the living room, and he singled out Justin. "You fit the description."

"You're wrong because he hasn't left my sight," I quickly explained.

He looked at Ty, but he said, "It isn't you. The person I'm looking for is heavier."

Next was Jeremy.

"Why are you looking nervous? Were you outside?"

"I'm nervous because the police just came into the house with a loaded gun," he said.

The officer couldn't identify Jeremy because he had changed clothes. His radio went off. "We have him," the other officer on the radio announced.

"Sorry to bother you," the armed officer said and left.

Jeremy explained that they had gone to Peekskill, and one of their friends told them to take a ride with him. It already sounded like a lie. He went on to say they were arguing with a guy over the phone who owed them money, and when they got around the corner from my house to drop Tre' off, the cops surrounded the car, and they ran.

Bullshit, bullshit, bullshit! "Where is Tre' and Will?" I asked.

"I don't know; we all went our separate ways."

Hours passed, and I hadn't heard a word. I called Vinnie to let him know we had a problem. I had no idea where Tre' was and relayed the story Jeremy had told me. Vinnie made it to my house in record time. But by the time he arrived, I had received a call from Tre'. He was in the custody of the state troopers.

Vinnie, his sister, Selena, the boys, and I headed to where Tre' was being held. Of course, the officers wouldn't give us any information. We waited for hours. They said they didn't have to tell us anything because Tre' was considered an adult. He was sixteen and being charged for a crime. They didn't feel the need to tell us what crime. We could hear Tre' yelling, "You're hurting me!" and screaming my name.

Vinnie became impatient. He banged on the window and argued with the officers. I didn't know he had a plan, and the plan was in motion. Finally, the officers came and put handcuffs on Vinnie,

arresting him for disorderly conduct. He'd purposely gotten arrested so he could talk to Tre'.

Vinnie was released and given an appearance ticket, and he told me the real story. They were in a stolen car, and a gun was recovered. The part about them arguing with a guy was true, but it was over drug money, and the guy thought they were coming after him, so he'd called 9-1-1.

Tre' was arraigned, and his bail was high. We needed time to gather the money, and I had to hire a bail bondsman. He was released a few weeks later. I was a nervous wreck. I had never been to jail and couldn't comprehend what it was like. Tre' found a lawyer that one of his thug friends had used for his case. I hired him, and Tre' was eventually sentenced as a youth offender with six months incarceration and three years of probation. He would've gotten off, but he'd refused to snitch on his friend who had the gun and had taken the stolen car from a crackhead.

He took the street code of honor to heart. He'd rather do the time than snitch. To me, it was foolish, but that's what he stood for.

My Truth

I feel like I let my sons down by exposing them to a life of violence and instability. They always tell me, "Ma, you did the best you could!"

But did I?

They didn't ask to come into this world. They're here because of the choices I made. It was my responsibility to keep them safe and raise them with the best upbringing possible. I had failed them and myself. I have to call a spade a spade. I can't say for certain my sons wouldn't have landed in jail had I done a better job, but there is a strong possibility they wouldn't have.

One of the worst feelings in the world is for your son to wind up behind bars, and there is nothing you can do to protect him. To answer my own question, no, I don't feel I had done the best I could do.

I am much wiser now and have learned valuable lessons. I made attempts to give them a better life. When I saw them headed down the wrong path, I moved to try and keep them out of the streets, but all I had done was put a Band-Aid on the problem. I didn't fix the underlying issues we had going on in our home. I thought working and providing for them would be enough. All that did was give them more idle time to get into trouble.

Through all of it, we managed to have the strongest bonds a mother and her sons could ever have. I guess all wasn't lost!

LETTER FROM JUSTIN

Dear Ma,

I just want to say thank you for all you have done for me. Seeing you raise five boys as a single mother and going through hardship after hardship but never giving up spoke volumes.

Your strength and hard work have made me who I am. I have had many hardships throughout my life, but I was always able to overcome those circumstances with your help, love, and guidance. Whenever I needed something, you were there for me. You also enabled me to see the beauties of the world.

Your financial investment has allowed me to go to college, study abroad, live freely, and travel all over the world, which has provided me great knowledge and unforgettable experiences. If it weren't for that, who knows where I would be today.

Even today, as an adult, you continue to bless me with a place to stay and financial help while I find myself and follow my entrepreneurial dreams.

Without your love and help, my life would be much harder. So again, I just want to thank you for everything. I appreciate everything from the bottom of my heart.

You are a beautiful and loving mother, and your wounds have helped you to blossom into a wonderful and caring person, so keep blessing the world with your beauty!

You have done enough for your family, and it's time for you to be happy and live a stress-free and adventurous life. So follow your dreams, see the world, take risks, and live to the fullest.

Yours truly,
Justin Da'Quan Cohen (Just)

CHAPTER
Fourteen

With all that happened with Tre', I started letting Vinnie spend more time at the house. We were having casual sex and getting along well. I still refused to let him live with us but did agree to him spending more time with the boys. He blamed me for not being able to watch his kids grow up the way he had planned—together as a family. It was never my intent to keep him from his boys, but I had to have some control. I couldn't allow myself to ever be unsafe again. I decided when he could come and when it was time for him to go so I could feel secure. He also knew the boys were older and they weren't about to stand by and watch their mother be slapped around.

Tre' had been close to his father, but their relationship was beginning to change. Tre' was feeling himself. He was making money in the streets, and nobody could tell him he wasn't a man. His size only aided his ego.

Vinnie and Justin's relationship became much stronger. Before, his focus had been on Tre'. But Tre' was more into hanging with friends and being home as little as possible. So Vinnie spent more time talking with Justin about school, sports, and everything else.

For some strange reason, Vinnie never had a connection with Ty, maybe because, of all the boys, Ty was more like me. We are both Pisces, which means we're emotional beings, and we speak our

183

minds. Unfortunately, the strained relationship with his dad caused Ty some heartache. Knowing his father didn't have the same affection toward him was painful. I know firsthand. My biological father had a relationship with my brother, his child from his marriage, never with me. It made me feel like I wasn't good enough.

But Vinnie was always involved in their academic and sport activities. He never missed one of his boys' basketball and football games. He was always in the crowd rooting his children on. He was a proud dad, and he would light up while watching them. It was his way of living vicariously through them. He was athletic and had dreamed of playing professionally. There was no sport he couldn't play. He was talented. Had his anger issues not gotten the best of him and he had finished school, our paths would have been different.

Ronnie Jr. was on his second child; however, like many other young couples, he and his girlfriend were having problems. He drank a lot and buried himself in work. He was doing sixty-plus hours a week, leaving his girlfriend home to care for their children. Eventually, it took a toll on them. The stress began to be too much. One day, his girlfriend decided to pack up and move out with the kids. It crushed Ronnie Jr. He started drinking even more and became more depressed. He was hurting, feeling like he had failed his family. In his heart, he had done everything he could do for them, but now they were gone. He knew the mistakes he had made, but it was too late. The house was empty, and the love of his life had walked out the door.

Vinnie and I had our good days and bad days, which led to arguments. It had been four years since he had physically assaulted me and held me against my will, but I still resented him for everything he'd put me through. My love for him had changed. I wasn't in love with him anymore. That's what I kept telling myself. I didn't hate him. I just hated what we had become. He had good qualities, but his demons got the best of him sometimes. I was drawn to the other person inside of him, the loving father and caring boyfriend, his selflessness and intelligence, the hard worker, best friend, confidant,

and teacher. He had taught me how to drive and was patient with me. He catered to my every need. He cooked, ran my bath water, gave me massages, and made me laugh at random, silly things. He had my back when everybody else had turned their backs. He encouraged me to do more. He protected me from danger. He would walk for miles to make sure I was okay. He dried my tears and told me, "We got this."

That was the person I loved and had always loved.

My Truth

Reflection has a funny way of making you face your reality. Vinnie and I had a toxic relationship, but he was consistent in my life. He had flaws, and so did I. Our families hated our relationship but knew there wasn't much they could do about it. We weren't good for each other, but something kept bringing us together. We would be enemies one day and lovers the next. It was crazy. How could I love someone who caused me so much pain? I ask myself that question all the time, and I am still seeking the answer. Vinnie was the person I loved and had always loved.

Vinnie loved his sons and saw himself as my other sons' step-father. He would come to their rescue if needed and gave them the attention he gave his own sons. Whenever any of the boys were giving me a hard time, Vinnie would be there to put them in check. He was supportive with them and attended functions they were involved in. But love/hate relationships take a toll on the entire family.

CHAPTER
Fifteen

July 3, 2006 was Tre's seventeenth birthday. It was a nice day, and I decided to have a cookout for him. Vinnie and I had gotten into a heated argument about something stupid; however, it was his son's birthday, and he wanted to be a part of the plans. He called me early that morning asking if he could come to the house. I wasn't in the mood to have him around because we had argued the night before, but Vinnie never missed a birthday for his boys or me. Against my better judgement, I agreed to let him come.

He didn't have a ride, so I called Ronnie Jr., who was planning to come over, and asked him to pick Vinnie up on his way from work.

I had already started preparing macaroni salad, macaroni and cheese, corn on the cob, hamburgers, hot dogs, and collard greens. Tre's friends picked him up, and he told me he would be right back.

Ronnie Jr. and Vinnie arrived with a case of beer and immediately started drinking. We got the grill started, and the party was underway. The beers kept coming one after the other. The guys played video games. A few of Tre's friends came and went. Overall, the mood was peaceful.

The calm before the storm.

I had been watching Vinnie, and he looked a little preoccupied, like he had a lot on his mind. I knew he had been released from jail a few weeks prior for breaking his girlfriend's arm, but he looked

troubled. I'd seen him sitting outside by himself smoking a cigarette. I could tell something was bothering him.

He came into the kitchen and kissed me on my cheek. "I know you're still in love with me," he said.

I looked at him with disgust. "No, I'm not. Get away from me." I gave him a little smirk. I would regret not telling him that, despite everything that had happened during our eighteen-year relationship, I loved him more than he would ever know.

Vinnie tried to change his mood and suggested we play spades. We played spades at every gathering and event. It was a ritual in our house. Usually, Vinnie and I would be teammates against the boys. We had mastered a cheat system. If he or I said we were going to Tipton's, which was a club I used to go to, that was a signal to play clubs. If he said, "What's your name?" referring to his nickname for me, I knew to play diamonds.

We grabbed our partners, and it was time for the rules. Vinnie stated what he thought should be the rules, and Ronnie Jr. stated his. And of course, they started arguing about the damn rules.

They were both letting out frustration. It had nothing to do with the game. These were two men who were angry about the direction their lives had taken. Both men had lost the people they cared most about. Both were separated from their families and feeling inadequate, lost, and abandoned. They were more alike than different. They shared the same demons (alcohol addiction), and they were both intelligent, but, most of all, they both had anger issues.

The argument grew louder, and the words were beginning to cut deeper.

"That's why your family left you!" Vinnie yelled.

Ronnie Jr. struck back. "That's why your children don't love you and can't stand to be around you."

I'd had enough. I knew this wasn't going to end well. They had already started posturing for a physical fight. "This is Tre's birthday, and he has company!" I screamed.

When they wouldn't stop, I grabbed the house phone and told

them I was going to call the police. Vinnie insisted that I didn't. He had a warrant for not showing up to court from when he was purposely arrested when Tre' was locked up. "You can't call the police," he said.

I had already dialed 9-1-1. I hung up at his insistence—or so I thought.

Vinnie and Ronnie Jr. were in each other's face. Vinnie went into the bathroom, and as he came out, Ronnie Jr. was walking toward the door. Vinnie swung at Ronnie Jr., and they started tussling. I screamed for them to stop. I picked up the phone again and dialed 9-1-1, telling the dispatcher it was an emergency.

Vinnie picked up a screwdriver and jabbed Ronnie Jr. with it on his nose or wherever he could reach. Ronnie Jr. grabbed him and was able to subdue him.

Vinnie yelled for help, claiming he couldn't breathe as Ronnie Jr. choked him. He told Tre' to get Ronnie Jr. off him. Tre' tried to assist but couldn't separate them. He was embarrassed because his friends were there watching the violent episode unfold. "I'm out of here," he said to me.

The police seemed to be taking forever. I started pacing the room. I could hear the sirens, and I said to myself, *Finally, this will be over.*

Both Vinnie and Ronnie Jr. dropped from exhaustion. I watched my son fall to the floor and Vinnie fell to his knees sucking in deep breaths.

One of the boys let the state trooper inside. He immediately asked me what was going on. I tried to explain, but I was in panic mode. "Both are down. Who do you want me to work on?" he asked.

Of course, I said Ronnie Jr. The state trooper went over to Ronnie to check if he was still breathing. "He's still alive," he said.

Those words hit me hard. Until that point, I couldn't even fathom that it was that serious. The state trooper radioed for an ambulance and assistance. He went over to Vinnie and checked his pulse. A strange look crossed the officer's face, and he stepped away.

I called both Vinnie's sisters to let them know what happened. I felt bad for calling Selena because she was pregnant with her daughter, but I had to.

The ambulance arrived after what seemed like forever. By the time they got there, multiple police cars and News 12 were outside. We were told to leave the house because they were treating it as a crime scene.

What? A crime scene. Why?

I heard one of the EMTs say, "He is deceased."

Justin, Ty, and I stood outside, unaware of what was going on inside. I called Ronnie Jr.'s father and told him what had happened, instructing him to get to the hospital immediately. Confused, I asked the officers about both Vinnie and Ronnie Jr. I was told that one was coming out shortly.

Ronnie Jr. was wheeled out on a stretcher. I ran to him, but he looked at me strangely. I could tell he was upset with me, but I didn't know why. What had I done? He probably assumed I was upset with him because of the fight. Actually, I was upset with them both because it had gotten out of hand. This was supposed to be a celebration, not a hardcore wrestling match.

There was too much to focus on, so I figured I would deal with him later.

The EMTs removed Vinnie from the house and brought him onto the porch. They worked on him diligently.

I was relieved to see that neither Ronnie nor Vinnie were deceased like the EMT had claimed.

"How is he doing?" I asked the one closest to me.

"He has a slight pulse. We're going to rush him to the hospital."

The house was swarming with news crews and different people. A detective walked up to me and questioned the boys and me. "You can question me as much as you want, but you are not to ask my children anything," I said.

He apologized and took me to the side to further inquire about what had transpired. I didn't want to talk. I wanted to be at

the hospital. Vinnie's sisters arrived, and I told them to go to the hospital, which wasn't far from my house. Feeling alone, I called my godmother, Carolyn, to tell her what was happening.

Finally, the officers released us so we could go to the hospital. They informed us we couldn't return to the house while the investigation was being conducted. *What, I can't come back home?* I had no money and nowhere else to stay. I didn't have family I could stay with, but I did have Ronnie Jr.'s keys to his apartment, so we could stay there.

Tre' came back to the house. I told him things didn't look good, and they weren't allowing us to go back into the house. I asked him if he wanted to go with us to the hospital, but he didn't. He left again with his friends, thinking everything would be fine in the morning.

When we arrived at the hospital, Vinnie's sister Tempest was outside. I could tell by the look in her eyes something was horribly wrong. "Vinnie is gone," she said.

I didn't want to believe her. Vinnie's whole family was there. I had to go inside to see him. I walked past the family, but before I could get to Vinnie, I saw Ronnie Jr. He was in a hospital room with his father and stepmother. (Ronnie Sr. had married a few years prior.)

I asked Ronnie Jr. how he was doing, but he had an attitude, and he wouldn't look at me. My son wouldn't speak to me. He had suffered a broken nose and had multiple contusions. "I have your keys and your wallet," I said. "The boys and I are going to stay at your house because the police aren't allowing us back into the house."

Ronnie Jr. nodded with a cold stare. I figured he was upset with me for putting him in this situation. Had I left Vinnie a long time ago, we wouldn't have been going through this. Was this my fault? They hadn't been arguing because of me; they'd let their hot heads and feelings of inadequacies get to them. Both weren't living up to their potential, and that had nothing to do with me. At first, I was upset about Ronnie Jr. being angry with me. But the more I thought

about it, the more I realized I wasn't going to carry this burden. We had way too much to deal with. Now was not the place or the time.

Tempest and I walked to Vinnie's room. At first, he didn't look like he was dead. He looked like he was sleeping peacefully. But reality quickly sank in. I begged him to get up. I pleaded with him, and I told him how much I loved him. I wished I had told him when he'd asked me in the kitchen. I loved Vinnie through thick and thin. We'd had highs and lows, but we had been together for eighteen years. Despite everything, he had taught me so much. How could he leave me? We weren't done seeing the boys grow up. He still had to see them play sports and grow into men. I no longer had him to turn to when the road became difficult. Besides my boys, he was all I had. My mother, grandmother, aunt, stepfather, and cousins were all gone. I had no one.

My Truth

Who am I to judge?

It's so easy to judge others. People may wonder how I could love and be with a man who had beat me and disrespected me. But no one could understand without walking in my shoes. The people I choose to love, I love forever through life and death.

Vinnie was such a major part of my life, and my heart still aches for him. I wish I had an opportunity to talk to him and let him know I will never love another man like I loved him. I want to tell him how losing him has affected us in ways in which we find hard to describe. Never could we have imagined life without him. I see his mannerisms in our sons. He is never forgotten. I can't fight back my tears as I write. I am saddened things ended the way they did. It pains me that he didn't get a chance to see his grandchildren.

As a family, we are not the same. The loss is unbearable. My sons have difficulty expressing their pain, but I know it's bottled up inside. Ronnie Jr. started drinking even more because of it. It's way too much for him to handle, and he still struggles with it daily.

Truthfully, we all needed therapy, but it's still shunned in the black community. It's thought of as a sign of weakness. In hindsight, I should have encouraged my family to seek counseling. The pain hasn't subsided and never will.

I love you today, tomorrow, and always, Vinnie. Forever my love!

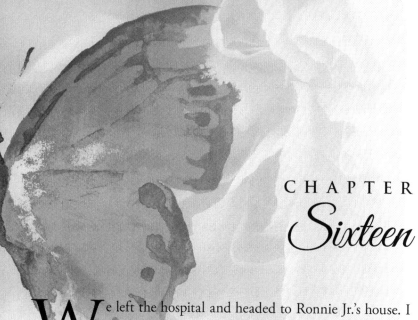

CHAPTER
Sixteen

We left the hospital and headed to Ronnie Jr.'s house. I still hadn't heard from Tre', and I was worried. I had to be the one to tell him about his dad.

Justin grabbed me and said, "Mommy, it's going to be all right." Coming from Justin, that was a big deal. He had always been the son who didn't show any emotions. For the first time in a long time, I could see his pain. But through his pain, he held strong for me.

Vinnie's family had already started rejecting me, but Justin said, "Who cares about them? We don't need them. We got each other."

I couldn't blame his family; they would have to bury their loved one. Vinnie didn't get along with most of his family, but blood was always thicker than water. There were things about me they didn't like. They felt I'd caused situations with him and had him locked up, which was partially true. I wasn't always the victim I portrayed, and I had made my share of mistakes.

As soon as we settled in at Ronnie Jr.'s house, the phone rang. It was his grandmother, Denise. She wanted to know what was going on. I explained that Ronnie Jr. was still at the hospital, and he wasn't being released.

Denise told me that Channel 12 News had run a story: "Son Kills Stepfather Over Spades Game." She was upset because Ronnie Jr. hadn't been charged with a crime. She told me that first thing in

the morning, she was going to have them retract the story, and she did. They did.

Weeks passed before we could get back into the house. The hospital had conducted an autopsy, and the family and I patiently awaited the results. In the meantime, detectives questioned me repeatedly. On the final day of questioning, I had to meet one of the detectives at my house and walk him through the story step-by-step. I didn't want to go back into the house, but I did. I told him the same thing I had told him the four or five times he had asked before.

"We have a copy of both nine-one-one calls. It seems the first call wasn't disconnected, and everything is like you said. But I still have two questions."

"Okay," I said, growing frustrated.

"First, why didn't Vinnie want you to call the police?"

"Because of a warrant."

The detective called the station and had the dispatcher research it. They found the warrant for his nonappearance. "The other thing puzzling me is that you had mentioned Vinnie picking up a screwdriver."

"I saw him with a screwdriver, and I believe it had a yellow and black handle."

"That's funny," he said, "we have searched this whole house and haven't come up with anything."

Now, I was worried that he didn't believe me.

He wanted me to show him where Vinnie was when I saw the screwdriver. I started questioning myself. Had I seen him with the screwdriver? My mind was beginning to play tricks on me, and I was confused. Doubting my recollection, I said to the detective in a condescending tone, "I picked up the phone and was walking from the kitchen toward the bedroom, and I saw Vinnie approximately right here," I pointed to the area, "with the screwdriver in his hands. I don't know if he had it when he went to the bathroom or what, but I know I saw it."

"Where, here?"

"Yes," I said again, "right here."

The detective and officers moved the mattresses in Tre's room where both Vinnie and Ronnie Jr. had collapsed, and there it was. It wasn't yellow and black but red and black, so I was wrong about the color. It had slid beneath the baseboard. They all chuckled, but nothing was funny to me.

Finding that screwdriver determined Ronnie Jr.'s freedom.

"Ms. Mayes, this was the last piece of the puzzle. This is what we needed to close this case," the detective said. "You can return to the house, but I may have to get in touch with you again if I have any other questions."

I couldn't live in that house. Too much had happened. We stayed at Ronnie Jr.'s one-bedroom apartment until I found a place. I found out during our stay that he had been dating his old girlfriend (not his children's mother), so he was never home. His apartment was huge. I took over his bedroom while Justin and Tylin slept in the living room. Tre' rarely stayed. He really hit the streets once he learned of his father's passing. He remained at the old house, having parties and doing whatever he wanted to do.

One night, the police were called because a fight had broken out. Tre' and his friends had some girls over, and they had been drinking and drugging. I wanted to respond, but I was tired. I was tired of the years of drama. All I could do was shake my head and cry. I started drinking to ease the pain, but the pain never went away. I questioned God's motives. It wouldn't be the last time I questioned Him.

I had to pick up the pieces, and I had to do it fast. Vinnie's family had distanced themselves from me. I was hoping they would reach out to the boys because they needed them. Finally, Vinnie's aunt called me and asked if she and her husband could come by and talk with me. I agreed. I needed someone to talk to, and they were pastors, so I figured it couldn't be that bad.

They came to Ronnie Jr.'s apartment and hugged the boys and me. I was glad to see them. I had spoken briefly to Selena, but our conversation was strained and rightfully so. This was her second

big loss. She and Vinnie had a disagreement a few weeks prior to his death, and they hadn't been speaking. Like me, she didn't get a chance to let him know how much she cared about him. But we both knew that, despite everything, he knew we loved him. Selena and I had been close before this happened, but I knew it wouldn't be the same again. The pain cut too deep.

Vinnie's aunt and uncle were warm and inviting. They asked about Ronnie Jr. and how he was handling things. Ronnie Jr. was an emotional wreck, and there was nothing I could do to comfort him. He chose to stay away as much as possible. He carried the guilt and pain with him and would for the rest of his life. He was hurting for his brothers.

I told Vinnie's aunt and uncle what happened because they wanted answers. They prayed with us and for us. I will always be grateful for their words of comfort.

My Truth

This was tough and emotional for me to write. I know it will also be hard for all the boys, but we need to heal. We are still dealing with the trauma from this life-changing situation. I tried to block it out of my head, but I knew it would resurface.

Like the saying goes, "Life goes on" whether we want it to or not. There was a moment when I couldn't get out of bed. Throughout my life, I have questioned God about His decisions. I was taught we aren't supposed to question God's work and the choices He makes for our lives, but I do. I still want to know why. That's me being real.

I have had my share of pain and sorrow, and just when I think I can't bear anymore, something else is thrown into the pot to be stirred. I handle each curveball the best I can. I have highs and lows. I keep fighting because I don't know any other way. I was forced to be strong because I haven't had anyone else to lean on since the passing of my closest family. I had to make it for my sons. I couldn't let them see me fail or give up. With their father's death, I had to play dual roles.

Yes, Lord knows I was tired and weary, but failure wasn't an option. I would have loved to have someone rescue me, but who would that have been? I put my big girl panties on and made the best out of every situation that crossed my path.

I somehow found willpower to do the unthinkable.

DAY ONE

By Ronald L. Davis Jr.

A pain that is surrounded by victory
How could glory feel like misery
Even when I win, I lose
So then what do I choose?
To carry on and feel hurt
Or smile, keep strong, and remain curt
When no one understands
Or everyone gets it
Should I pray for forgiveness or
Remain indifferent?
Ambivalent to the wrath that I caused
It leaves me with pause,
Yet still a time to recall
When days taste as sweet as the proof
My moment, a truth
It was always about more than the loot
A moment of truth
And let the sun ray sit and blaze
Upon my skin
Prayed that my glory
Wasn't sin
Met a new day

It showed me brighter days in the shade
Met a new day
It taught me betterment to my ways
Met a new day
It taught me everything I needed to know
Met a new day
It showed me keys to success
My new day showed me how to progress
My new day taught me how to be a man
And to think, one day, I had tried to
teach the day how to be a man.

CHAPTER

Seventeen

The day of Vinnie's funeral had come. If I could have, I would've stayed in bed, but I had to be strong for my sons and put on a poker face. We arrived at the funeral home early. I couldn't do it alone, so my best friend, Beebe, attended with me. I needed her, and she was with me every step of the way. She had met Vinnie and taken a liking to him, and she enjoyed his cooking.

We sat in the middle row, and I could see the family in the first two rows. Selena came to our row and gave the boys a hug. I told them to go to the front with the family. "This is about your dad," I said.

They didn't want to leave me. They were showing solidarity, but it wasn't the time or place.

As they made their way to the front, I looked at the collage of pictures on an easel. There were so many pictures of Vinnie, my boys, and me, all the memories and good times we had shared. I couldn't fight the tears.

The funeral was packed. Vinnie's father said hello, and I could see that it had taken everything in him to conjure up those words. He was hurting inside, and my presence was a reminder of his loss.

I watched the different people who entered the doors. Tre', Justin, and Ty's coaches and friends came. That's when the boys broke down. The realization of how great their loss was broke their

hearts. Ronnie Jr. and I had discussed his attendance, and we decided against it. It would have been too much for the family.

But Ronnie Jr. needed closure as well. He was hurting also. Vinnie had been a major part of my older sons' lives, as much or more than their own fathers. He had watched them grow into adulthood. Vinnie and I had been together for eighteen years. How could they not be affected by his loss? He'd taught them about manhood and schooled them about life. He had been influential in their upbringing. They spent time together on holidays and sporting events. When they had problems in school or in the streets, Vinnie was the first one to show up for them. He did the best he could to be supportive with genuine love for them. He may not have showed it like he wanted to, but he cared about them. They'd spent countless hours talking and hanging out. This was a loss for them all.

As the funeral continued, I saw her walk in. Immediately, I knew who she was, partially because Vinnie had described her in detail but also because she had the twins with her. All this time, I'd hated the mother of Vinnie's twins, but I realized she wasn't even a factor. It was time to let it go, and that's what I did. The boys don't have a relationship with their siblings, and I don't know if they ever will. I hope they meet someday, but I think their loyalty to me has deterred them from building a relationship with them.

I wanted to be one of the last people to see Vinnie. There was so much I needed to say. As I stood, I could feel my heart grow heavy. I had to brace myself. I grabbed each chair in my path. It was a short distance, but it took every breath from my body. The closer I got, the farther it seemed. I mustard up enough strength to make it to the front of the funeral home where he lay peacefully resting. I had to reach him. I needed to tell him what I hadn't said before. As soon as I made it to his casket, the boys stood and joined me. We cried.

Justin rubbed my back and said, "It's okay." Tre' held on to me for dear life. Tylin said, "Mommy, I love you."

I looked at Vinnie. "I *do* love you, and I'm sorry. I will miss you,

but rest. Gonna need your help taking care of these boys. Watch over us. We will meet again. Until death do us part."

The loss was greater than even I would've expected. Vinnie had been my everything. Yes, he had abused me, but he had also taken care of me when I needed it. He was there for me when I didn't have a soul. He cried when I cried, and he laughed when I laughed. He got pleasure from seeing me happy. He gave me his last to make sure we had what we needed. For all the pain he'd caused, he also brought love. It's crazy how someone can be both good and evil.

My Truth

Vinnie always said, "Until death do us part." I guess he was right.

For Ronnie Jr., the pain was greater. I wish I had encouraged him to seek therapy to deal with this life-changing event. He loved Vinnie and carries the weight of his untimely death on his shoulders. Thirteen years have passed, and he still hasn't gotten over it. None of us have, and I don't think we ever will. I believe that's why my sons started the path they've travelled, because the loss changed them and not necessarily for their betterment.

They say time heals all wounds, but does it really? The wound is still there, but it is masked by the beauty of watching my grandchildren flourish. So we bury our wounds because life goes on, but the wounds never heal; they're only covered by love and understanding.

Why did I stay? Because when Vinnie loved, he loved unconditionally. He could make me angry, but in the same breath, turn around and make me smile. He had a way of making me feel like a queen. We had times of turmoil, and I hated every moment. Had that been all, I would've gotten out sooner. But there was a point when the good outweighed the bad. I believed things would get better, and sometimes it did. He wanted his family, and he would do what he needed to keep us. I couldn't turn my back on him because I knew he needed me as much as I needed him. He was dealing with his demons, and I wanted to rescue him and be by his side just like he had been by mine.

I miss him so much, and I've had a void in my life since the day he left. I know it was his time to go, but I thought we would grow old together and forever be friends. Life just hasn't been the same without him.

CHAPTER
Eighteen

Time to move again. Ronnie Jr. was moving in with his girlfriend, and it was time for us to have a fresh start. We had moved everything out of the apartment, and I found a place on the other side of town, a house with four bedrooms. We were still healing but ready to go on with life.

Unfortunately, the boys had to change school districts. They hated their new school, but they always rolled with the flow.

The sports teams weren't the same for them. Because of racism, they were treated differently. They struggled from the time they entered the school but not because they couldn't do the work. They had been through too much and, like me, they were tired. Tre' said to hell with school, Ty was acting out, and Justin was doing enough to get through the day. With resiliency and dedication, Justin still managed to graduate high school as scheduled. Ty and Tre' did not. I was proud of Justin and his accomplishments. He did the very thing his father would have wanted him to do: get his diploma and go to college.

De'Von and his best friend, Marcus, had moved into the house. Marcus was like another son of mine. Tylin started dating a girl down the block and spending as much time as he could with her. Her mother was okay with him being there. She would even let him spend the night at her house. I would have to send one of the boys to

go get him. He would come home with an attitude, and as soon as I turned my back, he was gone again. I had a conversation with the girl's mother, but she didn't give a shit, and I knew it. She was too busy running the streets herself and consumed with getting high. So she wasn't any help to me.

Tre' was still staying out a lot and running the streets. I couldn't keep up with him. I just kept talking to him until I was blue in the face. But he didn't pay me any mind. He was dealing with the loss of his father in his own way.

Justin maintained as he always did. He went to school without making a fuss about much of anything. He was like De'Von, no drama and always maintaining the status quo. I never had an issue with him running the streets or getting into any real trouble. He'd hang out with his friends, but unlike Tre' and Ty, he wouldn't want to stay over someone's house. Justin always managed to make it back home. He wanted the comfort of his home and his bed.

We were all going through the motions of life. So much had happened beyond our control. A good day for us was waking up and not dealing with any drama. There wasn't much to smile about, but we managed to get through each day with some humor. De'Von, the comedian, always kept the jokes going during the day.

My friend BeBe invited me to a cookout she was having. BeBe was my mother's age. They had the same birthday but were born in different years. She was like a second mother to me, and I adored her. We had similar stories—we both had a lot of children. I had met her at work, and we hit it off perfectly. We talked all day and night. We did things together, and if she needed me, I was right there and vice versa. She helped me recover after Vinnie's death.

I learned of the results of Vinnie's autopsy that day. He had a preexisting condition, and any excitement or stress could've caused his death.

Several years prior, Vinnie had been stabbed in Mount Vernon with an ice pick over a dispute with someone. I don't recall where on his body he was stabbed, but I think it was his lungs. Selena and

I had rushed over to the hospital, frantic. When we arrived, he was asleep, heavily sedated. Selena and I went home to get some rest because we had been there for several hours. The next morning, we received a call stating he was in intensive care. Vinnie was eventually discharged, but he shared with me that his body wasn't the same. Since the incident, he was unable to hold his urine and still felt pain at the site of the wound. He knew he wasn't right but refused to see a doctor. I'm sure his condition had something to do with the stabbing.

I needed a break, and drinks with friends was the perfect escape. Patrick, one of my work buddies, and I headed over to Bebe's house for a little relaxation and fun. We drank and bullshitted most of the night. Patrick was getting a lot of attention from the single ladies, but I had my eye on Bebe's son, Lamar. I had never met him before, but he piqued my interest.

He was only two years older than Ronnie Jr., fourteen years my junior. What in the hell was I thinking? I *wasn't* thinking, and that was the problem.

I had dated other guys over the years. There was English, the Jamaican. He was about 5'8" with a caramel complexion, hazel eyes, and reddish-brown hair. His birthday and my birthday were a day or two apart. We were the same age, and we got along well. But there were a couple of issues: He was a ladies' man, and he was trying to move in with me. Hell nah! Vinnie would have killed me if I had another man around his kids. I cared about him, but we knew it wasn't going to last. Then there was Keith. He wasn't the cutest I had ever dated, but he'd put so much effort into getting my attention that I finally gave in and started dating him. He was very well endowed, and I enjoyed every minute of our sexual encounters. But, just like the others, he didn't last.

I was now plotting on the next fling at Bebe's cookout.

We were having a good time mingling, playing games, and drinking. Patrick was ready to leave, but I decided to stay the night. I fell asleep and heard a noise. When I opened my eyes, Lamar was

standing there. I guess he'd figured out I had my eye on him. I awoke completely, brushed my teeth, and freshened up a bit. Lamar and I talked all night long about God, life, money, politics, everything. We talked until the sun came up. All the while, I was thinking, *Girl, you have lost your mind.*

Lamar was on the short side. He was brown-skinned with light brown eyes, and he was cute. He had a nice physique, and he was a street thug. That was my type—tough in the streets and soft at home. I always liked a guy who could hold his own. It meant security for me.

Lamar and I talked every day. He was so attentive, and he brought out a different side of me. He constantly asked to spend time with me, but I kept throwing up the age difference. Of course, he said what most younger guys say: "Age ain't nothing but a number." Our personalities clicked, and he was willing to do some of the fun things I enjoyed like going to the movies, arcade games, walks in the park, and gambling.

Against my better judgment, I started dating him. It was the most fun I'd had in many years, and I enjoyed every bit of it. I tried to keep it a secret, but as time went on, I didn't give a damn. His mother knew, and I was cool with it. The first of my sons I told was De'Von. He was easy going, so he was happy if I was happy.

"Oh, are you sure?" he asked.

"Yes," I said.

"Well, I guess that's what it will be."

I'm sure he wasn't thrilled about it, but what was he going to do? Next was the three youngest boys. They looked at me like I was crazy, but as always, my boys rolled with the flow. They were convinced that their mother was different—in a good way—and she always kept it real. When it came time to tell Ronnie Jr., I had to prepare myself mentally. He was the more critical one. He was only sixteen years younger than me, so we had grown up together. Ronnie Jr. had always been wise beyond his years. Shit, sometimes I felt like he was my damn daddy. He had a way of looking at me like a parent

giving his child the eye. I would stand there looking dumbfounded like I needed to go get a switch off a branch. I could read Ronnie Jr.'s looks and know what he was thinking. We were close like that.

I explained to Lamar how Ronnie Jr. would probably give him the cold shoulder. He was prepared for Ronnie Jr. and told me not to worry. I knew Ronnie Jr. wouldn't be disrespectful because that wasn't his demeanor, but he had a way of looking at people to let them know he didn't like them. Ronnie Jr. didn't give him a hard time, but he gave him a look that said, "I will be watching you, so don't slip up."

Not only was Lamar younger than me, but he had a criminal record. He'd spent eight years in jail for stealing cars and other crimes. He was sixteen at the time and sentenced to eight to ten years of incarceration. He had been released from prison two or three years prior, and he was on parole.

This was a crazy time for me. I was still mourning the loss of my sons' father, and now I was dealing with a much younger guy. I wasn't keeping up with the bills, which caused me to be homeless for several months. I don't know where I got the strength from, but I managed to keep my job. If I didn't do anything else, I made sure I went to work. Work may have been the only thing to keep me from going into a psychiatric ward.

Justin went to live with Ronnie Jr. and his girlfriend. They were about to have a baby. I sent Tylin to stay with BeBe, but that didn't work out because he was too much like me. Sometimes he could have a smart mouth, and BeBe wouldn't put up with it. Tre' was staying with Lamar's cousins. Lamar had introduced them to him some weeks back, and they all hit it off. I stayed in a room that I had at the job until I found an apartment two months later. The room was set up like a studio apartment.

Before we knew what was happening, Lamar and I were inseparable. We worked it out with his parole officer so he could move in with me. Lamar was my escape from reality. Through him, I was able to redeem my youth. He made me feel special, and he

213

catered to my every need. We received confused looks from people, and we knew what they were thinking but didn't care about what the world thought. Girls always gave him the eye, and his response was to grab me and hold me closer. He let them know he was with me, and they were quick to look away. I did the same when guys looked my way. However, Lamar's reaction was different. He would get an attitude and stare the guys down. He saw their gawking as a form of disrespect, and he wasn't having it. He didn't mind letting the world know I was his lady.

Outside of our age difference, we fit perfectly. He completed me in every sense of the word. I was in love. He had qualities that reminded me of Vinnie. Lamar was gentle with me, always handling me with care. If I was upset about something, he knew it. He wanted to make sure I was good. Because I hated to iron, he would wake up early to iron my clothes for work. If I was thirsty, he'd go to the kitchen to get me a glass of water. If my boys were getting on my last nerve, he talked to them. If I was sad, he made me laugh and brought me joy. When he worked, he gave me his paycheck, only taking for himself enough for transportation and lunch.

I took care of him also. There was nothing I wouldn't do to make sure he was happy. We were a perfect combination like the song by Stacy Lattisaw and Johnny Gill. With him, I could be myself, and he could do the same with me. We didn't have to pretend. He knew my inner most secrets, and I knew his. We were comfortable together. I loved coming home to him, being with him, and loving him. It was always an adventure with him. We only had two major arguments in our relationship, and I attribute those to our likeness to each other. We could read each other's mind at times. We answered questions the same way, and we were in sync with each other. He knew what made me upset and vice versa, so we didn't tread in certain directions. When I had mood swings, he'd look at me sideways then instantly do something to make me laugh and take me out of my element. When he was upset, I gave him his space, and he would snap back to the loving man I knew he was. Lamar completed me in a way that

was effortless for him. He was so refreshing, and I wanted to hold on to that for as long as I could.

When we were good, we were great. But all good things eventually come to an end.

The first two years were blissful. But when he was released from parole, things started to change for us. I was happy for him when he was released. He hated reporting every two weeks, and we both hated the fact that his PO could show up at our home anytime he wanted to. He had a curfew, and he was always anxious about getting home on time.

Getting off parole was freedom. He could now do as he pleased with no stipulations. I understood. It was like the way I felt when I'd decided to leave Vinnie, like I had regained my freedom. Lamar was ready to spread his wings, and that meant not being tied down in a relationship. He wanted his youth back and all that it came with. I knew we would have to face this issue. Besides, I knew his desire to have another child. He wasn't afforded the opportunity to be there like he wanted for his first born. He wanted that experience. If I could have, I would've birthed a child for him because I loved him. But after I had Tylin, I made sure my tubes were tied, burned, and cut! I knew there was no way he and I would be forever.

Did he use me? I think we used each other. I needed and wanted exactly what he'd given me, and I'm sure he felt the same way. We had love for each other; we just needed to go in opposite directions.

But why did things have to get so bad? And it went from bad to worse.

Right before Lamar's parole release, his behavior started to shift. He began spending more time in the streets and less time with me. At first, I was understanding, but then I became frustrated and angry. I didn't want to seem selfish, but I wanted his time, and I wanted things to go back to the way they were.

But it was too late for that.

My Truth

I was dumb as hell. I can't even blame this one on being young and naïve. I knew better than that this time. He was way too young for me, and I had gotten caught up in playing house again.

I had to call my friend Andrea'. She is my voice of reason, and she got a kick out of this one. I want to know why she didn't bring me to my senses. But I know the answer to that—because I had kept him hidden until there wasn't anything anyone could say or do about it. I had left Andrea speechless, and when she saw us together, she chuckled under her breath and stared at me with her head tilted to the side, calling me a hot mess.

I was a hot mess. I can chalk it up as a moment when I'd lost my mind. I guess I had several of those moments. I'm still laughing at myself because the shit is funny. I wish it were a blur but it wasn't. I knew what I was doing, and I remember it piece by piece.

I am embarrassed but not ashamed; there's a difference. Besides, in this book, I am releasing all the skeletons in my closet, even the craziest ones!

THE WOMAN YOU ARE

— JLT(Lamar)

You're like water to the earth
That fills my body
When I'm in need of thirst
You're like that wife to a good husband
You always know my worth
You're like that voice in my head
When my thoughts need to think
I love your touch and warm kisses
Your way of putting me to sleep
You're like a blessing in disguise
You give me strength and hope
You're like a prayer for the sick
You hold faith when most don't
You're like a hole with no depth
Your wisdom runs deep
You're like and angel without sin
You show and prove what you preach
You're like the sun to the sky
You complement my presence
You bring light to my life
And the sight is always pleasant
Your love is accepted

With open arms and no fear
I just love the thought of you
Whether through smiles
Whether through tears!

THE MAN YOU ARE

By Lori Smith

You're like **pieces** to a puzzle
You **fit perfectly**
I **admire** your **courage**
And **sensitivity**
You're like the **twinkle** of a star
Shining all night
Your **honesty** and **devotion**
Let me know **everything** is **all right**
You're like **lyrics** to a great song
I enjoy your **music** (love-making)
Even when I'm the one who's wrong
You're the one to **fix it**
I see your **soul** through those **big, beautiful brown eyes**
Your **warmth, patience,** and **softness** are such a nice surprise
You're **genuine** and **unique** and oh so **rare**
I thank God for sending me you
In my time of despair
You're **heaven** to someone who's been through hell
You're the **water** that remains in my **wishing well**
You continue to be my **strength** when I am weak
I take heed in what you say and listen carefully as you speak
You have **graced** me with **your style** and **your charm**

Making me feel **safe** and **secure** in your **arms**
You're like **food** for the hungry
You **satisfy my appetite**
Providing **nourishment**
What a **tasty delight**
You're the **man I prayed** for
And the one **I adore**
You're like **shelter** for the homeless
You **got me covered**
Through thick and thin
My best friend
I'm handing over my **heart** along with the key
Never needing anyone else because
You complete me!

CHAPTER
Nineteen

My relationship with Lamar was coming to the end. I, of course, held on to every moment. He was letting go as I tried to hold on tighter. How could he just walk away from me? I knew it was a matter of time, but I wasn't ready yet. I still needed him, but he still needed to be free. I knew he was about to abandon me like many others.

Lamar came up with some story about wanting to help his cousin work on his music. I fell for it. This was going to be our big financial breakthrough. He told me how talented his cousin was, and he wanted to give him the push he needed to make it in the industry. Lamar was also very talented musically. The boy sure knew how to write a hook for a song. I had watched him in the studio with aspiring artists, and he made their songs pop. By the time they were done, we were believers.

This wasn't our first big idea for financial security. We had spent countless hours trying to figure out how we were going to make it happen. He wrote music, and I enjoyed writing as well.

With Lamar deciding to venture out with his musical excursion, I convinced myself that being apart wouldn't be an issue because of our commitment to each other. I also figured I didn't have anything to worry about because Tre' was also staying in the same area where

he was going. Lamar's cousin lived about an hour away, and I had visited him a few times and knew where he would be.

In the beginning, Lamar stayed out on the weekends. He made sure he was home on Sunday nights only to return to his cousin on Fridays. The new schedule seemed to work out well, but I wasn't seeing him as much because, during the day, I would be at work. At first, I didn't complain about not spending as much time with him because we had agreed. I understood how the music business operated, with a lot of studio time, hard work, and dedication. I saw the excitement in his eyes as he explained the work he was doing. I couldn't kill that for him. He wanted it to work, and I knew it.

I was starting to feel like our relationship was on the backburner, and through our separation, things were changing rapidly. The way he touched me and talked to me were different. Maybe I was reading too much into things, but I felt like he no longer needed me. He was making a new life for himself, getting the freedom he finally needed. All those years he had been locked up made him desire freedom, and I represented commitment—a loss of his freedom. With me, he couldn't come and go as he pleased. He had someone to answer to, and he couldn't explore all the things he had been forced to be without like running the streets and dating and sleeping with different girls—regular man shit.

Days turned into weeks, and weeks turned into a month before he came home. Every time we talked, he told me they were in the studio until all times of the night and morning. He would come spend a night or two with me but rush to get back there.

One night, he was lying in the bed next to me, and my intuition got the best of me. I grabbed his phone, ran into the bathroom, and locked the door. I looked at every text message and listened to all the voicemail messages. I knew as soon as I saw the word "baby" it wasn't from my number. I marched out of the bathroom and woke his dumb ass up. He should've known better.

He woke up confused until he saw me with his phone in my hand.

We got into a major argument. We had argued before but this one was different. This was about hurt, anger, deceit, and mistrust. He got up and started getting dressed. He was caught and he had another chick, so he wasn't about to sit there and argue with me. But he wasn't getting that phone. I wanted to talk to her. I wanted to see how long they had been together and find out the extent of their involvement. It would help me determine what I was up against. Was this a fling or a long-term relationship?

I threw on my clothes and followed his ass down the street. I told him I wanted to talk, and we got into the car. Like most guys do, he tried to flip the shit on me, claiming I didn't pay him any attention and never had time for him.

Well, dammit, he wouldn't have had time either if he had kept his job working in construction. One day, he'd come home and had the audacity to tell me he'd quit. He wasn't built to be a laborer, and his hands were starting to get calluses. He was making good money, too.

He continued to tell me everything I was doing wrong. I looked at him and said, "You must have lost your fucking mind." I caught myself because I knew that wasn't going to get me the answers I needed. I lowered my tone and tried again. "Baby, listen, just tell me all about it."

This fool fell for it and admitted he was seeing her. He went on to say that he felt like less than a man because he wasn't making the amount of money I made. I had moved up at my job and was headed in the right direction. He said I was too independent for him.

I reared back and slapped the shit out of him, and he jumped out of the car. His look told me he had done it for my safety. He got on the train and left me heartbroken, confused, and alone.

I was in distress when the other woman called back. She wanted to know who I was because her man had told her he'd lost his phone. The conversation wasn't going to be easy. I found out the chick knew about me, and they'd been seeing each other for about six months. She said he was torn because he wanted to be with her, but he was

still in love with me. The more she talked, the worse I felt. She knew everything about me, and she knew a couple of my boys. He didn't even have the decency to date someone unfamiliar to his family and my sons. It was a bit much to swallow, but what could I do?

I hung up and called his mother, my best friend, BeBe. I knew she knew about the other girl by the way she paused when I asked her. She was my best friend. We shared everything, but I guess blood was thicker than water. I looked like a fool. Not only did she know, his cousins knew, and so did Tre'. My relationship with Bebe never recovered.

Lamar had been my everything. He'd brought joy to my life and gave me strength to face the day. He was my soulmate, and I loved him.

I was shocked when Tre' confessed that he didn't tell me because it wasn't any of his business. He said, "I thought you knew. That man ain't never home, so I figured y'all weren't together."

I went off on him and made him feel bad about not telling me. But it wasn't his fault. That's what I got for dating a street dude who was much younger than me.

I became depressed. I couldn't eat or sleep, and I wasn't going to work. I cried every day and started drinking again. I even begged him to come home. I promised I wouldn't interfere with his relationship if he spent time with me. Of course, he agreed to that. He would stay with me for a few days and go back to her. I became the other woman. Damn, I was desperate and stupid as hell. I had given up my power, and it sufficed for a while, but it wasn't built to last.

What the hell was I thinking? My ass was a complete idiot for believing in him. The more I thought about him, the angrier I became. How dumb of me to lower my standards and allow him to have his cake and eat it, too. That was the type of woman I would call stupid and talk about to my girlfriends. Shit, I had become her.

I never try to break the next woman down, but I felt my competition was beneath me. Lamar didn't deserve me. And to think, I had allowed that nonsense.

Oh, hell nah!

I asked myself if I was really in love with him or the thought of him. Whatever it was, I was over it and engaged in a lot of self-talk. I told myself, "Stop wasting time and raise the bar." I picked my foolish tail up, wiped my tears, and made my way back to church. I was sick and tired of being sick and tired. So much had happened, and I didn't have the energy to do anything else. I became so involved with God that I didn't have time to be depressed.

I was baptized and began living a saved life. I felt free. I had clarity about wanting to live a better life. I had never truly invested in myself and my happiness. Church was not only my refuge, it became my sanctuary. I was at peace with my transition from broken to renewed. I had inner peace and went back to my love of writing. I wrote every day, morning, noon, and night. When I wasn't writing, I was empowering and coaching young women I worked with. It was my passion to make a difference in the lives of others. Before I knew what hit me, I was feeling fulfilled, not empty because I didn't have a man around like I had felt in the past. It was amazing to go from feeling like it was the end of the world to enjoying waking up each morning. I was looking forward to new things and working hard.

Things were going well. I received another promotion and found life after Lamar. But one night, my phone rang at three o'clock in the morning.

Who is calling me this late? I thought as I answered the phone. It was Lamar. He sounded strange, and I immediately knew something was wrong.

"Don't worry, but Tre' has been shot."

My heart dropped. "Huh? By who ... when ... where?" I asked in a panic.

"They were in the Bronx, and some guys were shooting at them. Tre' and another guy were shot multiple times."

"Where is my baby, and is he still alive?"

"I told you he's going to be fine, but they won't let me see him."

If they wouldn't let him see Tre', how the hell did he know his condition? But I didn't have time to talk; I had to get to my son.

I called a friend to drive me to the hospital. It took us about ten minutes to get to a thirty-minute destination. I ran into the hospital and found out Lamar had been arrested for disorderly conduct. His cousins were sitting in the hospital waiting area.

I asked to see my son, but I was told I couldn't due to a pending investigation. In certain areas of New York City, people were prohibited to visit family in the hospital following an attempted homicide or shooting. The rule was created after someone had pretended to be a family member of the victim and killed him.

But that wasn't the only reason I couldn't see him. Tre' had used Lamar's name because he had a warrant in Yonkers. He was being placed under arrest. The officers informed me he had been shot twice with bullet fragments in his back. He was also shot in the shoulder. The other guy was hit in his leg and arm. They were both doing fine.

It was gang related. Both Lamar and Tre' were in gangs. Gang life was not the path I wanted for my son or someone I loved.

Tre's shooting was traumatic for him and me. He was released from the hospital and served a few months for the warrant. Tre' never recovered mentally or physically. He'd thought he was invincible, like nothing could stop him, but his perception was now shattered.

The day he was shot was an eye opener for him. He realized life could be over in the blink of an eye, and for what? The physical pain was unbearable. Without the pain medication, he suffered. He quickly became addicted to Oxycodone and Xanax. He lost a sense of himself and became hardened emotionally. He had something to prove. He refused to be that vulnerable again and allow someone to shoot him. He began constantly looking over his shoulder, prepared for whatever was to come his way. He was living in fear, although he would never admit it.

I was hopeful he would leave the streets alone because he'd had his first child, a daughter, his pride and joy.

My Truth

How much can one mother take? There are no words to describe what I felt when I heard, "Tre's been shot!" My hands were shaking, and my heart was racing. I had told him repeatedly to stay out of those streets. Nothing good would come of it.

And finding out he was with Lamar made me angry. Why would he be around the man who had broken his mother's heart? Tre' and I had a big falling out because I questioned his loyalty to me. That sounds stupid, and I'm the one who said it. He let me know he had stayed out of our business and purposely chose not to interfere. And to my dismay, he said I shouldn't have been with Lamar in the first place. Ouch! Those words cut like a knife. But what he'd said was true. The truth hurts, but I had to wear it. We were close enough for him to tell me like it is. I guess he told me about myself.

CHAPTER
Twenty

T hings were moving along. Ronnie Jr. was on child number four. De'Von was living in Massachusetts with his girlfriend and son. Tre' was still living upstate with his two children, and Justin was on his way to school farther upstate closer to Canada. The following year, he studied abroad in France. Tylin had some brushes with the law but was headed toward college.

I was working and going to church. I had been seeing someone, but it was more about having something to do. It lasted for a few months. I would drink a few beers and go chill with him. I needed the beers; otherwise, I wouldn't have been around him. He'd had a crush on me growing up, but I never gave him a chance back then. He was something to do, and I figured I had nothing to lose. We went on a few dates, but nothing really came of it because it wasn't supposed to. I hurt his feelings when I told him I wasn't interested in seeing him, and I felt bad. But at this stage in the game, I wasn't willing to be in a relationship that was headed nowhere. What would be the point?

I was tired and had lived through too many disappointments, so I gave up on love. It didn't seem like it was in the cards for me. I had prayed for my husband, but maybe God had other things in store for me. I decided to go it alone, to get myself right. Lord knows I had a lot of work to do. My life thus far had been a complete

disaster. I had chosen all the wrong men for all the wrong reasons. Some women make a few mistakes, but not me; I made the same mistakes repeatedly. Casual sex was now off limits for me because my dumb ass often mistook lust for love. Most guys were after sex, and I wanted love and attention. So I used to compromise myself, figuring it would be a win-win situation, but it wasn't. You can't mix the two; it doesn't work. The loves in my life felt good for the time they were there, but they didn't last. I yearned for more and wanted better. Shit, I *deserved* better, right?

Life had flown by, and I was back to where I'd started. I was over all of it, all the pain and drama. Time to turn a new leaf. I had done the same things over and over and expected to get different results. I knew that to get the results I wanted, I had to make changes. The first change started with the way I approached things. I had to stop being so vulnerable and jumping at the first man who paid me attention. I had to take my time instead of hoping into bed with him. I went on a crusade to find myself. I wrote what I wanted to change within myself and the standards I wanted to set with the next man to come into my life.

Women may know they want a man, but many times, we don't know what type of man we want. When we're single and thinking about a relationship, we must be clear about our expectations. So I became clear as to what my next man should possess. I needed some of the superficial traits like tall, dark, and handsome. He had to be hardworking and a provider because I refused to take care of a man. He had to love God. And there could be no baby mama drama. I had watched Lamar go through that; I would no longer entertain it. He had to be good to his mama and/or sister. If he wasn't good to them, I knew he wouldn't respect me. He had to know chivalry wasn't dead. I appreciated when a man treated a woman like a lady. I wanted my man to open my car door for me and pull out my chair. He should drop me off at the door while he parked the car. Vinnie and Lamar were like that.

For now, I still had work to do, and I questioned if there was

someone out there for me. I wanted to be prepared in case someone came along, but I wasn't optimistic. As time passed, it became less important to me. I knew I needed to continue to focus on me, my flaws, and my lack of confidence. My self-esteem was low, and the worst thing to do was enter a relationship without knowing my worth. I started exercising and eating better and seeing results. Before I knew it, I felt and looked better. I got to a point where I didn't want a man to come in and complicate my life. I was good by myself.

But never say never. As life would have it, my plan was soon shifted.

I was having a conversation with my girlfriend Barbara, telling her how I was tired of the same type of man I had been used to. I wanted a regular guy, no street thug or ladies' man, just a man who got up every day and went to work, enjoyed going to church, and loved his family.

Barbara said, "Girl, I have the perfect man for you."

Here we go.

I shook my head and laughed.

"No, seriously," she said. "Let me tell you about my brother. He is all those things. He's not my biological brother, but I've known him forever, and he is the perfect man for you."

She showed me a picture of him, and I thought he was a decent-looking man. He was tall, dark, and handsome, just what the doctor ordered. I let Barbara convince me that he might be my knight in shining armor. She called him right away and gave him the same spiel she had given me. "Shawn, I have the perfect woman for you ..."

I watched as she got excited. She was happy about the love connection she was making. Barbara the matchmaker was glowing, and she had us both sold.

Against what I'm sure was both our better judgement, we agreed to have her give our numbers to each other. Like me, he was done with finding love. He had been through two failed marriages and was at the point of throwing in the towel. We were at the same point

in life, not wanting any drama or games. We were way too grown for that type of relationship.

I was still on the fence about being set up with a blind date. Although I had seen a picture of him, I was never big on being set up. I knew I wouldn't call him first, but part of me hoped he would call me.

Of course, he did.

My phone rang on Super Bowl Sunday. I had his number and name stored into my phone, so I knew it was him. Barbara had given him the number that day. Shoot, he wasn't wasting any time. I watched the phone ring. I was nervous. I didn't want to pick up the phone. I waited to see if he would leave a message. And he did. His voice was deep and strong. Damn, I liked the way he sounded. I contemplated whether to call him back. But before I got a chance to dial the number, he was calling me again.

In my sexiest voice, I said, "Hello?"

He told me he'd left me a message. I pretended not to know. "Oh, you did? I guess I didn't get it yet," I said.

He went on to say that Barbara had given him my number. Of course, I knew that already, too. He told me about himself. His name was Shawn. He was a single father with one teenage son. He was a truck driver, a church goer and had his own place. So far so good.

I told him a little about me. "First thing's first, I have five children, and only two are living with me. I'm an administrator of a residential treatment facility, and I've been there for ten years. And I spend my free time in church and doing fun things."

For two people who were done with relationships and love, we sure seemed open. From the sound of things, we weren't done like we had claimed.

Shawn and I talked every day and night for two weeks. Eventually, he became tired of talking on the phone and was ready for us to meet. (He hadn't seen my picture.) I was a little apprehensive due to my struggles with my weight but figured it was time to shit or get off the pot.

We decided to meet at Barbara's house, and the plan was for her to cook dinner for us. I tried to postpone the meet and greet as I had a business meeting in the city and knew I wouldn't arrive on time, but Shawn wasn't having it. We called the dinner off, but he still wanted to see me. I agreed to stop by his house on my way home. I passed his town to get to mine, so it wasn't out of the way. I told him I couldn't stay long, but I would come by to say hello.

I called his phone, letting him know I was outside. He came out. *Damn, he got it going on!* I thought.

Shawn was taller than six feet, about 200 solid pounds, dark-skinned, and bow-legged. I got out of the car. My heart skipped a beat. He started walking toward me but immediately turned around. *Oh, my God. He doesn't like me.*

Then he turned back around, grinning from cheek to cheek. He gave me a hug, and he smelled amazing. His body was solid. It only lasted a moment, but I felt safe in his arms. We went inside his apartment. It was cozy but lacked a woman's touch. His son and some friends came in. His son was well groomed and handsome.

We talked for so long that we didn't realize how late it was getting. He walked me to my car, and I knew I would be seeing him soon. Before I pulled off, my phone rang. He called to tell me to make sure I call him to let him know I'd gotten home safely. He scored brownie points for that one. The only reason I hung up was because I wanted to call Barbara. As soon as Barbara picked up the phone, Shawn was beeping in on her line. I was excited to hear what he had to say, so I told her to take his call and call me back as soon as they hung up.

I waited for what seemed like hours. He sure could talk. Finally, she called, and she couldn't stop laughing. I think she was more excited than I was. She said, "Girl, he likes you!"

"So why did he walk away?" I asked.

"He was just nervous and scared that you weren't going to like him."

I felt my cheeks grow warm with a blush. "Oh, damn," I said. "I gotta go. This is him calling me now."

I could tell he was still smiling. He said, "Just checking to see if you made it home all right." He knew better than that. I had literally just left him a few minutes ago. He was eager to talk, and so was I.

I broke the ice, pretending I was clueless. "So, tell me, you didn't like what you saw?"

"Why would you say that?"

"When I was walking toward you, you turned and started walking away."

"I'm sorry. I think you're beautiful and sexy. I was in awe of you. I was so nervous, and I was thinking, damn, this girl is too fine for me."

I laughed to myself. We had the same thoughts.

Shawn and I spoke day and night. We talked about our pasts, the present, and what we wanted for our futures. I hung out at his house a lot only because it was much more convenient. He worked long days and a lot of overtime. I could easily stop by on my way home from work since it was on my route home, and he would have a meal waiting for me. I thought that was special. He was into me, and I was into him. Before long, we were together all the time.

On Valentine's Day, he introduced me to his mother, and we took his son with us on our date out. Things moved rather quickly after that. Soon, I was staying at his house more than at home. When my lease was up, I moved in with him. I had moved into a director's position, and it came with a three-bedroom, three-bathroom duplex with a patio, deck, and a spacious living room. Both of us decided that Justin, Tylin, and I would live with him until the place was ready. When it was time, we all moved as a family.

My relationship with Shawn had its good and bad times. It was a big adjustment for all of us, and I was struggling with a gambling addiction. Shawn despised my gambling habit. He thought I was out cheating on him, which was furthest from the truth. The other issue we faced was the same as a lot of blended families. There was a lot of testosterone in the house.

My boys were used to me and only me being the disciplinarian

in the house—or the lack thereof. I am not a push over, but it didn't matter. Hell no, this guy wasn't going to tell them what to do! So I became the person in the middle. Shawn would complain to me and so would they. I was the referee, and I hated it. I was sick of the complaining, so I used it as an excuse to spend my days and nights at the casino.

Shawn's mother passed away, and it added another element to our relationship. It made me feel more connected to him. I felt like he needed me. I'd felt like that about most of my previous relationships. And that's probably where I've gone wrong. With every relationship, I have always put myself on the backburner.

I was committed to Shawn, and after what he'd been through with his mom's passing, I vowed to never leave him. I was going to be there for him no matter what came after.

De'Von was planning his wedding, and I was excited for him. I loved my soon-to-be daughter-in-law, Megan. She was the perfect woman for him. They met through friends when De'Von was attending Purchase College, working on his bachelor's degree. Megan's best friend was dating De'Von's best friend, Marcus.

They hit it off instantly and started dating. Megan's family accepted him with open arms. They were the family he needed. Growing up, our family was dysfunctional and there was a lot of drama, way too much for De'Von. I'm sure Megan's family had issues, too, as all families do, but maybe to a different degree.

I was excited for their marriage. I liked everything about their family unit. It was a long time in the making. They chose to buy their first house before getting married. They had set goals and were accomplishing them. I was proud of them both.

Thinking about them, I started reflecting on my past relationships and being single after all this time. I guess watching their happiness made me envy what they had and wish I could have it, too. I was happy for my son, and I knew he would make Megan a happy wife, but things weren't looking too great for me. Shawn and I were struggling, having more bad days than good. We were holding on to

our relationship for dear life. It boiled down to our codependence. I didn't want to grow old alone and neither did he. But I was in love with him and wanted us to work out. Shawn had some good old-fashioned qualities that I admired. But he was set in his ways. Often, we clashed because he was a homebody unlike me. I wanted to go out and have fun and add some spice to life. I wanted someone who wanted to do both. I was conflicted about what I wanted. I loved the fact that he didn't run the streets or hang out with the fellas all night; however, I was beginning to feel crowded. He wanted me around all the time to do wifely duties and spend every moment with him, but I needed space, and it bothered him. He let me know that I wasn't spending enough time with him. I tried, but I became bored quickly and headed right back to spending time at the casino.

Then it happened.

On March 7, 2014, Shawn proposed to me and we got engaged. It was unexpected because we had issues, but my heart told me I was ready for it. Shawn wasn't perfect, but we were in love. That's all that mattered, right?

On June 27, 2014, Shawn and I married. We had a small wedding with our boys and a few friends. I finally felt like I had someone for better or worse, a person I could depend on to hold me down. I thought we would have unconditional love that would last a lifetime. The next day, we left for our honeymoon, a seven-day cruise to the Bahamas. It was amazing. We were so in love and happy.

Mr. and Mrs. Smith had a nice ring to it. I loved the sound of it. Everything became "my husband" this or "my wife" that. Marriage felt different. I didn't think it was possible. It was different than a boyfriend-and-girlfriend relationship. I had a sense of belonging to someone. I took pride in having a husband. I had been engaged before to Vinnie and discussed marriage with Lamar, but this was serious. We took the leap of faith. I put my trust in him, and he put his trust in me.

My Truth

Marriage. I was so happy to finally have a committed partner in my life. I had been engaged before but didn't make it to the alter. Damn, I was elated about this union. Finally, someone loved me enough to want me as his wife. I started feeling whole and complete. Up to this point, there was a void in my life. I felt unworthy of love and being a wife. Vinnie had drilled into my head over time that no man would ever want to be with a woman who had five children. As much as I didn't want to believe him, his words had resonated in my mind. Shawn proved him wrong, and I love him for loving me.

Shawn wanted to show me off to the world. He was proud to be my husband, and I was proud to be his wife. This was a different type of love, not like the previous relationships I'd had. This was forever, in sickness and in health and for richer or for poorer. He was my ride or die, and I was his. I loved this man unconditionally and I was willing to fight for our love by any means necessary.

I'm not naïve, and I know there isn't a such thing as a perfect marriage, but I wanted us to strive for the best possible marriage. Shawn and I both had flaws and, sometimes, it wasn't easy to overlook them, but we tried to work around them and handle it the best way we could.

CHAPTER

Twenty-One

L ove was in the air. De'Von and Megan's big day arrived. All De'Von wanted was for his brothers to be a part of his wedding, and they were all groomsmen. Their wedding party was huge. Both Shawn and his son attended along with my best friend, Barbara, and her cousin, Sandra. Over 200 people were there to witness De'Von and Megan's matrimony.

The wedding was beautiful. Megan looked gorgeous. Her dress fit perfectly, and De'Von looked as handsome as ever. We danced the night away, and by the looks and sounds of it, there wasn't a sober person in the room. I'm glad we had booked hotel rooms upstairs because none of us were able to drive. We had a good time. But with our family, prolonged drinking was never a good idea. By the end of the evening, there were a few arguments amongst my sons. This was the first time they had all been together at the same time in a long time. Emotions were running high. We vowed to never have alcohol at any gathering with the five of them again. That didn't last. Since then, we've had more events with alcohol, and the outcome has been the same.

But love still prevailed. Ronnie Jr. got stung by the love bug at their wedding. Megan's best friend and Ronnie Jr. hit it off well and started dating long distance. She lived in Alabama.

The first year of marriage for Shawn and me flew by, and it was

our best year. We put our best foot forward, trying hard to make this marriage thing work. Shawn was invested in making sure our marriage was successful since he had been married twice before. For me, this was a first, and I took my vows seriously. I wanted to be the perfect wife, but I felt like I was losing myself.

Here I was again, being the nurturer and putting my feelings on the shelf. My life was boring, and I needed excitement. While Shawn was happy going to work and coming home to his wife, a home-cooked meal, and a clean home, I was miserable. On the weekends, he was tired from working crazy hours. He would leave the house at two a.m. and wouldn't get home most nights until eight p.m. By the time he came home, showered, and had dinner, all he could do was sleep. He was working six days a week, and the man was tired. My job was also demanding. I was now the director of the program, and all emergencies were vetted through me. I had to respond to crises and be on call every day and night of the week. Shawn was physically tired, and I was mentally tired. His down time called for rest, and my down time called for an escape from the norm. That is a bad combination.

The honeymoon was over along with the marital bliss. Due to frustration, we started arguing more. Most of the time, we weren't speaking to each other, and we stopped having sex completely. We'd created so much tension that we began to vilify one another to our friends.

With all the day-to-day stressors and pressures, I removed myself and stayed out of the house as much as possible. Some of the boys were back home, and that added to the madness. Shawn accused me of cheating. But I never cheated on him for the entire time we were together, not in the relationship nor the marriage. But one of my boys found some messages he had been sending to other women on the computer. Here he was accusing me, when he was flirting with other women. I was upset about it, but had it happened when I was younger, I would have reacted differently. I told him, "If there's something else out there for you, go to it. I'm not fighting

and pleading with any man to be with me." I was certain that I was a damn good woman, and I was not about to chase after any man. Like my mama used to say, "You can't keep a man who doesn't want to be kept." We decided to work on things and, again, we had our ups and downs, but we were committed to being together.

Things were moving along and changing all around me, and it was happening quickly. Shawn had gotten hurt at work and had to take some time off. He was also diagnosed with chronic obstructive pulmonary disease and needed surgery for glaucoma. I still wasn't happy, but I wouldn't let him conquer his challenges alone. I never turned my back on the people I loved.

I changed jobs due to new leadership and my supervisor's departure. Thankfully, a position was available with another residential treatment center, which was about five minutes away from my other job. So we had to move again. This place was smaller; we downsized to a two-bedroom, two-bathroom apartment.

Shawn's son decided to move to Los Angeles with his girlfriend. He always knew he didn't want to stay in New York. His goal was to travel, be successful, and live life to the fullest. Since the first day I met him, I knew that whatever he set out to do, he was going to do it. He was ambitious and he, too, had a good heart. He took after his father by working hard, partially because he enjoyed nice things. He was always well groomed and looked the part. He and I had a great relationship, and we would talk for hours. Most of the time, I gave him advice on his next adventure or his relationship. No matter what I said, even when I corrected him about something he had done wrong, he remained attentive and took it all in. When he decided to leave, I knew I was going to miss him, but I knew nothing I said was going to change his mind. He had become my sixth son, and I loved him as such. I was the mother figure in his life since he didn't grow up with his biological mother. His father had raised him since he was eighteen months old while his mother was in Alabama.

Next was Tylin. He was at a crossroads in his life and decided it was time to move on. Cordell, one of the friends he and Tre' grew

up with, had moved to Florida. Ty got in touch with him, and Cordell invited him to move with him, his wife, and children. He had bought a house and said Ty could stay with them until he got on his feet. Ty was excited. He was in desperate need of change. He had been in two bad relationships that ended abruptly and was looking to start over. He loved hard. When he got involved with someone, he went all in. But like his father, he could be possessive, which tended to cause problems. His heart had been broken; one of the girls he had been dating had an abortion, and it changed him. All he ever wanted was his own child. Tylin had always been good with kids, and he adored them. When I used to babysit my granddaughter, Ronnie Jr.'s first born, Tylin would be the one to take care of her. He was so delicate and caring with her. So when his girlfriend aborted their baby and didn't tell him until afterwards, he wasn't the same. They broke up, and he jumped right into another relationship. It was a disaster, and it didn't last long. He made up his mind and moved to Florida.

Justin was living with De'Von in Massachusetts, working and maintaining. I was in awe of him. He was so easy going and didn't complain much about anything. But he was true to his sign—a Gemini. He may talk to us one day and he may not the next. I used to think he was an introvert, but as he got older, I realized he could be the opposite. I learned a lot about him through his college years. He was one of the popular students. Maybe he just didn't like talking to us that much because he was friendly with everybody else.

Tre' was living upstate with his two children and girlfriend. He was a family guy like De'Von. He jumped leaps and bounds to make sure his family was all right. I knew that about him, but I still worried about the other stuff. He tended to get caught up in street drama. He and I spoke every day, and I constantly counseled him about life.

Ronnie Jr. had picked up and moved to Alabama to be with the girl he'd met at De'Von's wedding. They had been dating for a while,

and he needed a change in scenery. He was in love and wanted to be with her.

On May 16, 2015, Ronnie Jr. tied the knot. His wedding was nice. His wife worked at a movie theatre, and they decided to have it there. It made no sense to me, but it was the cutest thing, creative and fun. She outdid herself. Ronnie Sr., his wife, daughter, uncle and aunt made it to the wedding. And of course, we were all there.

Ronnie Jr. appeared to be happy in front of us, but my intuition told me there was a lot more going on. However, I decided to let it be. I knew my sons, and when they were ready to talk, they would. I was the first person they called when shit wasn't right with them.

Our family seemed to be headed in the right direction. Things were calm, and each of us had purpose and a plan. It was about time the dust settled.

I felt like I could finally exhale and breathe again. I was looking forward to spending my life with my husband. I was ready to get my act together and focus on being the best wife I could be. Shawn wasn't perfect, but I was ready for us.

My Truth

I love Shawn, and there's nothing I wouldn't do for him. However, since I have been on my journey, I understand who I am. I don't need a man to complete me. I like me now—my quirks, my flaws, every part of me. That's what makes me, me! I refuse to conform to what people want me to be. I am my own woman. I don't feel guilty for wanting an unconditional love. I will not lower my standards to make someone else feel worthy. I will not sacrifice my happiness to make someone else happy. It's okay to want to be spoiled by a man when you're willing to give as much as you receive.

I know what I am capable of and what I am deserving of, and the man in my life must know my worth. I'm not compromising with the things I require or want.

I may be unclear about the future and marriage, but I'm very clear about my expectations. Point blank, period!

GEMINI

By De'Von W. Witter

Harmony
This is where I find myself
Among the decadence of my
Jubilation
Bewildered by the ideal
Amazed by the thrill
I can walk on the clouds
and can taste the purity of my
Soul
Empty days are removed
I now rejoice in being whole
The joy of being free
What a feeling it is
No longer do I live to die
I now live to live
I now live to die
No longer do I live to live
Even though I try
The anger of being restrained
I now lament that I am
Incomplete
In this frantic world

My mind is stuck in concrete
A place where I've been before
Conscious to the allure
Among the degradation of my
Pity
This is where I find myself
Chaos
GEMINI
Chaos
This is where I find myself
Among the degradation of my
Pity
Conscious to the allure
A place where I've been before
My mind is stuck in concrete
In this frantic world
Incomplete
I now lament that I am
The anger of being restrained
How can I maintain
Even though I try
I now live to die

I now live to live
No longer do I live to die
What a feeling it is
The joy of being free
I now rejoice in being whole
Empty days are removed
And can taste the purity of my soul
I can walk on the clouds
Amazed by the thrill
Bewildered by the ideal
Among the decadence of my

Jubilation
This is where I Find myself
Harmony
GEMINI

Twenty-Two

T he ringing phone woke me up. I had been here before. It was
three o'clock in the morning. From past experiences, I knew
it couldn't be good. As much as I didn't want to answer the
call, I felt obligated. Shawn looked at me with a frown, and I knew
what he was thinking.

*Who the hell would call at this time of the night? Must be something
with one of the boys.* Of course, it was.

It was Ronnie Jr.'s wife, and she was panicked. Ronnie Jr. had
suffered multiple seizures and was rushed to the hospital. "Oh, my
God!" I screamed.

"I don't know if he's going to make it. I need you to get here as
fast as you can," she said.

I told Shawn what was going on, and he reiterated that I had to
get there fast. It wasn't like I could get into my car and drive to him.
I immediately called De'Von, my go-to person, and explained the
situation. Megan reached out to her friend and made reservations
for De'Von and I to take the next flight out. I didn't like planes, and
Megan knew there was no way I would get on a plane alone. Shawn
couldn't go with me because he was just getting back to work and
didn't have any time accrued. De'Von would never let me do it alone.

That morning, De'Von and I flew from New York to Alabama.
I was a nervous wreck and didn't know what to expect. We arrived

at the hospital, and Ronnie Jr. could barely talk. He had no memory about what had taken place. He was lethargic, confused, and angry. He was hostile toward the doctors but only because he was afraid. The doctors informed me that Ronnie Jr. had multiple lesions on his brain called cavernous malformations. He was born with the condition, and they were trying to determine the cause of the seizures. He would need to take a daily dosage of medication to treat the seizures. They recommended he see a neurologist for follow-up treatment.

Ronnie Jr. was released from the hospital within a few days and sent back home. When we got to the house, I could sense things weren't going well with the married couple. I could tell by their body language and how they were communicating. I decided to intervene before I left, and all seemed well. But it didn't last long. By the time I arrived in New York, Ronnie Jr. called me and told me he was leaving his wife. Within a few weeks, their marriage was annulled, and Ronnie Jr. moved out. He planned to stay in Alabama because of his job and because he liked the area.

Things always got worse before they got better.

A month later, I received another three a.m. phone call. It was Ronnie Jr. His speech was slurred, and I knew, instantly, he had been drinking. We had been down this road before. He'd flipped his car over, and he was in a ditch. I asked all the necessary questions. "Are you hurt? Was anyone in the car with you? Did you hit another car or anything else?"

All he could tell me was that he didn't know, and he didn't remember. He must have fallen asleep behind the wheel. He did know he was only a short distance from his house. I told him to call the police and let me know when they arrived.

Ronnie Jr. and I didn't talk for days. I tried to reach him via phone but no avail. Megan called his ex-wife, and they called all the local hospitals. Finally, they located him at the county jail. I wasn't happy to learn he was locked up, but at least we knew where he was. He was arrested for driving while intoxicated and sentenced

to six months of incarceration. Once he was released, he made his way back to New York. He found employment right away and was able to get back on his feet. I was glad he'd come back because his kids were here, and he needed to be a part of their development.

Justin decided to return home from living with De'Von. He felt it was time, and they needed their privacy. It had been a few years, and he wanted to figure out his next step.

Tylin was still in Florida but started getting into trouble and got locked up. The friend he'd gone to stay with had sold him a bunch of lies. He didn't have a place to live when he had Tylin go out there. I told Ty he could come back home, but he refused and said he needed to make it on his own.

Shawn and I had taken a turn for the worst. Most days, we didn't speak, and life together was becoming more difficult. He wanted out and decided to leave the marriage. I was devastated. I thought marriage was about unconditional love, through thick and thin, and, most importantly, forever. I wasn't happy. I didn't want us to end. I wasn't in love, but I loved my husband. I wouldn't have left him no matter how bad things were. I am a fighter and had been fighting all my life. He was abandoning me just like everyone else, except my boys. This wasn't the first time he had threatened to leave, but this time was different. Shit, I was different. I wanted to beg him to stay, but I was tired. I wasn't about to fight for a marriage I wasn't satisfied with. I damn sure wasn't going to beg a man that I'd been good to not to leave. If he wanted out, so be it. Let the chips fall where they may. Shawn moved out and moved next door for a fresh start.

It seemed I moved after each life-changing event. There hadn't been much stability. But it was how I had been able to cope with life's ever-changing realities.

My Truth

I miss different things about my husband, and sometimes I weep tears of sorrow, but we weren't happy. We're still married but separated. I'm still finding my way. Shawn and I talk a lot, but it's different. We've discussed getting back together, but too much time has passed. It's been three years. If we were going to make it happen, it probably would've happened already.

I have a new outlook on life. I'm working on being happy with myself because I now know it starts and ends with me. I know the type of man I want in my life. I don't want to be with anyone who thinks he can put me in a box. I am different, and I need a man who understands my quirks and silliness. I want someone who is fun and outgoing. Most of all, he must have a good heart. I will take that over anything else. Your heart speaks to the person you are. I am an easy-going and judgeless person. I meet people where they are. If I roll with you, I've got your back. But I am loyal to a fault. My man and I must have the same attributes.

Shawn will forever be in my heart. I have made some mistakes along the way and so has he, but we will always remain friends.

I am still having a hard time coming to grips with things. I am at the cusp of a breakthrough but not quite there yet. Prayerfully, I'll have total healing after telling my story. I don't feel like I'm in God's good graces. But I am asking for mercy and favor. Do I deserve it? I'm not sure, but I want it. My spirit is a little torn but not completely broken. I am a work in progress. Lord, renew my strength!

CHAPTER
Twenty-Three

It was an ordinary work day. Barbara and I were talking and laughing about the day's events. But things quickly turned from laughter to tears.

When my phone rang, I looked at the caller ID and knew it wasn't going to be good. It was one of Tylin's ex-girlfriends, Jodi, who lived in the same area as Tre'. She called me from time to time to ask about Ty, but my discernment told me this wasn't that type of call.

I was already concerned about Tre' and the kids because I knew he was under a lot of pressure and losing his way. During our conversations, I could tell he wasn't handling things well.

He had been a single dad for the last three years with my support. Sharnise, the children's mother, had left and was dealing with her own demons. She had slipped into the underworld of prostitution to support her drug addiction. She was out there in the streets trying to heal her own wounds from her past. Her mother had died when she was young. Shortly after, her brother was murdered and, a few years later, her father died from cancer. It became too much for her to cope with. Like so many people do when they are emotionally lost, she turned to drugs for an escape. Besides Tre', she didn't have a soul to turn to. The pressures of motherhood and being a nurturer, fiancée, and provider while struggling with her loss became unbearable.

Tre' went into survival mode. He was a fighter; that's how he was built. When faced with traumatic situations, he found his way out. But we didn't always agree about how he handled the situations.

There was no way he would let his children suffer. He wasn't going to allow them to be homeless or hungry. He wanted more for them. I was the only support system for him and those children. I was worried about them and knew Tre' was trying to figure things out. I let him know if he did his part, I would help him. I knew how hard it was to be a single parent and the obstacles he'd face each day. We had a plan; I would pay his security deposit, rent, and utilities until he got on his feet. He had found a place and was due to move in the following month. I told him he had three months to find a job. (He had been working odd jobs.) Things were set into motion. All I needed him to do was keep his head on straight.

I also knew Tre' wasn't one for handouts. He hated asking me for anything. As a man, he always felt he needed to stand on his own two feet. I respected that, but there are times in life when we all just need a shoulder to cry on or some assistance. Tre' never wanted to be a burden to anyone, not even me. But he wasn't a burden. I found comfort in knowing my family was taken care of. Once my mother passed away, I had no one to say, "Girl, I got you. Don't you worry. We will figure it out." I had to shit or get off the pot. Many nights, I went to bed hungry. Sometimes, I cried myself to sleep because I didn't know how I was going to make it.

I answered the phone. "Hey, Jodi."

"Ms. Mayes," she said, calling me by my maiden name, "Tre' is in trouble, and my sister and I have your grandkids."

"Are the kids okay?" I asked.

"Yes, the kids are fine."

I took a deep breath and tried to clear my head. I didn't know what she was about to say, but I knew it wouldn't be good.

"Someone has been shot and, somehow, Tré and Sharnise may have been involved."

I couldn't make sense of any of it. But I did know I needed to get

my grandbabies. I was a nervous wreck. I didn't know what to do. Justin drove upstate to get the kids because I was concerned about Child Protective Services coming for them. All I could do was break down and cry.

I asked God, *Why? When will the peace come? Don't You know how tired I am? Haven't I endured enough? When will the pain stop?*

I could go on forever with all the questions. But when I stopped asking questions, I became angry with God. He was always in control, so why was He allowing this to happen? My life hadn't been the best, yes, due to my mistakes, but my heart was good, and so were my boys'. I did right by people, so why, yet again, was I faced with turmoil? He'd taken my mother, my family, and, now, my son. My spiritual walk hadn't been the greatest, but I knew I was a child of God. I believed in Him and loved Him, so why had He forsaken me? Why had He allowed the devil to come in to kill and destroy?

Tré was given permission to make his one phone call. I knew once I spoke to him, I would be able to determine how bad the situation was. I quickly learned he had messed up—bad.

He said, "Ma, I'm sorry. I made a mistake, but I need you to get the kids. This one doesn't look good, but you will be okay. Don't worry about me. Just make sure those kids are good." He didn't have to say another word; I knew we were in store for some rough days ahead.

The kids were excited about coming to Nana's house. They enjoyed being with me, but I knew they could sense that something wasn't right. Tré's oldest, his daughter, kept asking a lot of questions. She wanted to know where her daddy was. For weeks, I changed the conversation because it wasn't appropriate to tell her. I was glad that school was out, and they were on summer break, so I didn't have that to worry about.

I tried to keep them busy, taking them to the park and doing fun things with them. However, I quickly realized how challenging it was to raise grandkids. I hadn't taken care of kids in many years, and I was having a difficult time, but I wouldn't let them go into

foster care, especially after working in the field for so many years. I knew the stories of how children were mistreated. This experience made me see things through my mother's eyes. I'd left her with two kids to raise when she was finishing up with me. And if it was hard for me, I know it must have been painful for her. Grandparents want to admire their grands, have fun with them, spoil them ... and send them home. Lord knows I wasn't up for the task. My patience was thin. My grandson had so much energy and was the most hard-headed child I had ever seen.

De'Von and Megan were my lifesavers. They felt sorry for me. We talked it over as a family and decided they would take over custody of the kids. Tré and Sharnise signed over their rights, and the children went to live with them.

Before the kids moved to their new location, I took them to see their dad. It was emotional but a much-needed visit. First, Tré shed tears of joy. Seeing them meant the world to him. Then came the tears of regret and heartache. He would be separated from the two most important people in his life, his son and daughter, for an indefinite amount of time. I felt his pain, and when I looked in his eyes, I could feel his soul crying. How did he let himself get to this point? But there was no turning back. The deed was done. The crime had been committed. But if he could turn back the hands of time, if he had it to do over again, I know his choice would've been different.

My Truth

All right now, I was at a point in my life where I felt we kept bumping our heads against the wall. I told my sons, "You can't expect different results when you're displaying the same behaviors."

My life should be a constant reminder of how a person can end up in a rut. What did I expect? I was caught up in the same old patterns. A constant revolving door.

I had to break free of the cycle, do something different every day. Change starts with me.

At fifty-plus, I view the world differently. I have no qualms about where I have been or where I'm headed. My past has come and gone. Reflection is for healing.

Despite a few setbacks, this journey I'm on is gratifying. I have a new outlook on life, and "it is what it is." It's not that I don't care about anything; I don't worry about things I have no control over. I cannot stop life from throwing curve balls. Some things are inevitable. But I am choosing to walk by faith and not by sight.

I believe God wouldn't bring me to it if He wasn't going to bring me through it. Yes, I have doubted His way, but I am a believer, and it is my conviction that He has all the power to do the impossible.

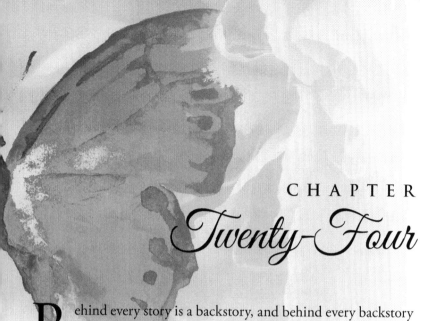

CHAPTER

Twenty-Four

Behind every story is a backstory, and behind every backstory are the people. My family, we are the People.

I sat in that courtroom reflecting on our lives. The people behind the story of this young man who sat waiting to hear the judgement to be bestowed upon him. Wanting to speak truth to the jurors about how Tre' hadn't shot anyone. How his back was against the wall, and he hadn't seen another way out. How he wanted to pay for the crime he had committed. How no one was seriously hurt.

The prosecution offered Tré a deal. They had enough evidence and knew the backstory. And as much as I wanted him to take it, he couldn't. He'd never snitch. I didn't understand it, but I hadn't walked in his shoes. His codefendant wanted the case to go to trial at any cost. I believe he felt the jury would be inclined to think Tré had committed the crime, and he would walk away free and clear.

Sitting through the trial was painful. Tré was being painted like an animal. These jurors had no idea of our family history or what had led up to this point in his life. They didn't know him, and they didn't know what we had been through as a unit.

He was being judged by his mistake. They didn't know how much he loved his children and, like me, would do anything for them. They didn't see the big teddy bear with the big heart. What they saw was a person who had made a bad decision, a life-changing

decision. Hadn't we all made mistakes? But the power wasn't ours. We couldn't tell the story. There was no sympathy. It was all about the facts.

If poor people decide to take a case to trial and lose, they suffer a heavier sentence. How fair is that? And with a codefendant, the choice to go to trial isn't theirs.

The trial lasted a few weeks, and Tré was sentenced to twenty-two years in prison. I thought I died when I heard it. There were people in jail convicted of murder who weren't sentenced to that much time. The victim in this case wasn't in a life-threatening situation. The verdict and sentence were about sending a message. The town where the crime took place was a high-crime area, and they wanted to let the gangbangers and criminals know what happened when they committed crimes.

My Truth

We will continue to fight this battle, and I believe that, eventually, the crime will match the punishment. Tré is a fighter, and he is tougher than ever. He inspires me to stay positive. I went to visit him recently, and he is working on his appeal. Prison life is different, but it's nothing he can't handle. When faced with adversities, we get stronger.

Of course, I worry, but I know everything will work itself out. My family and I have overcome many obstacles, but we are determined to never give up. We will keep the faith and give it to God.

I owe the assistant district attorney an apology. I prejudged her without knowing her. I detested her, but this wasn't about her at all, and I don't know her backstory. She didn't deserve my criticism. That black woman had a job to do, and she did her job. She presented the case brought before her and had the evidence to back it up.

A Letter from Tylin

This is for the most beautiful and powerful woman I have ever met in my life. I call her Momma Love. But most know her as Lori.

I just want to say thanks to this lady for providing not only for me but all her five boys. She raised us with great values and morals. Through everything she has endured, she showed her young boys how to become men. Who says a woman can't raise boys to become men? My mother worked multiple jobs, helped with sporting events, homework, and she cooked and cleaned. You name it, she did it. To me, she was superhuman, breaking up our arguments, dealing with our school issues, fights, girls, sports, and everything else we dealt with. And she did it all while maintaining her sanity. (Well, she may be a little crazy.) She is my superhero.

For everyone reading this book, I thank you. She is a very special woman, and I am grateful she was able to fulfill her lifelong dream of becoming an author.

For the women out there who have faced trials and tribulations, use her story as the motivation you need when you think there's nothing left. She can guide you to find your own inner peace. She has helped youth and women of all ages get their lives back on track.

I love you, Momma Love
Tylin A. Mayes

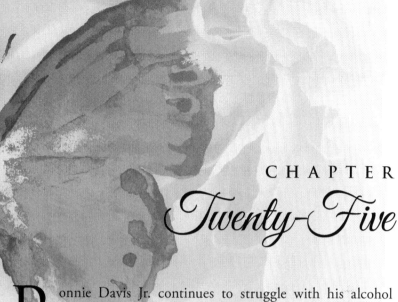

CHAPTER
Twenty-Five

Ronnie Davis Jr. continues to struggle with his alcohol addiction, but he has admitted to having a problem, which is the first step. He is headed toward a treatment program. He is back on medication for his seizures, and so far so good. He is scheduled to see a neurologist soon.

When he isn't working, his time is spent bonding with his children. He is taking one day at a time, learning self-love. He has come to realize his addiction comes from a dark place. With love and support from his family, he will find inner peace. Love conquers all.

De'Von W. Ritter and Megan Ritter are working hard and taking care of their expanded family. The kids are happy and all honor roll students. They are involved in extracurricular activities like baseball, gymnastics, and basketball. They are always on the go. I am ever so grateful for De'Von and Megan for taking on the responsibility. I don't know where we would be without them. Family above all else.

Jarrin T. Mayes (Tré) remains incarcerated and is steadily working on his appeal. He is optimistic and refuses to let his circumstances define who he is.

Justin D. Cohen is in the process of deciding his next venture in life. He is mentally, physically, and spiritually sound. He has set goals and plans to accomplish them all. I admire his determination.

Last year, he set out on a journey to become his best self. He has been following Dr. Sebi's alkaline lifestyle commitment and hasn't turned back. He plans to open restaurants in black communities and offer better healthy alternatives. Health is wealth.

Tylin A. Mayes is currently incarcerated and preparing for what the future holds for him. He is the proud father of a baby girl and looks forward to spending as much time with her as possible. The future is ours.

My Truth

I pray for my sons' success, health, and peace. Do I have regrets? I have many. I wish I had provided a better life for them and was able to give them the better part of me, not the broken and confused me, not the woman who didn't love herself enough to demand more of herself and from others.

The great thing about life is that it's not over until God says it's over. I am steadfastly working on my own personal and professional development. I have been and will continue to be there for my sons every step of the way. Like they have my back, I've got theirs. We make no excuses for our mistakes, but we always have each other to lean on. We shoot from the hip and tell it like it is. When you're wrong, you're wrong, and when you're right, you're right.

We are imperfect people figuring out how to make better choices and better decisions. Family above all things!

Twenty-Six

"Y ou reap what you sow" is a biblical reference that means you must eventually face the consequences of your actions.

My actions may be confusing or troubling for some, and I understand why it would be, but what doesn't kill you makes you stronger. I am strong because life brought about death, and death brought about life, which eventually forced changed. After each of my experiences, I acquired more faith, more hope, and more determination. I was knocked down several times, but it's not about how many times you crumble, stumble, or fall; it's about getting back up and learning from it. For some, it takes one major pitfall, and they can bounce back. Well, I'm not a part of that group. I repeated the same shit over and over again. I am stronger and wiser because of it. And because of my path, I can minister to others. I have been through it all, and I am not bitter, angered, or saddened. I am free. I set myself free, and I don't allow others to hold the past against me.

It's easy to judge another person and point out their wrongs. I own my faults, and I will never make excuses for bad behaviors. Behaviors are the result of feelings. When you're able to connect the feelings to the behaviors, you become enlightened about the cause.

The root of my problems stemmed from watching the abuse

around me. I was traumatized as a little girl. I didn't know how to feel or act. I lived in fear. My mother did the best she knew how and gave me all the love she had, but I still went to bed not knowing how the night would end. I would lie in my bed reluctant to fall asleep. I was always on edge, listening for the sounds of shattered glass or strange noises. I was in panic mode every single night, and I believe my mother was, too, but her way of handling it came in the form of a liquor bottle. My form of handling it was rebellion. I'm not proud of it, but it is what it is.

People have called me stupid for being in a domestic violence relationship or for not getting out sooner. They were right; I shouldn't have been in a domestic violence relationship, and I should have left the first time he put his hands on me. However, when you're lost and looking for love, it will find you in the worst places and at the worst times in your life. It found me, and it grabbed ahold of me tightly, refusing to let me go. I had to release the shackles that had me bound. How did I do it? From the inside out. I began with self-love. I reached deep down into my soul and asked myself a question: "Do you forgive yourself for all the hurt you have caused yourself?" The next question was even harder: "Do you love yourself?" It took time for me to answer, but it was necessary for my process. I spent countless hours telling myself I am worthy of a better life, and I deserve greater. It didn't happen overnight. I prayed, prayed some more, and prayed even more. I listened to motivational speakers, kept the gospel music playing in my head and on the CD player, read daily affirmations, and read bible scriptures. It takes work to change negative thoughts into positive thoughts.

Some have said I deserved the life I had because I made the wrong choices. It was my own fault. My focus should have been on school. They were right; I did make bad choices, and I should have focused on school.

My actions and reflections have helped me understand myself better than anyone else will ever be able to. For many years, I beat myself up for those same damn decisions. I have felt worthless

and disappointed in myself, but today, I am grounded. I am my own worst critic, but I am learning to let go of that in which I cannot change. I didn't do the impossible by picking myself up and demanding a better me. I acknowledged my shortcomings and wrongdoings.

I do regret that it took me until age fifty to begin the healing process. I finally let go of some of my baggage. I went from weighing 243 pounds to under 200 pounds, which represented all the years of pain and dead weight I'd been carrying in my heart.

I am reaping what I have sown. I am owning my mistakes and accepting my consequences. I planted seeds that prospered and shone light into the hearts of others. I have helped many youth who remain in contact with me, thanking me for guidance, patience, and understanding.

I've learned so much about myself. I have been through the wringer and back and had my share of ups and downs, good and bad times. Some from my doings and some from others. My life hasn't been easy, but God knows it could have been worse. I have confessed my sins and tried to make amends with those I have hurt.

Recently, I was asked, "What was your a-ha moment?" I have been thinking about that question, and it finally dawned on me! Throughout my life, I have had many a-ha moments. At different points, I knew I needed change, and I have been striving for my betterment daily. As each day passes, I feel like I am learning more about myself and inviting others to see the best parts of me. No more self-doubt, no more fear, and no more selling myself short. I am victorious, and I have triumphed over depression, separation, jealousy, envy, and all other trials. This is the new and improved Lori who speaks truth! We all have dealt with stuff, but it's never too late to make a change. Release those pity parties, and get up and do something different in your life.

Change and growth begins with you. You have a choice right now to continue to be miserable or go out there and grab your happiness. I would be remiss to tell you it's going to be easy, because it won't

be. What I can guarantee, without a shadow of doubt, is that it will be worth it because you are worthy. Your biggest investment should be you. Come to terms with whatever it is that has kept you back. Forgive yourself for letting yourself down and move forward. Don't stay stuck, and if it means you need to get out of your own way, then do it. Let yourself know how much you love you. Pat yourself on the back for making it this far. When they said it couldn't be done, you did it. When they said you wouldn't amount to anything, you proved them wrong. I did it, so I know it can be done.

At one of my previous jobs, I became the first black female director without a degree. People told me, "You will never go any further. You won't become a director without a degree!" Had I listened to them, I would've remained part of the line staff. When you change your mindset about yourself, the road is endless. Whatever you set your mind to do you can achieve. I walked into my office with my head held high. I was a director of a program, responsible for ninety-plus youth and approximately 300 staff members. I supervised the transportation department, recreation programs, and switchboard, and I was responsible for a multi-million-dollar budget. All decisions for the program went through me first. And I did it with a GED. So don't worry about where you are; look at where you're going. Even in the face of adversity, it can be done. God is good all the time!

I have apologized to my sons for not being the best mother they needed me to be. At times, I was selfish and put my wants and needs before theirs. My immaturity played a major role in the way I raised them. But I always loved them with all my heart. My desire is for them to be successful and get all the blessings they are so deserving of.

At age fifty-one, I am a changed woman. I still make mistakes, but I'm learning and growing from them. My quest continues to be the same, giving and helping others. I have the gift of discernment, and it allows me the ability to genuinely connect with people from all walks of life and different ages. I am partial to women because I have walked in many of their same shoes. I will continue my fight

to reach them wherever they may be. They will always have a friend in me.

My spiritual journey hasn't changed much. I was hopeful, but I still have some work to do. But I refuse to give up on my relationship with God. He has and always will be "from whence cometh my help" (Psalm 121). He has never left me or forsaken me. I may not always understand His plan, but I know He has His hands on me. I am upset and disappointed in Him and in need of prayer. But contrary to what others think, I know He hasn't written me off, and for that, I am grateful. I am and continue to be a work in process, still on my spiritual journey. I know He hasn't left me. He is waiting for me to seek Him, and He will show me the way. I don't know what it's going to take, but I am determined to get back on track.

Throughout my life, I have acquired some scars and wounds, but like they say, what didn't kill me made me stronger. My wounds birthed beauty; beautiful wounds are what I see.

My sons are the men I wanted them to be. Each one is unique, but they have a piece of me inside them. They are kindhearted, gentle, giving, selfless, genuine, handsome, and loving. My sons are the epitome of good people. So I have reaped what I've sown. My husband and I are on good terms. I still love Shawn, and I know he loves me. However, I'm not sure if that's enough. We are learning how to be friends again. We have our differences and see our marriage from two separate lenses. Our future is hopeful, but only time will tell.

This isn't our end to the story; it's our beginning.

AN EMAIL FROM JUSTIN

To: Loriann Smith

Hey Ma,

First thing I want to say is that this is probably going to be the most heartfelt thing I have ever written or given you. My motivation and inspiration come from you! You don't know this, but prior to coming back home, I was at the lowest point in my life due to my health problems and other things. It felt so bad that I was really close to committing suicide, and the only thing that stopped me was you. I couldn't put you through that pain and hurt and decided to fight instead of giving up. Actually, my whole life has been centered around making the right choices so I wouldn't cause you any pain because I've seen all that you've been through. Out of all of us, I feel that I've caused you the least amount of pain outside of your unnecessary worrying. LOL! I hope I have done right by you and given you more than I have taken from you.

Secondly, I want to say that your book is really good. I really enjoyed reading it again. Knowing all that you've been through, all we've been through as a family, not many people would have overcome our situation, but we did. In part, it was by your doing. Your grit, hard work, and determination have kept us afloat and provided us with many opportunities so we could strive for a better

future and happier life. So know that you are a great mother and have shown, many times, that you are willing to do whatever it takes to take care of your family, and you've made many sacrifices. We are all thankful for everything you have done for us thus far.

Now, let's get to the good part! I'm writing this message to give you motivation and inspiration as you have done for me throughout my life. Knowing we have to move, and we both have no idea where we're going to live, it's time for us to grind. My plan is to go to a shelter if I don't figure things out. I'm not saying this for you to worry because I'm not worrying about it. Over the next five months, I'm going to work my ass off, and I'm confident that things will fall into place.

With that being said, I extend my love for you by challenging you to do the same. All I want is the best for you, which includes you being healthy mentality, emotionally, and spiritually. So this is my challenge: Over the next five months, I ask that you give it all you have on all levels. I want you to really get back into the gym and focus on your physical health and use your time wisely. Start reading more and learning as much as possible on various subjects. In particular, I think you should focus on controlling your mind and thoughts by being disciplined and conscious of where you give your energy. It may be easy for me to say this because I'm a loner, but that will entail cutting back from your friends a bit so you can focus your time on your goals and dreams. You always put people first, and you are very loyal, but you have to be loyal to yourself first. As you will see, you will start to elevate spiritually, and you will become greater than you've ever imagined. From there, we will be unstoppable as a family, with you leading the helm like you have always done! Think about the effect you will have on the rest of us. We are all mama's boys, and seeing this complete and whole version of you will give all of us the strength to become the best versions of ourselves. It can help Ronnie Jr. and his condition, Ty's mental state, De'von's health, and Tré's peace of mind. Although it may seem that I'm asking you to sacrifice yourself again for us, that's not the case. I'm asking you

to make this sacrifice for you! For you to be happier, healthier, and able to enjoy this beautiful life the way you should. You deserve it.

That's my challenge. You always say you will start next week, so I will give you a week to decide if you want to go on this journey. It's going to be hard work, and it will challenge you on all levels, but you've shown, many times throughout your life, that you can handle any challenge thrown your way. It's time to stop being a work in progress and complete the project, which you can do in as little as five months if you put your mind to it. We both know that to be great in life, the project can never be complete, so keep striving for your greatness!

How bad do you want it?

To: Jay Cohen

Damn, I am in tears. I needed this message, and I thank you. I do want it, and I love you. I don't know if anyone has ever said that to me, that they would be willing to help me focus on me. I want to do this.

You are a private person, but your message is heartfelt, and I want to let the world know how my sons are the reason why I always keep pushing.

More inspiration for my soul.

A Letter to My Sons

I am blessed to have five amazing sons. You all are my special gifts from God. The way you came into this world may have been chaotic, but I love each of you with every fiber of my being. I am grateful I was chosen to be your mother.

I thank you all for encouraging me to share my story, knowing you would, too, be exposed to the world. But that's the type of young men you are. You all are my biggest fans and greatest support system. Team Lori!

We have managed to navigate through life by being silly, entertaining characters and laughing our way through the most difficult situations. When we get together, we have a blast. De'Von the comedian, thanks for always bringing the funny moments and finding a way to make us smile, laugh, and have a good ol' time. You keep us in happy tears. Let's never forget the good times. They are the defining moments we must treasure.

Lastly, there were several times in this book when I mentioned a search for someone to love me unconditionally. Writing my letter to you all made me realize I was searching for something I already have—you!

Thank you all for loving me unconditionally. You five are the Beauty that comes from my Wounds.

Love ya to pieces,
Mom

I am Not My Circumstance

By De' Von W. Ritter

I
Am the embodiment of willful expectations
Must
Navigate through my situations
Overcome
Thoughts that hold me back
Myself
Yield, learn, adjust and react
Changing
Inner pain and regressive
thoughts
Reality
Clearly understand the lessons
taught
Using
My outcome from this plight
Strength
Turning anger into might

Attitude
Never allow the loss of this
chance
Courage
Evading my beginnings, my
circumstance
I AM NOT MY CIRCUMSTANCE

Thank you for reading Beautiful Wounds

Comments or questions? Contact Lori Ann Smith
Website: ~~Loriannsmith.com~~
Email: ~~lsmithpublishing~~@gmail.com author lori ann 37
Instagram: ~~@author_lorismith~~ beautiful wounds
TiKTOK: @ lori ann 37
Phone: (914) 338-8680

Made in the USA
Middletown, DE
12 May 2024

54148702R00177